D# 291206

CAMERA EYE
ON IDAHO

CAMERA EYE
ON IDAHO

Pioneer Photography

1863–1913

Arthur A. Hart

The CAXTON PRINTERS, Ltd.

Caldwell, Idaho 1990

Library of Congress Cataloging-in-Publication Data

Hart, Arthur A.
 Camera eye on Idaho : pioneer photography, 1863–1913 / Arthur A. Hart.
 p. cm.
 Includes bibliographical references and index.
 ISBN 0–87004–343–9 : $24.95
 1. Photography--Idaho--History. I. Title.
TR24.I2H37 1990
770'.9796--dc20

90-43033
CIP

Design by Arthur A. Hart

Publication of this book was made possible in part by a grant
from the Idaho Centennial Foundation, Inc. The author's
royalties have been donated to the Foundation.

ISBN 0-87004-343-9

Lithographed and Bound in the United States of America by
The CAXTON PRINTERS, Ltd.
Caldwell, Idaho 83605
153589

CONTENTS

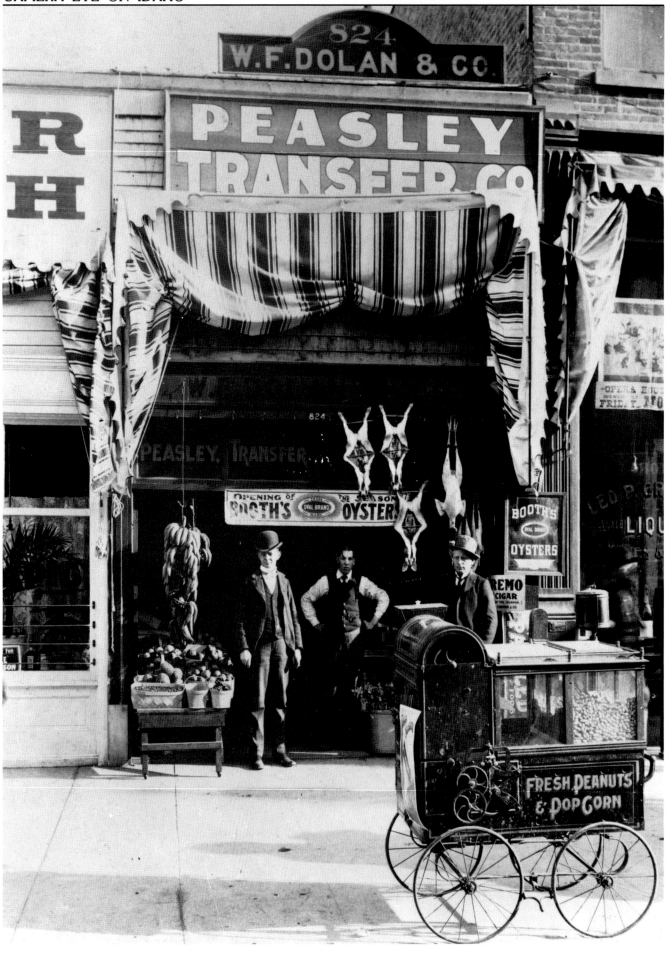

FOREWORD

This book seeks to fulfill several long-felt needs in one volume. First, it recognizes the work of pioneer photographers who until now have been little known and largely unstudied. Some of the most important historic photographs in library and historical society collections across the state, often reproduced in books and journals, have never been credited to their makers. Increasingly we have come to realize the significant contribution to our knowledge of early Idaho made by photographers who recorded people, places, and events in nearly every city and town.

Only in the past fifteen years, for example, have the superb Barnard-Stockbridge and C.E. Bisbee collections attracted the attention of scholars and been widely shown in exhibits and publications—some national in circulation. The Barnard-Stockbridge work, now at the University of Idaho, is a significant chronicle of life and times in Wallace and the Coeur d'Alene mines; C.E. Bisbee's, in the Twin Falls County and Idaho State Historical Societies, records the development of new irrigation empires in southern Idaho.

The first fifty years after the establishment of Idaho Territory in 1863 is the focus of this study of pioneer photographers which lists every one that could be discovered. The examples selected to illustrate their work comprise a striking pictorial history of Idaho and her people during that period. The pictures speak for themselves, but the accompanying information about the men and women who made them should be of lasting value for reference, and should encourage others to carry on the search for more. There were undoubtedly many whose names never found their way into written records, and there are just as surely private collections of photographs that should be known and studied.

This book is dedicated, not only to pioneer photographers, but to the people of Idaho over the past century who have preserved the images of our past shown here. Without their generous contributions of photographs to public collections like those of the Idaho State Historical Society, many of our county historical societies, schools, and libraries, a study like this would not have possible.

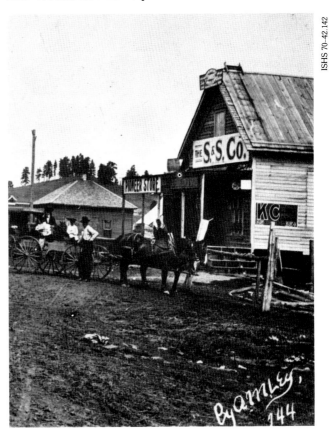

ISHS 70-42.142

This detail of an A.M. Ley photo shows an Idaho town that no longer exists: Van Wyck.

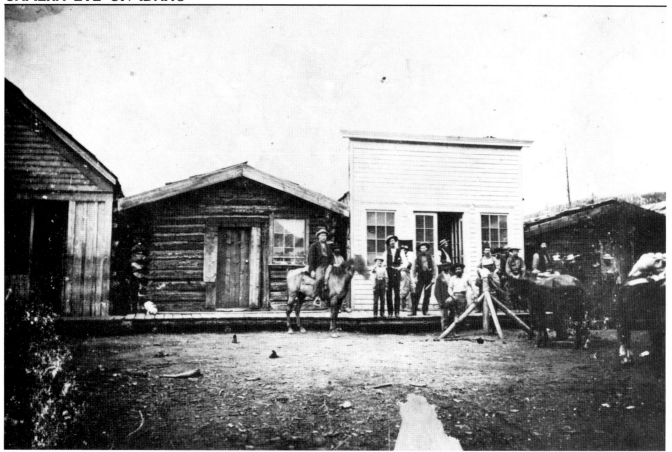

A.F. Thrasher visited Leesburg, Idaho, in 1870 and took this earliest surviving photo of that mining camp, named by its Southern founders for Confederate General Robert E. Lee.

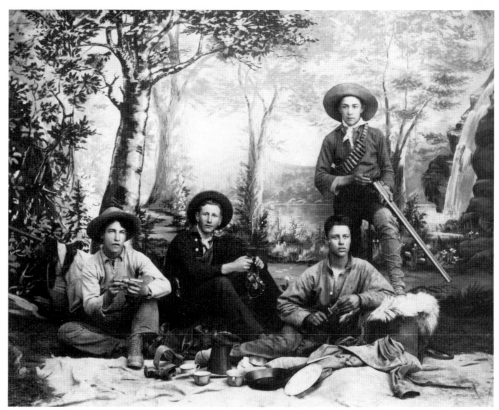

T.L. Graves of Boise took this studio portrait with a woodland backdrop of Frank Manville, Fred Brown, Alf Mitchell, and Ed Hawley in about 1890.

THE CHALLENGE

It took courage, perseverance, and skill to make a living as a photographer on the Western frontier. Producing saleable images in a highly competitive field, with the materials and techniques available in the nineteenth century, required care and patience. One slip, or lack of concentration during preparation of the plate, its exposure or its development could, and often did, result in failure. Factors beyond the photographer's control had to be contended with as well, such as changes in temperature or light, and subjects that moved.[1]

The enthusiasm of early photographers, despite all of these difficulties, is amusingly recalled in a Western reminiscence published in 1880:

> Mr. Thrasher the photographer is another character of public interest, whom I will not disguise under a fictitious name, because the one he wears by right so exactly suits him. He invests the profession of photography with all the romance of adventure. What other men will do for self-defense, or excitement, or a positive reward, he does for a "negative." No mountain is too high for him, if there's a "view" from the top. No perilous precipice daunts him, if it is just the place for his camera. If there is a picturesque region where nobody has been, thither he hastens, with company if company offers; alone if need be, he and his pack-mule, carrying the precious chemicals and glasses. Sometimes, after a long and arduous expedition, that mule will roll down a steep mountain-face, and smash everything. Then Thrasher begins again, nothing daunted . . .[2]

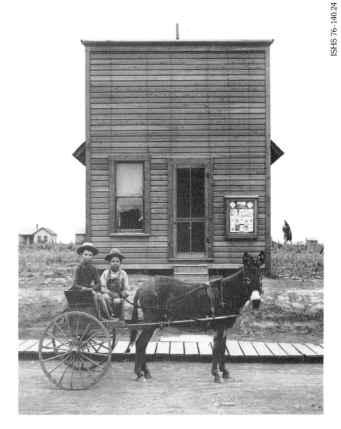

ISHS 76-140.24

These children posed in a donkey cart in front of a Council photographer's studio early in this century. The donkey is "watching the birdie," too!

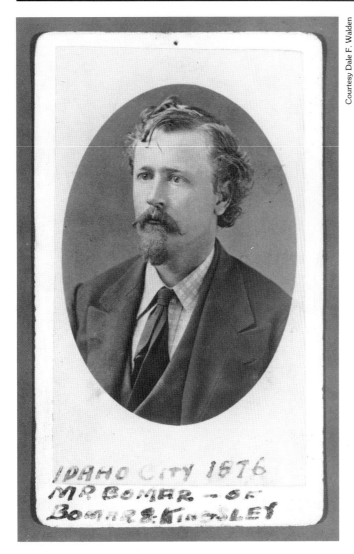

Courtesy Dale F. Walden

IDAHO CITY 1876
MR BOMAR - OF
BOMAR & KINGSLEY

*Albert C. Bomar had perhaps
the longest and most varied
career of any pioneer
photographer in Idaho.*

A.F. Thrasher, a Montana photographer based in Deer Lodge, visited eastern Idaho occasionally in the 1870s. His street scene of Leesburg is the earliest we have of that mining camp.

Portraiture made up virtually all of the pioneer photographer's business, requiring that he constantly seek out customers and compete with others for their patronage. This often meant moving from town to town on a seasonal cycle, advertising in local newspapers, and soliciting business by direct contact. Salesmanship was as important as technical skill.

Photographers were as vulnerable to the changing fortunes of the small towns where they operated as were other businessmen.

When times were hard, in mining camps especially, a wholesale exodus of the population could leave a place the ghost of its former self, with few customers to support any business.

The frequency with which early photographers formed and dissolved partnerships suggests that there were mutual advantages to be gained, but that changing economic conditions kept all parties flexible. Some entrepreneurs operated studios in several towns at once, taking in a local photographer as partner and furnishing him with necessary supplies. These included chemicals and plates and such auxiliary retail merchandise as picture frames and albums.[3]

Another evidence of the precarious nature of photography as a profession is the variety of sidelines the pioneer lensmen were forced to take up to keep bread on the table. In addition to their primary occupation, we find Idaho photographers listed in early directories as bartender, barber, machinist, jeweler, postmaster, postal clerk, druggist, farmer, cattle rancher, artist, miner, Indian agent, surveyor, mechanical engineer, general storekeeper, and school teacher. E.C. Lavering of Caldwell was a furniture dealer and undertaker as well as a photographer.[4]

Many drifted into and out of the trade from year to year, or eventually gave it up altogether. Albert C. Bomar, one of the mining camp pioneers, had studios in Boise City, Idaho City, Silver City, Centerville, and Bonanza City. At Bonanza he was postmaster, express agent, and ran a sawmill and a livery stable. After moving to Challis in the early 1890s he opened a jewelry store. The 1900 census listed him as "farmer," but by 1910 he had moved to Idaho Falls and was again, at age sixty, a photographer.[5]

THE WORKPLACE

The pioneer photographer's studio was primitive, like most other things on the frontier. In the days when towns were born overnight, the business was often housed in a tent. As things settled down and lumber became available, photographers, like merchants, bankers, and saloonkeepers, built more substantial quarters. These followed the usual course of architectural improvement over Idaho's first fifty years: tents were succeeded by wood-framed false-gable store buildings, and those by more permanent structures of brick and stone.

In a young state like Idaho even some twentieth century photographers started in tents, as can be seen in an early Twin Falls picture.[6] In the decade 1903–1913, many Idaho photographers erected substantial buildings to house portrait studios, dark rooms, and offices. Some of these doubled as homes and were located in residential neighborhoods. If the photographer built in the business section, he and his family often lived upstairs or in the back of the shop. This arrangement was convenient, saved money, and allowed family members, especially wives, to assist in darkroom and retouching processes. Some of these women were office managers, photo technicians, and artists in their own right, and often carried on alone if they were widowed. Sons and daughters who learned the photographer's trade at home sometimes made the family business their own life work. Idaho today has several third generation enterprises of this kind.[7]

The interior fixtures of early studios progressed over the years from extremely primitive to near luxurious. The furniture of an Idaho portrait studio of the 1860s might consist of a plain backdrop, a chair in front of the camera, and a source of natural light. Since a likeness of the customer was really all that was required,

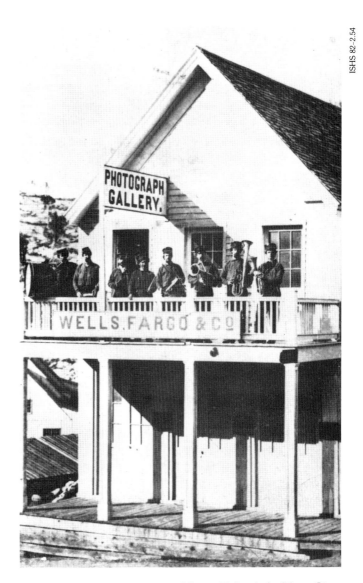

Hiram E. Leslie's Silver City gallery was above the Wells Fargo office in the late 1860s. The town band posed on the building's porch.

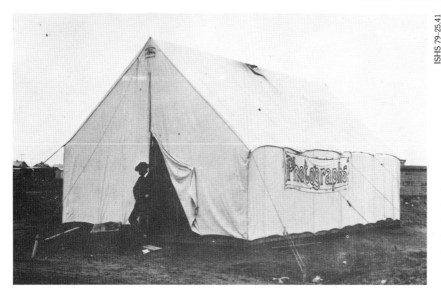

ISHS 79-25.41

This Twin Falls tent studio may have been the one C.E. Bisbee used soon after his arrival, but is probably that of an earlier photographer at the new townsite. It was labeled "First photography studio" by the donor.

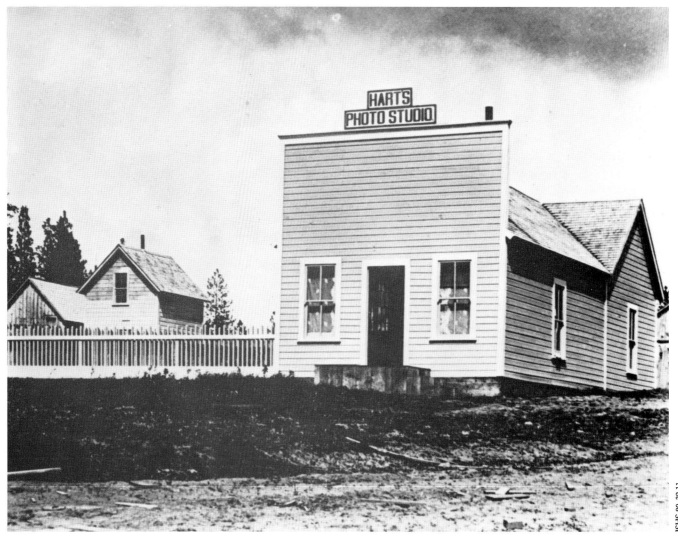

ISHS 80-32.11

William H. Hart settled in Forest, Idaho, in 1902, and built this combination studio and dwelling soon after. He moved to Vollmer in 1907. Forest, now virtually a ghost town, is southwest of Winchester.

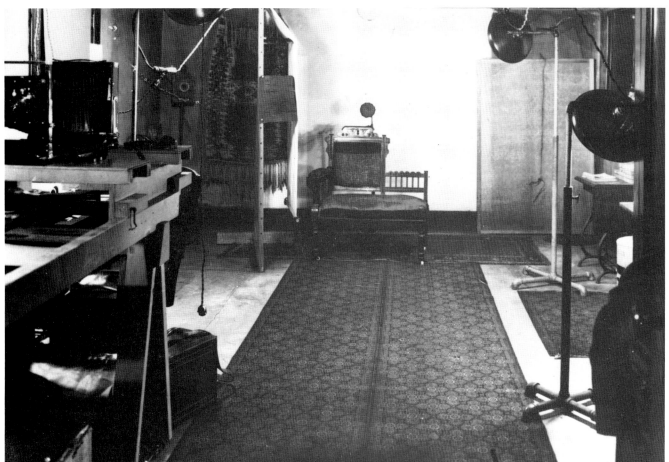

ISHS 68-8.14d

This interior view of an unknown Idaho photographer's studio shows electric lights and what appears to be a "head steadier" on the back of the settee.

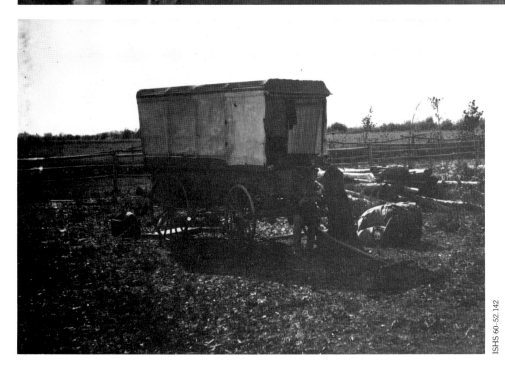

ISHS 60-52.142

Two young photographers who toured Idaho from about 1909–11 used this wagon dark- room. The pictures, donated by the Nebraska Historical Society, are superb, but the identity of the men is unknown.

ISHS 253–A

The album inscription on this 1865 carte-de-visite from Idaho City says "Frank Pastu, gambler." He could equally as well be taken for a church deacon or elder.

the chair was usually omitted and the subject posed standing. As lacking as these early portraits are in artistic merit or originality, they were gratefully received by families and friends back home when sent from an Idaho mining camp. They confirmed the safety and well-being of a loved one far away. For us today these old portraits are a delightful source of information on pioneer clothing and hair style—a vivid window into nineteenth century fashion on the frontier.

Since the popular carte-de-visite portrait measured only 4 x 2 1/2 inches, these standing figures have very small heads and faces. Half figures in the format were somewhat better, but larger pictures were soon in demand. The "cabinet photograph," 5 1/2 x 4 inches on a mount 6 1/4 x 4 1/2 inches, allowed the use of props that could suggest affluence, leadership, artistic taste, or other qualities flattering to the sitter.[8]

Formulas tried and true, used by portrait painters since Renaissance times, but especially in eighteenth century England, were now used by photographers. Classical columns or pedestals, rich velvet hangings, painted landscape backgrounds, and massive and ornate furniture created illusions of grandeur that ordinary Idahoans loved. It is said that some photographers could even supply elegant clothing if needed.

We know little about the artists who painted the scenic backgrounds for early studios, although we can judge their merits through the photos themselves. The only reference we have found to the production of such a backdrop is in the *Idaho World* of Idaho City on July 16, 1880: "Professor Gilbert Butler, who handles a paint brush in true artistic style, has just completed a beautiful scene for the photograph gallery. It will form the background of photographs."[9]

Although many early Idaho photographers were versatile, often carrying on a variety of other activities in order to eke out a living, we have found none to equal the remarkable Butler. At thirty-three, when the above item appeared, the English-born scenery painter was also Idaho City's schoolmaster, a mining engineer and surveyor, organizer and director of the town band, operator of the weather station

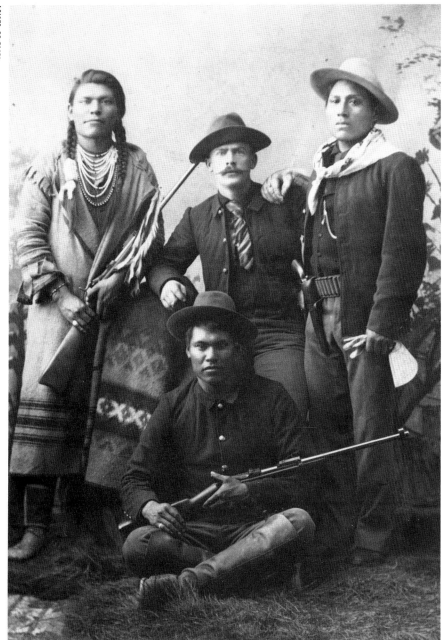

Cummings Brothers of Lewiston took this portrait of Ned White, center, with three Nez Perce friends. All appear to be looking as macho as possible.

for the U.S. Signal Corps, an amateur astronomer with a "fine telescope," director of local theatricals (for which he painted the scenic backdrops)—all in addition to his work as a photographer.[10] In November, 1880, he was elected County Surveyor.[11] Of his abilities as a school master, Episcopal Bishop Daniel S. Tuttle said he was "the best teacher in Idaho Territory, and . . . one of the best educators I ever met."[12] During most of his stay in Idaho City, Gilbert Butler was in partnership with pioneer photographer Albert C. Bomar, but a few surviving undated pictures bear his name alone.

In Idaho, as the wild and unsettled West became tamer, some sitters looked back with longing to more picturesque and heroic times. It was popular for young men to pose in frontier costume, brandishing guns and knives, as if they were participants in Indian wars or sheriff's posses. Young Indians enjoyed this nostalgia game too, and tried to look fierce and warlike for the camera.

Some Western photographers gained national reputations with Indian portraits that betray a longing for days that would never come again. Edward S. Curtis is the most famous of these, much admired for the beauty and sensitivity with which he recorded the faces of the "noble red man." As fine as these pictures are, it

Chubby Allie Bird looks too big for the high chair that serves as a prop in this carte-de-visite portrait of the late 1860s.

ISHS 455-23

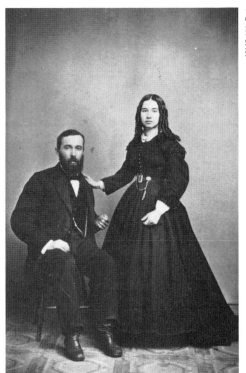

This superb portrait is of John Cozad, who represented Ada County in the House of Representatives of the Fourth Territorial Legislature, 1866–67.

Mr. and Mrs. Joseph Mizener. The husband, seated, wife standing with hand on his shoulder, was a classic pose for married couples. Mizener was Boise's first postmaster.

was sometimes necessary for the photographer to supply his subject with the eagle feather warbonnets and other bits of costume that helped recreate the romantic flavor desired.[13]

Parenthetically, it should be noted that Charles M. Russell and Frederick Remington, two of our greatest Western artists, were also trying to recapture a vanished world in their paintings of cowboys, Indians, and frontier cavalry. There had been historical painters for centuries, but Remington and Russell, at least, were looking back only fifty years for their Western subjects. Curtis, Russell, and Remington were all romantics, and if they did not portray Western life as they found it in their own time, they nevertheless created unforgettable images of a romantic West as we would like to remember it.[14]

By the end of the pioneer period we have chosen to chronicle, the studios of Idaho photographers still varied widely in style and elegance. Some, like that of Clarence E. Bisbee of Twin Falls, were exceptionally artistic and well appointed.[15] Others, in smaller towns, were no doubt much plainer and limited to the basic essentials of camera, backdrop, and a seat for the subject. By 1913 many, but by no means all, Idaho photo studios were equipped with electric lights. Most old-timers still relied on skylights and large windows with northern exposure for their most artistic and satisfactory results. Electricity was not available to towns like Twin Falls and Jerome until 1907, to Buhl and Filer, 1908, or to Gooding, Wendell, and Kimberly, 1909.[16] Arthur M. Whelchel, who built his photo studio in Emmett in 1905, proudly called it the Electric Gallery,[17] a name that suggests the novelty at the time of taking portraits with artificial light, even though both Hailey and Boise had had electricity since 1887.[18] It is unlikely that many Idaho photographers used electric lighting for portraits much before 1905, even though it was available to some of them.

Because Idaho's population was small and widely scattered in the nineteenth and early twentieth centuries, many photographers took to the road in search of customers. This meant taking a rolling darkroom along for preparing, developing, and printing glass plate negatives.

Some photographers traveled in specially built "cars" or vans pulled by horses, and took annual treks through the back country visiting isolated ranches and mining towns, far from any permanent studio. Although some such vehicles were little more than covered wagons, others were elaborate custom-built "studios on wheels," where a customer could sit for his portrait. Wives sometimes accompanied photographer husbands on these trips, and actively assisted in the work.[19]

Timothy H. O'Sullivan, photographer of the King Survey of the Fortieth Parallel, used an army ambulance pulled by mules as a photographic wagon in the late 1860s. When the party visited Shoshone Falls in 1868, King's report tells us:

> We were obliged to leave our wagon at the summit and pack down the camp equipment and photographic apparatus upon carefully led mules. By midday we were comfortably camped on the margin of the left bank, just above the brink of the falls. My tent was pitched on the edge of a cliff, directly overhanging the rapids. From my door I looked over the cataract and whenever the veil of mist was blown aside, could see for half a mile down the river.

It is this spectacular campsite that O'Sullivan recorded with his camera in October, 1868.[20]

After automobiles became common, Boise valley photographer A.M. Ley, who had traveled the back roads in a horse-drawn photographic van, switched to a truck. Although itinerant photographers continued to visit rural areas well into the 1930s, they rarely did developing and printing on the road by that time. Even in larger towns like Boise, it was good business to go to the customer rather than wait for him to come to you. The business cards of J.G. Burns proclaimed him to be a "specialist in home portrait photography," and carried the slogan, "Your Home is Our Studio." Burns had his own studio, of course, with a specially-designed north-lighted portrait room and a darkroom, but the offer of house calls and the opportunity to be photographed in one's own living room had real sales appeal.[21]

The carte-de-visite craze that created the family album, and the continuing popularity of portraits thereafter, made photographers and their subjects part of popular culture and fair game for humorists, satirists, and cartoonists.[22]

Early Idaho newspapers contain amusing anecdotes and observations on portrait taking, such as this from the *Idaho Statesman* in 1889:

> Baldheaded and very homely old gentleman to photographer—"Drat such pictures. Can't you make me look any better than that after five sittings?" Photographer (thoroughly exasperated) "I think I can sir, if you allow me to take the back of your head. It hasn't so much expression as the other side, but it's a blamed sight prettier."[23]

The Idaho Tri-weekly Statesman of March 6, 1877, had this advice:

> How To Fix The Mouth
>
> Suggestions from a distinguished photographer: When a lady, sitting for her picture, would compose her mouth to a bland and serene character, she should, just upon entering the room, say "Bosom," and keep the expression into which the mouth subsides until the desired effect in the camera is evident. If, on the other hand, she wishes to assume a distinguished and somewhat noble bearing, not suggestive of sweetness, she should say "Brush," the result of which is infallible. If she wishes to make her mouth look small, she must say "Flip," but if the mouth be already

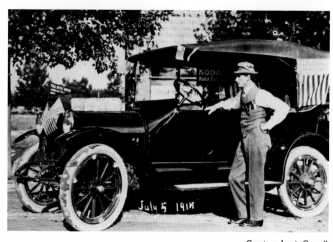

A.M. Ley traveled southwest Idaho in a horse-drawn darkroom wagon early in the century. He later used an automobile.

Typical carte-de-visite portraits were either full length or head and shoulders.

too small and needs enlarging, she must say "Cabbage." If she wishes to look mournful, she must say "Kerskunk," if resigned she must forcibly ejaculate "S'cat" . . .[24]

The humor in early stories about photographers could also be touched with insult, as was the case in April, 1866, when a leading citizen of Idaho City received a set of photographs from the Sutterley Brothers, then opening a gallery in Salt Lake City: "Preachers, deacons, speakers, military and civil officers, the principal buildings of the city, etc. make up the collection—everything but the women of that country. Sutterley couldn't take *them*."[25]

Newspaper advertisements by early photographers also used humor, as in these examples from John Junk of Silver City: "If you would see yourself as others see you, proceed to Junk & Co.'s and have one of their lifelike pictures taken from your own.[26] Secure the Shadow Ere The Substance Peters (the Substance is understood to be Greenbacks, etc.) May as well give us a call first as last . . . Don't be bashful! We'll take you just as well where you are as where you ain't, and cheaper than you can imagine it done in this rocky country."[27] Later, in an Idaho City ad, Junk said, "For a fine counterfeit presentment of yourself, go there. You will be 'took' true to life—maybe handsomer."[28]

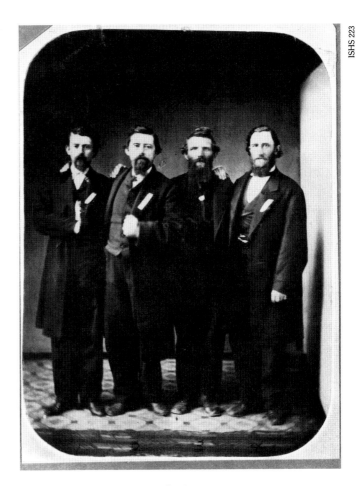

Henry F. Sayrs, left, was chief clerk in the Fourth Territorial Legislature. The men with him may also have served in that body, but have not been identified.

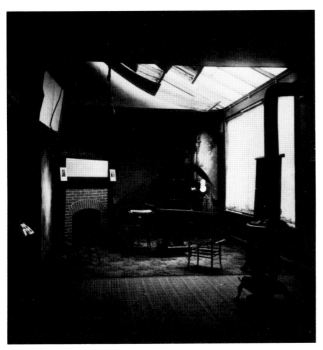

ISHS 80–16.1

Arthur M. Whelchel's portrait studio at Emmett had electricity, but was also well-supplied with natural light from a skylight and large north windows. Whelchel called his business The Electric Studio.

ISHS 74-128.55

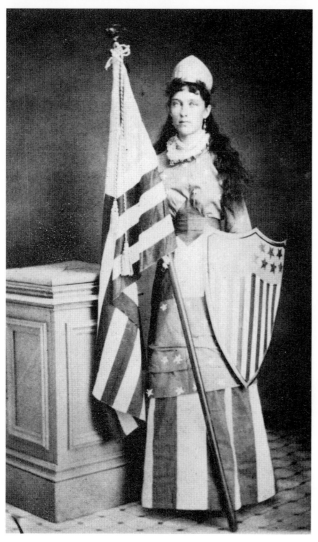

*Pretty Emma Bayhouse was
nineteen when chosen
Goddess of Liberty for the
1881 Fourth of July
celebration in Boise.*

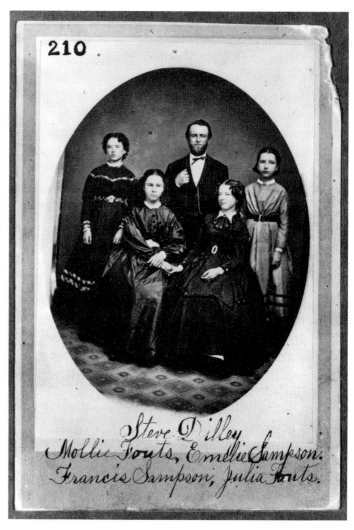

*Steve Dilley favored the
popular "hand grasping lapel"
pose, shown earlier in the
group on page 19.*

LEWISTON

Photographers came to Idaho as soon as there were settlements with populations large enough to support them. The discovery of gold in the mountains of North Idaho in 1860 led to the establishment of Lewiston as the principal supply center to the mines. The little town at the confluence of the Snake and Clearwater rivers, then a collection of tents and rude wooden shanties, was visited by a photographer from Walla Walla in the summer of 1862. On August 2, the Lewiston *Golden Age* ran an advertisement for Edward M. Sammes in which he "respectfully" informed the citizens of Lewiston that he had taken rooms on D Street where he was "prepared to take Ambrotypes, Melaineotypes and pictures of every description pertaining to the art."[1] He urged persons wanting pictures to call at once as he would return to Walla Walla in just ten days. We do not know if Sammes ever came back to Lewiston. If he did, no record of it survives.

When Idaho Territory was established in March, 1863, Lewiston was made capital. In October of that year T.M. Wood advertised in the *Golden Age* that he had just moved his "photograph rooms" from California to The Dalles and took pleasure in informing the citizens of Oregon, Washington, and Idaho territory that he was now prepared "to take all kinds of Pictures known to the Art from life size down to locket or ring pictures, unsurpassed by any in the world." Wood probably never opened a studio in Lewiston, but his ad in the *Golden Age* presents a good idea of the range of work skilled professionals of his day were able to perform: "Artistic and Life Like pictures by all the new and improved processes of fine tone and infinite durability, unsurpassed for boldness of outline or beauty of finish, will be

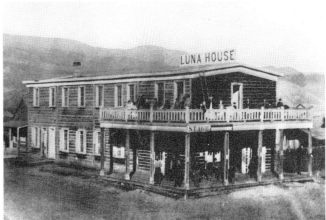

ISHS 1305

The Luna House was Lewiston's pioneer hotel. This view of the big two-story log structure was made in about 1868.

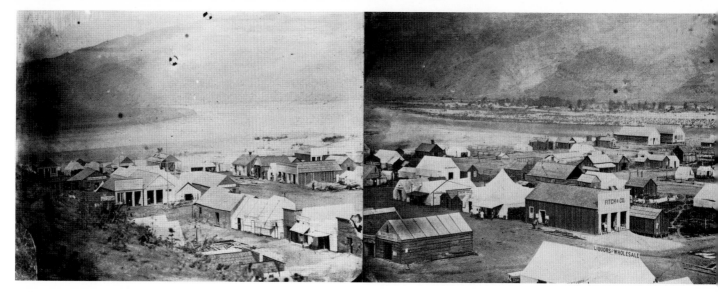

Our earliest surviving photograph of Lewiston was made in 1862 when Idaho was still part of Washington Territory. A panoramic view was created by combining three separate prints.

executed at all times and in all kinds of weather. Children taken in one second of time. Old Daguerreotypes and other pictures copied, improved, enlarged or refinished and rendered imperishable . . ."[2]

It is apparent from the above that by 1863 lenses and emulsions had improved to the point that the long exposures that had plagued sitters earlier were no longer necessary. Children especially had been very difficult to photograph. The clamps used to hold subjects' heads still were trying enough for adults, let alone for children, who often objected loudly and tearfully to such treatment.[3]

Another pioneer Lewiston photographer of the 1860s deserves special mention. Mrs. Amelia Strang opened "a Dagguerrian room" on C Street in November, 1864. She was probably Idaho's earliest female photographer—forerunner of dozens of women who would enter the profession in the next half century. Like Edward Sammes, she advertised her ability "to take all kinds of Photographs, Ambrotypes, and Melaineotypes in the most superior style and at reasonable rates."[4]

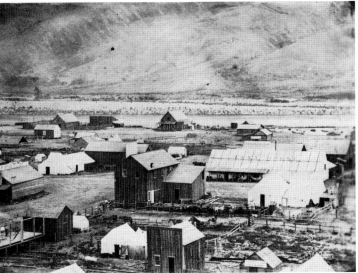

Oregon Historical Society

EARLY PHOTOGRAPHIC PROCESSES

Mrs. Strang's "Dagguerrian room" took its name from Louis J.M. Daguerre, (1787–1851), a French artist and showman who had pioneered the photographic art by building upon the earlier work of Joseph N. Niepce. He produced a remarkably clear photographic image of a corner of his studio in 1837. He named the product of his process for making pictures by means of a camera, a sensitized surface, and light, the "Daguerreotype," and sold the invention to the French government. Within months of France's release of the process to the rest of world, enthusiastic amateurs and fledgling professionals in Europe and America had acquired directions and equipment and were making Daguerreotypes.[5]

The process was a slow and demanding one, involving fixing a coat of iodide of silver on a copper plate, placing the sensitized plate in a camera obscura: literally "dark room"—a wooden box with a pinhole in one end that projects an inverted image of what is outside on the opposite wall of the box. The camera obscura had been used by artists since the Renaissance as an aid to drawing. In Daguerre's process light itself created an image on the plate only visible after development by mercury vapor. Each step in the sequence required manual skill and infinite care in controlling the chemical processes involved. The greatest disadvantage was the length of time needed to give adequate exposure to the plate. In weak light this could take almost an hour, making unblurred portraits nearly impossible, since few could sit still that long.[6]

More brilliant light, created by directing the sun's rays upon subjects' faces by means of mirrors, reduced exposure time to under ten minutes, but caused much squinting and great discomfort to the sitters. The first successful portraits, with short enough exposures to produce natural expressions, came in the mid 1840s. Improved lenses, more sensitive plates, and a new process for toning the final image made Daguerreotypes more practicable and attractive for portraits.[7]

Although Mrs. Strang called her studio a "Dagguerrian room," she did not offer photographs by that process. By 1864 when she came to Lewiston there were millions of Daguerreotypes in existence, but few photographers were still making them. Improved methods, much less demanding of the craftsman, were available.

Frederick Scott Archer, an Englishman, invented a process for making glass plate negatives in 1851 that would eventually make Daguerreotypes obsolete. Collodion, a recently discovered mixture of guncotton in alcohol and ether, formed a tough transparent skin when dry. Archer used this toughness to create the forerunner of modern flexible film. It took seven steps to create, expose, and develop a negative using a base of collodion flowed onto a polished

glass plate. Each step had to be done with care or the picture would be a failure. This "wet plate" process took its name from the fact that the sensitized glass plate was exposed in the camera while still wet, developed, and then dried. For greater permanence it was later varnished.[8]

As tedious as the collodion process was, with each negative made by hand before each exposure, pioneer Idaho photographers continued to use it well into the twentieth century, even after the invention of gelatin dry plates (available in 1867) and George Eastman's nitrocellulose flexible negative film of 1889. One only has to look closely at the sharp images created with the old wet-plate process to understand why experienced practitioners continued to use it. In controlled darkroom and studio conditions the process could be done almost automatically by those who did it daily.[9] Recording scenic views from wilderness vantage points presented a much greater challenge, as we have seen in an earlier reference to A.F. Thrasher.[10]

James Ambrose Cutting of Boston took out the American patent on Scott Archer's collodion process, but did not take advantage of its real potential for making multiple prints. Cutting's "ambrotypes," as they were called, were, like the Daguerreotypes that preceded

them, one-of-a-kind productions. The negative image was made to appear positive when mounted in a case against a dark background. (The same illusion of reversal of values is visible with some contemporary negatives when similarly displayed.)[11]

Melaineotypes, advertised by Idaho photographers of the 1860s, were better known later as tintypes. Unlike Daguerreotypes that used copper plates, or ambrotypes that used glass, tintypes were made on thin sheets of iron, lacquered black or dark brown. A coating of light-sensitive emulsion was applied and the plate placed in a camera for exposure. These cheap images were especially popular for portraits. Because there was no negative, special cameras with multiple lenses were built, permitting the photographer to take many images of the same subject on the same plate. Individual pictures were then cut apart with tin snips. Tintypes were enormously popular during the Civil War years when photography in Idaho was getting its start. They were lighter and tougher than Daguerreotypes or ambrotypes, did not require special protective cases, and could be sent through the mail tucked into an ordinary letter. They, too, were eventually outmoded by processes that created negatives from which multiple prints could be made.[12]

NEW ELDORADOS

Lewiston had no sooner become capital of the young territory than new gold discoveries in the southern part of Idaho began to drain off its population and influence. Boise Basin and Owyhee Mountain discoveries in 1862 and 1863 attracted thousands to new Eldorados. Boise City, started on July 7, 1863, a few days after the army established a military post nearby, was made capital by the second legislature, meeting at Lewiston in 1864.[13] By that time

Lewiston's population had dwindled to 359, and ninety percent of Idaho's people lived in mining areas to the south. Idaho City, Placerville, Centerville, Pioneerville, Boise, Rocky Bar, Ruby City, Silver City, and Warrens were all larger than Lewiston in 1864,[14] but few were big enough to support a photography studio. Pioneer photographers, like dentists and theatrical entertainers, had to go on the road much of the time to find enough business to make a living.

BOISE BASIN

Gold was discovered on Grimes Creek in Boise Basin August 2, 1862. When the word got out in Walla Walla, a mad rush into the area was soon on. Despite the approach of winter, thousands of men poured into the Basin to stake their claims and await the coming of a spring thaw that would make placer mining possible. Idaho was made a territory in March, 1863, and new towns sprang up in the Basin. A census taken later that year showed a population of more than 15,000.[1]

The earliest record of photographers in Idaho City came with the publication of George Owens' 1864 *Idaho Directory*. In it are listed the partnership of E.H. Train and W.J. Cromwell, and John Junk & Co. with Isaac B. Curry as operator.[2] By 1866, when a business directory was published, Cromwell had a gallery in Pioneer City. Train and a jeweler friend, Oliver C. Bundy, moved to Helena, Montana Territory, in 1866, not long after Edgar Train had met and married Phebe Goodell, aged fifteen. Phebe, like many photographers' wives, learned the trade and became his active partner in the studio for the rest of their years together. Bundy continued in the jewelry business in Helena and later married Train's sister Rhodina. The Bundys helped in the studio and took over its operation in 1871. They opened their own photographic business in Virginia City in 1872 and made annual tours with a photographic wagon for many years thereafter.[3]

Isaac B. Curry, who had worked for John Junk since 1864, became his partner in 1866. Junk continued to form partnerships as business conditions warranted, and ran galleries in Boise City and Silver City in the 1860s under the names Sutterley Bros. & Junk, Junk &

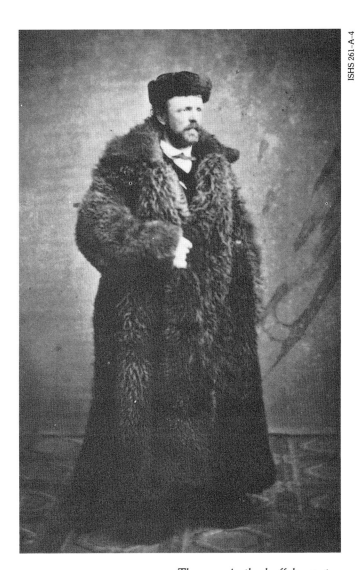

ISHS 261-A-4

The man in the buffalo coat was identified on the back of this carte-de-visite as "Mr. Goodrich, first expressman in Idaho City—Wells Fargo."

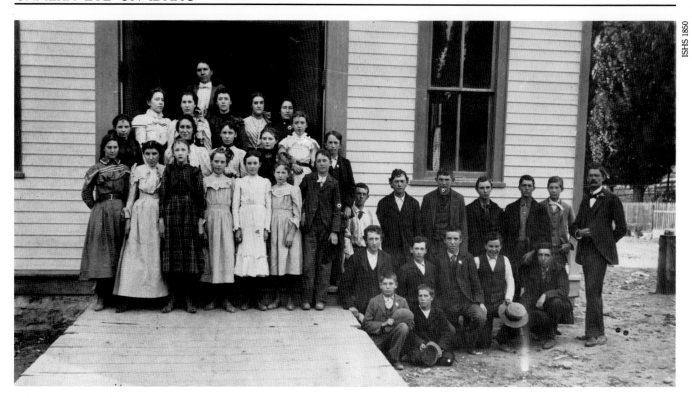

ISHS 1850

This interesting composition shows pupils in front of Idaho City's schoolhouse in the late nineties. The dapper principal strikes a somewhat Napoleonic pose.

Curry, and Junk & Leslie.[4] He too moved to Helena, in 1869.[5] Ike Curry continued in business in the area for many years. He moved to Boise City briefly after John Junk left, but returned to Idaho City a year later. The *Idaho World* had complained on May 5, 1870, that "Boise Basin has now been for several months without an artist. Business, from appearances, will soon be awaiting someone in that line . . ." On May 19 Curry had reopened his Idaho City gallery and the *World* noted that he was prepared "to catch the shadow ere the substance fade." (This quotation from Aesop's fable of the Dog and the Shadow was a favorite of early photographers in their advertising.)

In 1871 Curry was back in Boise and was frequently mentioned in the *Idaho Tri-weekly Statesman* thereafter. The paper said his work would "compare favorably with that of any artist on the coast," on the occasion of a new ad he ran in August, 1875.[6] He also returned to Boise Basin from time to time to see old friends and take portraits. The *Statesman* said, "Don't be afraid because you are not good looking, he'll make you a handsome picture anyhow."[7] Ike Curry continued in business at the corner of Seventh and Idaho streets until 1881 when he was bought out by Charles Kingsley.[8]

H.C. Tandy, a Silver City photographer of

the 1870s, also had a Main Street gallery in Idaho City during those years.[9] In 1878, he moved to Winnemucca, Nevada, and was listed in 1880 in partnership with Francis A. Cook at Tuscarora.[10] Cook would later come to Silver City and Boise.[11] The transient nature of early photographic partnerships is clearly shown by these many changes and moves.

Albert C. Bomar was another pioneer who moved a lot, as mentioned earlier. In 1871, he was a partner in Bomar & Bayhouse of Boise City, tried his luck briefly in Silver City, and then moved to Idaho City where he stayed until 1880. During that time he had partnerships with Thomas Currie of Centerville, Gilbert Butler, and Charles Kingsley.[12] In April, 1880, the *Idaho World* said he was building a two-story building at the corner of Montgomery and Wall streets that would serve as a photograph gallery and residence combined. Bomar was thirty at the time, with a wife Ceneth and a three year old daughter Stella.[13]

On July 16, 1880, the new gallery opened with "a New and Complete Set of the Most Improved Instruments known to Photography, together with all the accessories used in artistic portraiture . . ." It was at this time that Bomar formed a partnership with Renaissance man Gilbert Butler, the Idaho City schoolmaster. Butler's artistic skill made possible the new gallery's advertisement of "all styles of Watercolor, Oil, Pastelle, Chromo-Photo, and, in Short, Everything to be had in the Photographic Line."[14]

By 1880 Idaho City's population had dwindled to about 600 people from its 1863 high of over 6000. Bomar & Butler had to take to the road in search of customers. They visited the new Yankee Fork towns of Custer and Bonanza, then center of another mining excitement.[15] It was in Bonanza that Al Bomar next settled as a photographer, but in a few years he had gone into other businesses.

Charles Kingsley, briefly a partner of Bomar at Idaho City, was the son of Calvin S. Kingsley, a pioneer of the Basin who was a lawyer, minister of the gospel, and reputed ringleader of vigilantes in the 1860s. Charles came to Boise in 1881 as a photographer, but eventually passed his bar examination and was appointed Register

of the U.S. Land Office in 1889.[16] In 1890 Kingsley re-opened his gallery with Louis Sander of Salt Lake City in charge.[17]

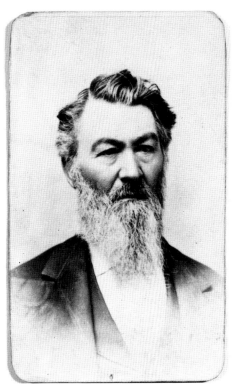

Courtesy Dale F. Walden

Charles S. Kingsley made this carte-de-visite portrait of his father Calvin Kingsley. The back of the mount was ornate.

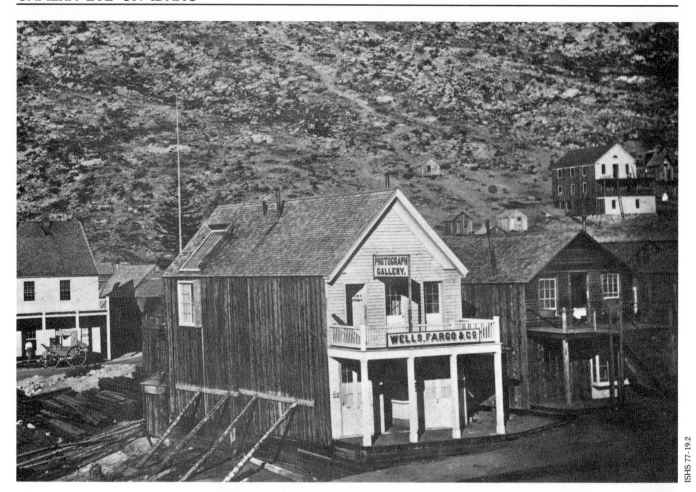

Junk & Leslie's photograph gallery was upstairs above Silver City's Wells Fargo & Co. office when this 1867 picture was taken. Note the studio skylight and large north window. The Idaho Hotel, left, had just been built.

There is a crude vertical-slab photographer's gallery in this 1860s Silver City scene. Just visible is a framed set of carte-de-visite portraits beside the gallery door. The More & Fogus Morning Star mill is at right.

SILVER CITY

The Owyhee Mountains in the southwest corner of Idaho Territory became a center of mining activity and population soon after the discovery of placer gold on Jordan Creek on May 18, 1863. Ruby City was shortly replaced by Silver City as the large town in the area, and quartz mining replaced placering. War Eagle and Florida mountains were soon marked by dozens of tunnels, shafts, and dumps as miners blasted their way into them in pursuit of quartz veins rich in gold and silver. Stamp mills became a prominent feature on the landscape—at first near town at the bottom of the slopes and later on the mountainsides themselves. Just about every available tree in the area was cut down for fuel, lumber, or mine timbering.[1]

All of this was recorded by photographers, and by the greatest good fortune, some of these views of the 1860s have survived.[2] The photograph galleries shown in two of them were primarily portrait studios, for that was the bread and butter of all early artists on the frontier. The craze for carte-de-visite portraits that could be exchanged with friends and kept in albums assured a steady demand. Tens of thousands were made in the 1860s and 1870s in Idaho, and many hundreds have survived along with some of the albums.[3]

Because of the varying fortunes of the mines of southwest Idaho in those early decades, photographers were constantly moving, forming and dissolving partnerships. We find the same men in business in all three of the region's large towns—Idaho City, Silver City, and Boise City—so many of those mentioned here will already have been met in Boise Basin.

The first to advertise in the *Owyhee Avalanche* was George Hastie, on August 26, 1865: "PICTURES. Ambrotypes, Melaineo-

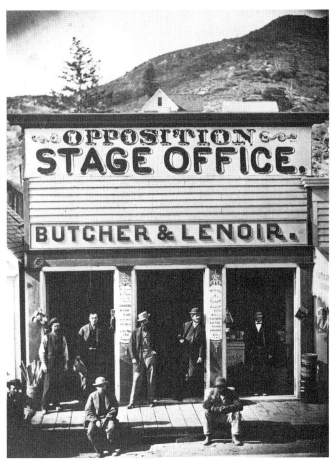

ISHS 77–19.1

This splendid 1868 picture shows the Opposition Stage Line's office, Butcher & Lenoir, agents. Hiram E. Leslie was probably the photographer.

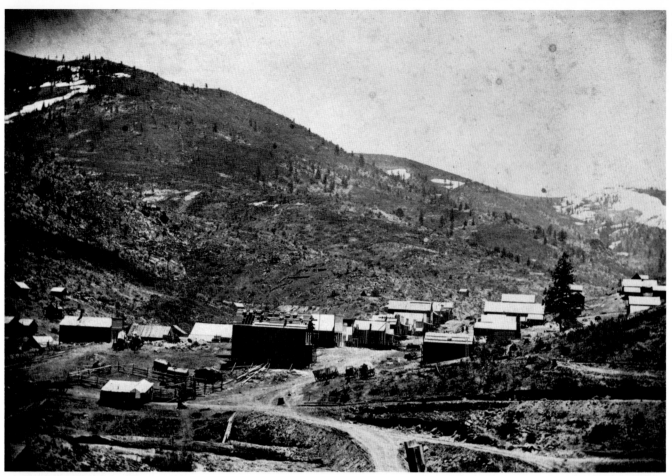

Clearly visible in this May, 1866, photograph of Silver City is the unfinished building that would house Junk & Leslie's gallery and the Wells Fargo office. The opening for the photographers' skylight shows, too.

types, Photographs. George Hastie, Silver City, I.T. begs to announce that having surmounted certain obstacles that stood in the way of his business he is now prepared to execute PICTURES in the above styles. Views taken to order. Terms—No likee, no takee, John."[4] Whatever Hastie's "obstacles" may have been, his last ad appeared on January 13, 1866, and he died only two months later. His last words in the *Avalanche* offered a somewhat different version of the familiar words of Aesop: "Call and see me, and secure the shadow before the substance perishes."

In August, 1866, the *Idaho Tri-weekly Statesman* of Boise City noted the arrival in Idaho of a forty-niner who had practiced photography in both California and Oregon: "Mr. P.F. Castleman, an old acquaintance who has been engaged in the Photograph business for ten years, has made arrangements with Messrs. Misener & Lamkin of our city, to arrange and publish a Lithographic view of Boise City. Mr. Castleman is connected with a Lithographic company in San Francisco, and

ISHS 77-19.21

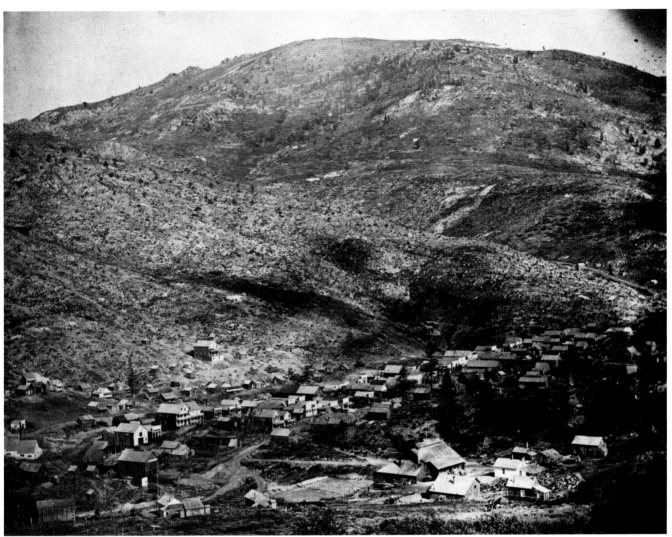

has a number of specimens of work, which when once seen will recommend Mr. Castleman to the kind consideration of our citizens."[5]

If Castleman succeeded in getting Boise merchants to subscribe to a city view, no copies of it survived. His Silver City lithograph of 1866 has, however, along with a number of photographs of the period. None are exactly like the scenes on the lithograph, although of the same period and subject matter. These were probably taken by John Junk or H.E. Leslie, both active in Silver City between August, 1866 and January, 1868.

Since printers did not have a process for reproducing photographs until the mid 1880s and this was not widely used until after 1890, Castleman's photographs of Silver City had to be converted by an artist to a crayon drawing on stone for reproduction by the lithographic process. Views of California and Oregon towns

There were very few trees left near Silver City when this 1868 view was taken. They had been cut for mine timbering and lumber to build the town.

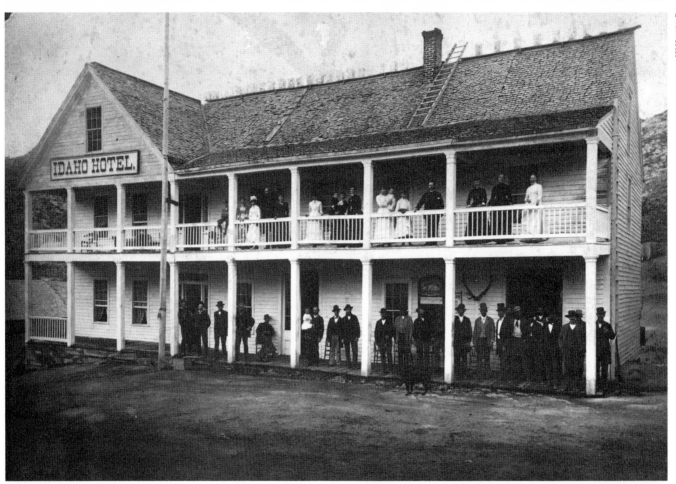

ISHS 1124-B

Another bay had been added to the Idaho Hotel by the time this picture was taken. Note the joint in the shingles and the porch eaves, right.

had been published by Kuchel & Dresel as early as 1855. The San Francisco firm of Britten & Rey issued a number of Idaho townscapes in the nineteenth century, some redrawn from photographs.[6]

Hiram E. Leslie, in partnership with John Junk in 1867, when they claimed to have "the only Photograph Gallery in Owyhee," was Silver City's leading photographer until his dramatic death by a lightning bolt in May 1882. He was rounding up his cattle at the time, just over the line in Oregon in what has been known ever since as Leslie Canyon. His obituary does not mention his many years as a photographer but calls him one of the largest stock owners in the country.[7] Leslie gave his occupation to the census taker in 1880 as "stock raiser," but listed himself in the 1880 *Pacific Coast Gazetteer* as "photographer." In 1870 the census had listed him as "photograph artist."

In the mid-seventies Leslie had brief partnerships with J.C. Potter and H.C. Tandy, perhaps prompted by his increased involvement with cattle.[8] Tandy opened his own gallery in Silver

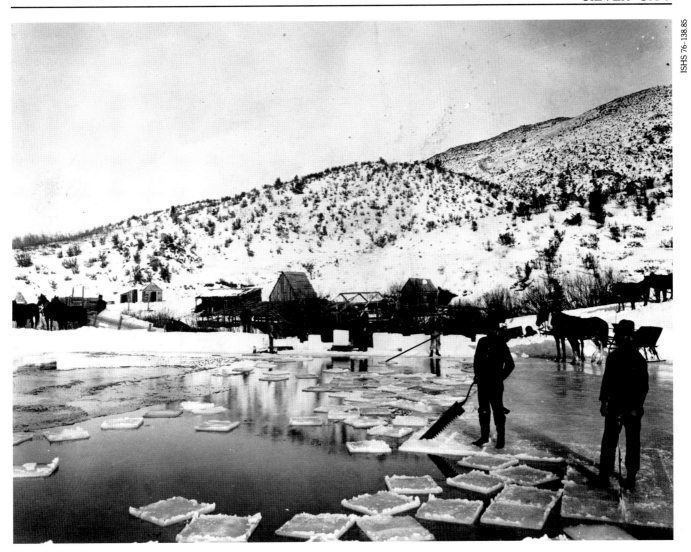

Sawing ice in winter, for use the following summer, was standard practice on the Idaho frontier. This Silver City picture is probably the work of Norwegian-born Charles C. Hedum, circa 1898.

City in August, 1875, at which time the *Avalanche* called him "a gentlemen well known to this community as a competent and thorough photographic artist," and praised his new gallery as "first class, splendid, and elegant."[9] Photographs in the Dale Walden collection also show that Tandy worked in Idaho City during these years, and that his stock of carte-de-visite mounts was later used by Bomar & Currie with a rubber stamped overprint on the back. In June, 1878, the *Avalanche* said that Tandy had "returned to Winnemucca and will remain there permanently."[10]

On April 14, 1871, one S. Norton advertised in the *Owyhee Avalanche* that he was bringing a first class photographic outfit to Silver City "in a few days," and that he would "keep a first-class artist in the gallery." He then added: "I will be at liberty to work at mill wrighting; all who desire work done in this line will do well to call on me as

I am second to no man on the coast." Again we see a familiar pattern among pioneer photographers. Most were forced to have more than one string to their bow. In the case of Norton, one wonders if he himself were a photographer or simply an entrepreneur who thought it might be a profitable sideline. In any case, Norton's ad last appeared on July 21, 1871, and it is possible that he never opened at all.

Francis Cook, a Nevada photographer, was in Silver City between 1885 and 1890,[11] and, as noted earlier, had a gallery in Boise in 1887. The *Ketchum Keystone* reported in August, 1889, that Frederick J. Pilliner, photographer, was

Among these Silver City friends of the 1890s are Henry Swanholm, far left, and next to him, Permeal French, soon to be the first Idaho woman elected to high public office. She was State Superintendent of Public Instruction from 1899 until 1903.

leaving that town for Nevada, but by December he was advertising in the Silver City newspaper.[12] Frederick J. was the son of William H. Pilliner, an English-born pioneer photographer who was in Malad, Idaho in 1880, in Salmon City and Shoup in 1887, and in Mountain Home in 1900.[13] When he opened a gallery at Salmon City in October, 1887, the local paper described him as "one of the oldest photographers on the Pacific Coast."[14] He was fifty-one at the time, and had been in the U.S. since he was nine. The birthplaces of his children, recorded in the census of 1880, allow us to deduce that he was in California between 1866 and 1869, and in Nevada in 1878. He joined son Frederick briefly at Silver City in 1891.[15]

Charles C. Hedum, a Norwegian, was Silver City's last resident photographer. He was only twenty when he joined Allen K. Bishop, aged twenty-seven, in a brief partnership in the old mining camp, then in its last days of major activity.[16] Hedum carried on the business alone until well into the teens of the new century.[17]

BOISE CITY

Law & Miller's "new photograph gallery" at the corner of Idaho and Eighth streets received its first notice in the *Idaho Tri-weekly Statesman* on January 5, 1865. An Ada County directory published that year identifies them as John Law and G.W. Miller, located at the corner of Idaho & Eighth. By July, Law & Miller's gallery had been rented by the Sutterley Brothers of Virginia City, Nevada. This pioneer firm, as noted earlier, also had rooms at Idaho City, and would open its main gallery in Salt Lake City in early 1866. The Sutterleys' Boise City enterprise was operated by J.C. Brewster.[1]

In October, 1865, William J. Young offered ambrotypes and melaineotypes from rooms on Main street, a few doors above Crawford & Slocum's saloon. The price was eight dollars per dozen. In February, 1866, the *Statesman* printed this:

> PHOTOGRAPHIC.-
> Mr. Young has been improving the fine weather lately in taking lots of fine pictures. The views of different por- tions of the town are worth pre- serving. One can also get as good likenesses at Young's as anywhere in America, and almost as cheap. Call and get a dozen and replenish the albums of your friends.[2]

The 1866 views of Boise City that have survived are probably those mentioned in this item. They are the earliest images of Idaho's young capital in existence, except for an 1864 oil painting of Main Street. Although the views are not marked with Young's name, a carte-de-visite portrait in the collection of the Idaho Historical Society is, and notes that "Bradley & Rulofson's Patent" was used in its production.

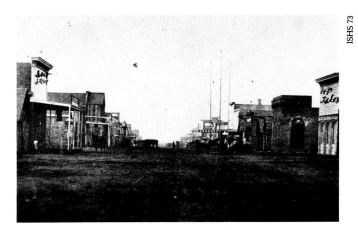

ISHS 73

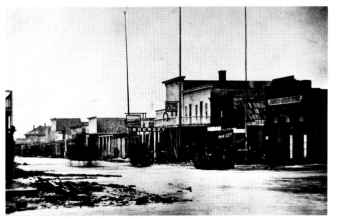

These Boise Main Street views were all taken in 1866–67, probably by William J. Young. The town had only a few brick buildings by then, but a number of elegant pictorial signs, such as those on G.W. Stilts' blacksmith shop, and the Stage House hotel.

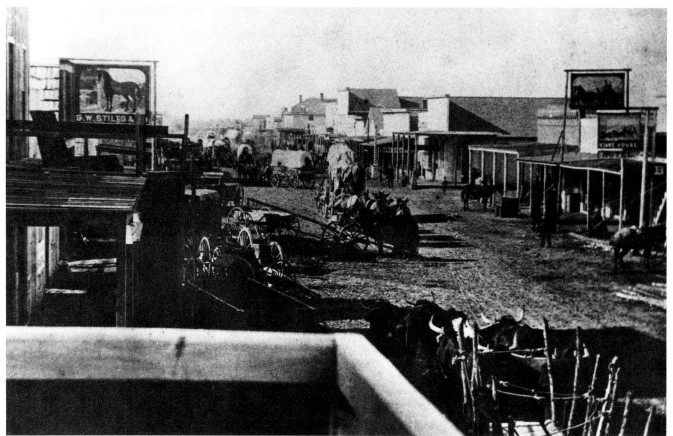

ISHS 73

This classic Main Street view of Boise shows what had become part of the Oregon Trail by 1866. Covered wagons, pulled by oxen, mules, and horses, fill the street.

(San Francisco photographers Bradley & Rulofson were still in business in 1880, proudly advertising gold medals won at a number of major exhibitions, and "the only elevator connected with photography in the world." Since most photographers had walk-up studios, this was a novelty worth touting.)[3]

Ike Curry and H.E. Leslie were both in Boise in 1870, but Leslie returned to Silver City within a few months. Curry remained as the town's leading photographer until Charles Kingsley took over the business in 1881. Albert C. Bomar was also in Boise briefly in 1871, before moving to Idaho City. In fact, these familiar names turn up in southwest Idaho towns with such regularity that one is reminded of musical chairs. It was the exception rather than the rule for an early Idaho photographer to settle in one place and stay there for even five years.

W.H. Logan made a valiant try at establishing himself in Boise City in 1875. After arriving from Pennsylvania in June, he started business in a tent on Idaho Street.[4] The services offered in his ad of July 20, 1875, included a new twist: "Groups on horseback, in buggies and views of residences." "Copying and enlarging from old

ISHS 80-97.3

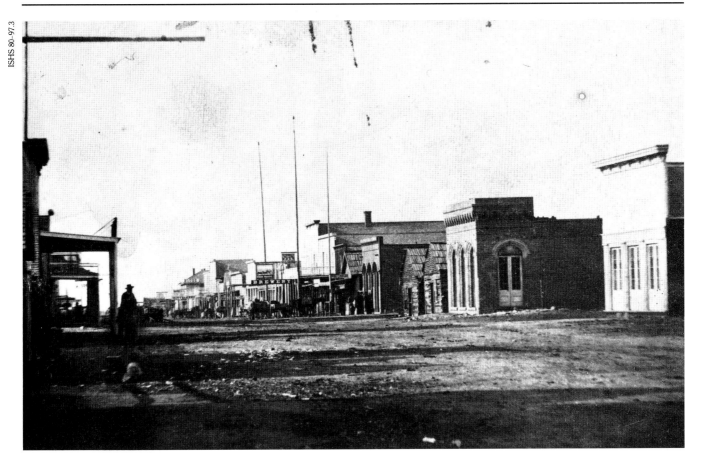

ambrotypes a specialty" was also mentioned.[5] By 1875 both Daguerreotypes and ambrotypes were long outmoded, and since both processes produced only one original image, copying was necessary if additional prints were needed.

That Logan took his camera around town looking for business is revealed in an amusing *Statesman* item of July 31, 1875: "Two typos (printers) were worshipping yesterday at the shrine of Bacchus and joyfully pouring beer down their necks, when Logan of the art gallery happened along. He got his camera lucida on them. Their pictures are worth going to see at Logan's gallery on Idaho street."[6]

Early in August the photographer was robbed by a sneak thief who slipped into the tent gallery where Logan slept and carried off his trousers with a twenty dollar gold piece and thirty dollars in currency.[7] Whether this loss was a factor or not, the Pennsylvanian last advertised in the *Statesman* on November 9, 1875.

Francis Moore, born in England in 1827, began his Idaho photographic career in Boise City in about 1879. He had come to the U.S. in 1848 and served in the Union army during the

Another 1866 view of Boise, possibly by Young, shows brick buildings next to crude log cabins.

37

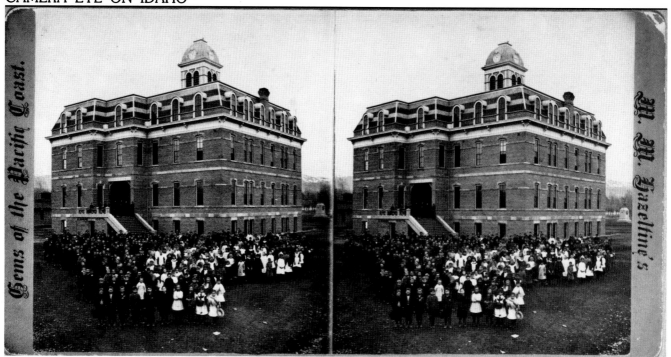

Martin M. Hazeltine was in Boise in the early 1880s before moving to Baker City, Oregon. He took this stereo view of Central School and its entire student body in December, 1883.

Civil War. The birthplaces of the Moores' six daughters, recorded in the census of 1880 when they lived in Boise, reveal the family travels after the war: The first girl was born in New Jersey, the next four in Minnesota, and the last in Idaho, 1879. Moore moved to Caldwell in about 1888 and lived there until his death in 1898. Family tradition says that Mr. and Mrs. Moore traveled to Silver City on occasion with her portable organ and his photographic equipment loaded into a buckboard. Mrs. Moore taught music and helped start Caldwell's first library.[8]

Charles S. Kingsley, whose career we have mentioned earlier, practiced in Boise City between 1881 and 1887. Martin M. Hazeltine, later of Baker City, Oregon, and the creator of a notable series of stereographic views marketed as "Gems of the Pacific Coast" had a Boise gallery in 1884.[9] Wesley Andrews, a prolific post card photographer and distributor of the early twentieth century, recalled that Hazeltine had visited his parents in Boise in 1882: "At that time he made a picture of the entire student body of the Boise public school, about four hundred boys and girls lined up in front of the then new brick school, built in 1880 on the spot where Idaho's state capitol now stands. I was seven years old and stood in the front row for the picture . . . the photo is a double stereoptican . . ."[10] This is undoubtedly the

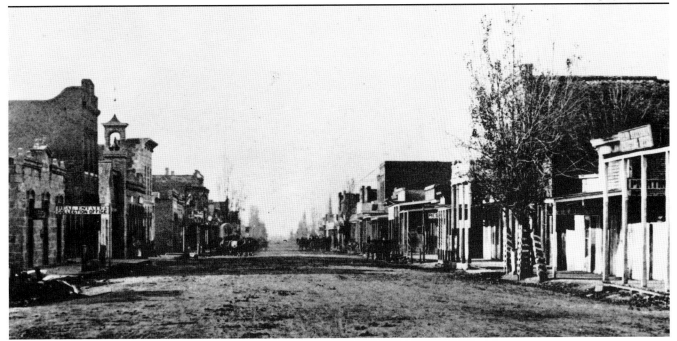

ISHS 78-64.1a

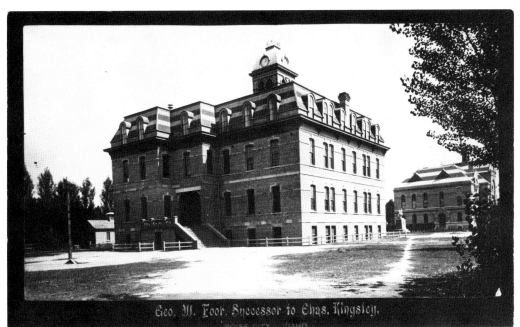

Geo. W. Foor, Successor to Chas. Kingsley,
BOISE CITY, IDAHO.

ISHS 442-0-2b

Charles S. Kingsley took this view of Main Street, looking west from Sixth, in November, 1881. The "Stone Jug," office of Territorial Secretary E.J. Curtis, is at left, then in order can be seen the Masonic Hall and tower of the fire hall. This print was made from half of the stereograph shown later in the book.

picture reproduced here, since the new school opened on September 25, 1882. (The foundation was not laid until November, 1881,[11] so Andrews' recollection that the school has been built in 1880 was in error.) In the many years M.M. Hazeltine worked out of Baker City he frequently visited Idaho towns and scenic locations for his series of stereo views. His brother, George I. Hazeltine, ran a photo gallery in Canyon City, Oregon, during the 1880s.[12]

Boise, as Idaho's capital and largest city, had so many photographers after Idaho became a state in 1890, that we shall discuss them in a later section.

George W. Foor's printed mount for this photograph of Boise's Central School dates it clearly as late summer, 1889, since that is when he took over Kingsley's business. By April, 1890, he had already moved on.

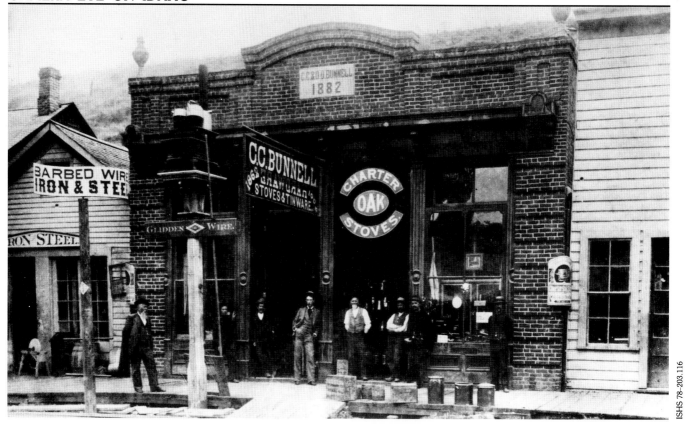

C.C. Bunnell's Lewiston hardware store was recorded for its owner by an unknown photographer sometime in the late 1880s. Many Idaho merchants had similar photos taken over the years.

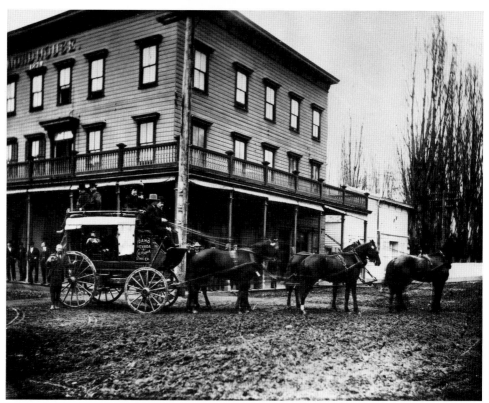

The Raymond House was a leading Lewiston hostelry, built in 1879. The style of the clothing worn by passengers on the stagecoach suggests that this photo dates from the 1890s.

NORTHERN LIGHTS: LEWISTON

At the end of the 1860s, gold rushes to the south had drawn away Lewiston's population, and left older mining camps like Pierce, Elk City, and Florence relatively quiet places. None but Lewiston, so far as we know, ever had a resident photographer of its own. It is possible that itinerant portraitists visited all of these camps in the 1860s, but documentation is lacking. We have no views of those places in that era, either.

Lewiston's destiny continued to be dependent upon her strategic location on navigable rivers. Before railroads, and after, Idaho's first capital served as gateway and outlet for a large part of central Idaho. With the development of agriculture and lumbering, and some mining activity within the vast drainages of the Clearwater, Salmon, and Snake, Lewiston was assured a continuing commercial importance.

George A. Frost announced the opening of a gallery upstairs in the Flanagan Building, corner of Montgomery and Fourth streets, in the *Idaho Signal* of Lewiston on January 17, 1874. As was the custom when a new ad appeared, the paper obligingly called attention to it with a local item: "Take a walk up into the new photograph gallery of George A. Frost and see how nicely arranged things are there for taking pictures. While you are there Dr. Dorr will accompany you to his new dental rooms. No excuse can be offered now if your friends complain of your not exchanging photographs with them, or if you have the toothache."[1] This was apparently not a successful venture for Frost, since he stopped running his ad on September 5, 1874.[2] The 1880 census lists only one Lewiston photographer, D. Curtis Lester, aged twenty-eight, a native of Pennsylvania. An Idaho business directory of that year lists none. The census does record a

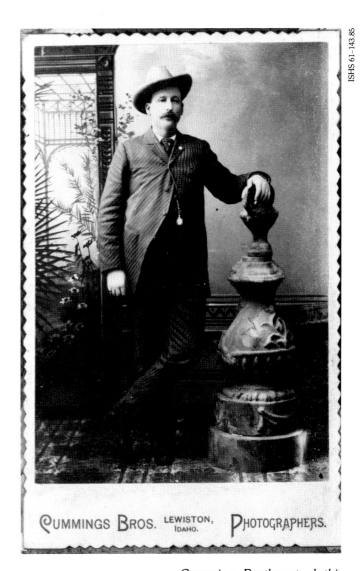

ISHS 61-143.85

CUMMINGS BROS. LEWISTON, IDAHO. PHOTOGRAPHERS.

Cummings Brothers took this portrait of a stylish gent with stylish studio props sometime in the 1890s.

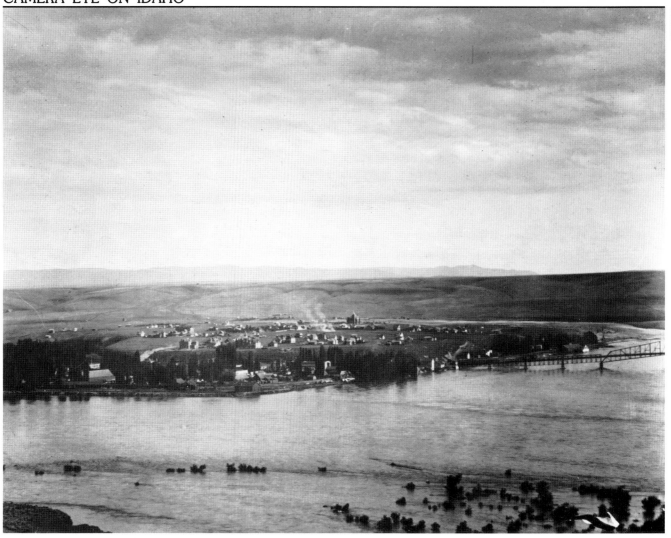

ISHS 700

This 1899 view of Lewiston was probably taken by Henry Fair—a photographer who preferred to be listed in the census and directories as "artist."

young machinist who may already have been learning the art of photography, since he would be well established in the business a few years later. He was Eugene J. Bonhore, son of Melanie Le Francois, aged fifty-two, proprietor of Lewiston's Hotel de France. Madame Le Francois was a Parisian who had been in California's gold fields before coming to Lewiston in April, 1862.[3]

James W. Riggs opened a studio in Lewiston in 1883 and was the city's leading photographer until August, 1887, when he moved his family to Roseburg, Oregon.[4] A Riggs newspaper ad of November, 1886, told readers "Now is the time to have your negatives taken for photographs. Fine weather, beautiful clear atmosphere, even temperature. Everything that is desired to produce fine pictures. I claim to do the finest work in Northern Idaho . . ."[5]

Apparently defending Riggs against outside competition, the *Teller* noted on March 8, 1887,

ISHS 78-203.6

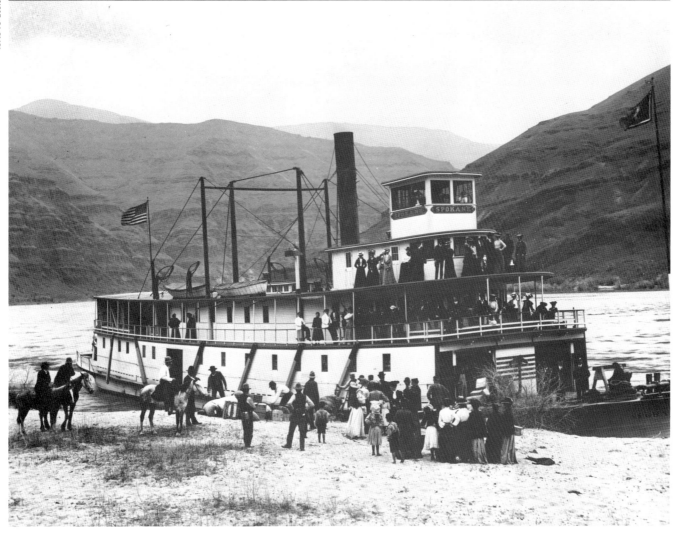

The sternwheel steamer Spokane *was unloading passengers and their baggage when this lively scene was recorded. The shallow-draft river boats could pull right up to shore.*

that "A couple of photographers have been in town during the past week taking views of the principal business houses of the city—an advertising dodge."[6] When Riggs himself took to the road in May to photograph the then popular Lake Waha resort nineteen miles southeast of Lewiston at the foot of Craig Mountain, the paper praised the resulting prints he gave to the editor as "Beautiful, perfect and natural."[7]

When the Riggs family departed in August, 1887, the *Teller* commented that (this) "throws the field clear to some good photographer to open a gallery."[8] When the building Riggs had used underwent repairs later that year, the paper said it would soon be occupied by "a photographer from the lower country."[9] In January, 1888, the new proprietors were ready for business.[10] William A. Fleming and D. Curtis Lester (mentioned earlier) formed a partnership that lasted but briefly, since only Fleming's name appears in Polk's 1889–90

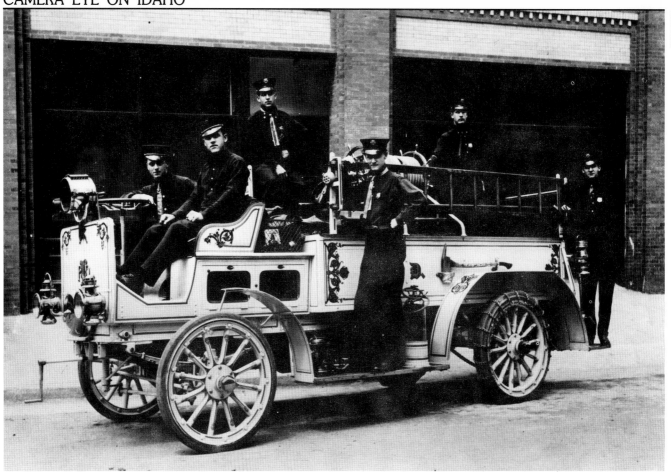

ISHS 2774

Lewiston's fire laddies were justifiably proud of this dazzling new machine. The photographer is unknown, but the time is about 1912.

Gazetteer of Idaho Territory. Fleming probably photographed Indians on the Nez Perce reservation, but we have failed to find examples with his name on the mounts.[11]

In addition to Eugene Bonhore, mentioned above, Lewiston's leading photographers of the 1890s were the Cummings Brothers, a number of whose portraits of local people have survived. E.G. Cummings continued in business into the early years of the twentieth century.[12] Charles W. Hansen, who would be Genessee's resident photographer for a decade after 1901, was in Lewiston in 1896.[13] J.W. Gomond and Joseph Fortin also ran portrait galleries during this period. Gomond was a French-Canadian who came to the United States in 1870. He was in Lewiston from 1900 until after 1905. The 1910 census found him in business in Wallace and he was still there in 1912.

By 1908 Lewiston had a number of photo-graphic studios. Henry Fair, listed in the 1900 census as "artist," preferred that title, as did many early practitioners. He ran *The Art Store* and was selling photographic supplies in 1905, a reminder of how popular amateur photography had become.[14] City directories all over Idaho began listing suppliers of cameras, film, and developing in this period. Most often it was drug stores that offered the new services, but some commercial photographers made it a sideline, too. Joseph Partain, John W. Webster, and Burns Brothers were other Lewiston photographers of the period. M. Bruce Burns is the only brother listed in early directories, but Ida A. Burns, his sister, appears as manager of the business from 1905 until 1913. That Ida Burns was a practicing photographer and not just an office manager is clear from the 1910 census which calls her "photographer in gallery."

Moscow was a city of substantial and stylish buildings when this Main Street parade was photographed.

MOSCOW

Moscow, trading center of vast wheat farming and logging empires in Latah County, was in its infancy when Schleswig-Holstein-born Henry Erichson opened a gallery there in 1884.[15] In October, 1885, he built his own shop on Main street in what would be his permanent home thereafter.[16] He earlier had plied his trade in California and had traveled all over the Northwest as an itinerant photographer for nine years before settling in Moscow.[17] The opening of the University of Idaho in 1892, and steady growth of the town made Erichson's Moscow Art Studio a profitable business that soon attracted competitors. He was in partnership with John A. Hanson briefly in 1890–92 before Hanson moved to Grangeville to become its leading photographer for the next decade. Hanson, a Dane, had, like Erichson,

Moscow's pioneer photographer Henry Erichson posed the handsomely uniformed Women's Riding Club in front of his Main Street studio building (center) in the mid-nineties.

Moscow was a new and growing Palouse country town when this 1885 photo was made by an unknown photographer.

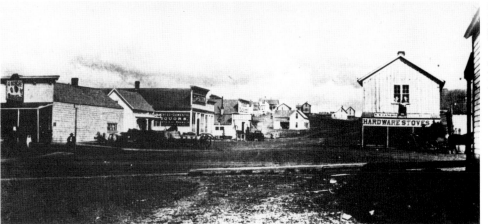

spent many years as a photographer in California before coming to the Northwest, and had been his partner there as well.[18]

Halvor P. Eggan and his wife, Inga, both photographers, ran a studio and art store in Moscow from 1901 until 1913. They were natives of Norway, he arriving in this country in 1876, and she ten years later. The Eggans also

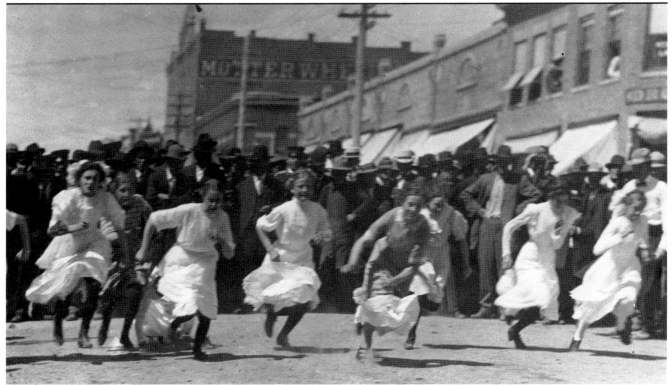

The Fourth of July, 1911, featured a foot race for Moscow young women on Main Street.

built and operated the Eggan Opera House. The number of Scandinavian photographers in north Idaho in the early years of this century is noteworthy, but may simply reflect the numbers from those countries who settled there at that time.

John J. Sterner, a Pennsylvanian, was in business on Moscow's Main street from 1905 until the end of our period. Many of his portraits are still to be found in family albums.[20] Two other Moscow photographers, not listed in directories, but whose names are imprinted on mounts of photographs in the Latah County Historical Society, are "Hanson Brothers Salt Lake Gallery" and "Prof. M.S. Eastman, Pullman, Colfax, Moscow." W.G. Emery, who wrote the first published history of Moscow in the late nineties, described himself therein as "The Photographer," and "for some years the leading photographer of Portland, Oregon." He opened a gallery in Pullman in 1895, and one in Moscow shortly thereafter. The autobiographical sketch in his Moscow history concludes with "Mr. Emery is ably assisted by Mrs. Emery whose artistic skill is no less worthy than her husband's. They are also alike popular with patrons and with their hosts of friends."[21] This modest self-appraisal at least recognizes his wife's contribution to the business!

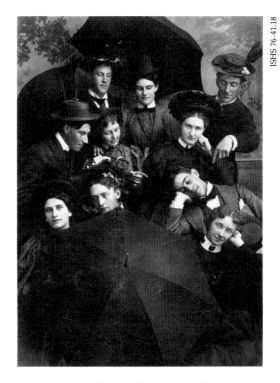

These University of Idaho students posed most solemnly for this group portrait. They called themselves, according to an inscription, "The Vegetarians."

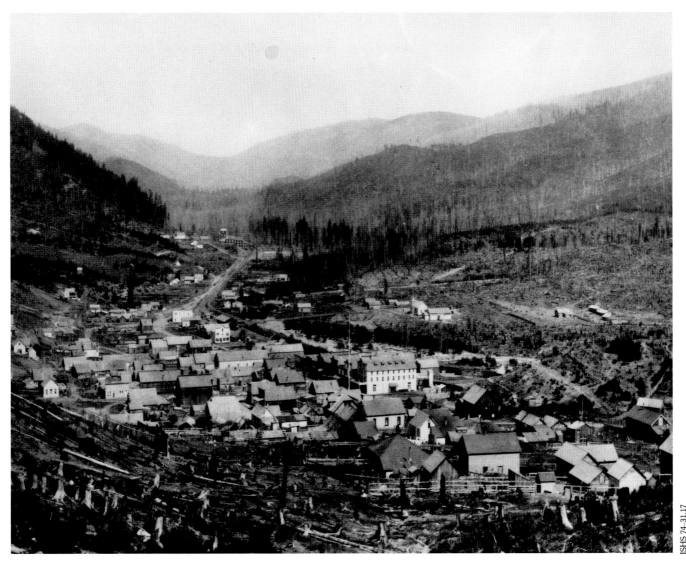

ISHS 74-31.17

Mullan was one of the leading towns in the booming Coeur d'Alene lead-silver district when this picture was taken in the nineties.

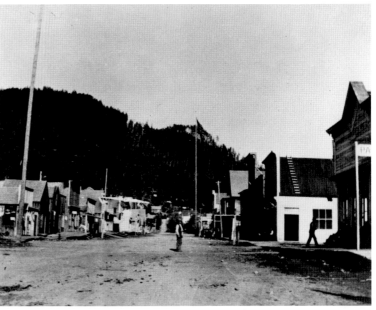

ISHS 62-108.36A

Murray was past its heyday when this view was taken. It had lost the county seat to its larger neighbor Wallace.

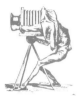

Mineral discoveries in the drainage of the Coeur d'Alene River between 1882 and 1885 led to the creation in rapid succession of new towns throughout the region. At first it was placer gold on the North Fork of the Coeur d'Alene that attracted attention and population, but ultimately, it was the lead-silver lodes to the south that created Burke, Mullan, Kellogg, Osburn, Wardner, and Wallace.[1] Coeur d'Alene City on Lake Coeur d'Alene, twenty-five miles to the west, grew with the mines, and was the home base for a fleet of paddle wheel steamers that carried supplies and passengers across the lake and up the river as far as Cataldo Mission.[2]

Murray, largest town on the North Fork, was visited by several photographers in the eighties, but none seems to have made it a home base. F. Jay Haynes, who worked for the Northern Pacific Railway, visited the region in 1884. His pictures helped publicize the mines and produce business for the railroad.[3] Thomas N. Barnard, most successful photographer to settle in the area, was briefly at Murray (then called Murrayville) in 1887. After two years at Wardner he moved to Wallace and became a leading citizen, businessman, and even its mayor. His studio produced one of the most complete documentations of local history we have, largely due to the continuing work of Nellie Stockbridge who ran the business after Barnard retired in 1914. She operated the studio and produced several thousand portraits and views between 1898 and her death at ninety-seven in 1965. The Barnard-Stockbridge collection of 29,835 negatives is now in the University of Idaho Library.[4]

At least two other women photographers were active in Wallace during Nellie

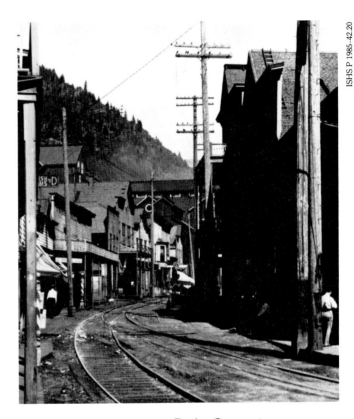

ISHS P 1985-42.20

Burke Canyon is so narrow that the railroad ran down the middle of the town's only street. Today virtually nothing of Burke remains.

ISHS 73-17.8

Coeur d'Alene City was a landing place for paddle wheel steamboats when this 1890s view was made from the hill southwest of downtown. The Coeur d'Alene Resort occupies most of this space today.

Stockbridge's years there. Minnie Ekeberg and Annie Thorild had a partnership from 1901 until 1904, but were not listed in 1906. The name of L.I. Jones appears in 1906,[5] but not anywhere in Idaho thereafter. Another firm not heard of again is that of Finn & Fehse in 1908. Joseph W. Gomond, who had been in Lewiston earlier, was active in Wallace from 1908 until 1913.[6]

Herman A. Tucker was Wardner's photographer during that period, and at Mullan the pioneers were Harry P. English, 1900–13, and Richard Standow, 1910–13. J.A. Brockman had a studio at Kellogg in 1912.[7]

COEUR d'ALENE CITY

The earliest Coeur d'Alene photographers listed in business directories are William N. Hall, 1887–90, and Henry Purcell, 1887.[8] Peter Mason was there in 1900 and O.O. Bartlett in 1901. The partnership of Smith & Lieuallen is listed in 1903, but not in 1906 when the Southerland Sisters appear. Mary Renick Gimble was official photographer for the Red Collar Line Steamship Co. in 1910, but moved to De Smet in 1912. The Museum of North Idaho has a collection of her photos.[9] Burns & Raymond, H.L. Olson, and Daniel F. Ross were

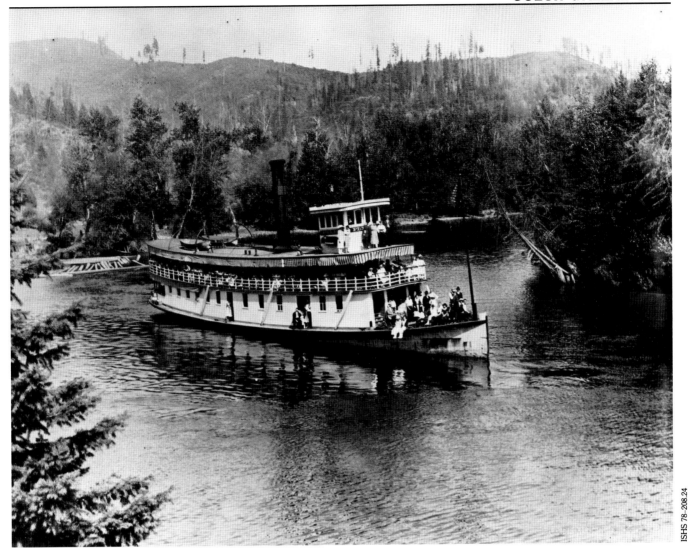

ISHS 78-208.24

The lake steamer Flyer *was a popular excursion boat. It cruised Lake Coeur d'Alene and the "Shadowy St. Joe" River early in this century.*

in business at Coeur d'Alene in 1908. Halvor L. Olson was born in Norway and came to the U.S. in 1873. He and his Iowa-born son John, were in partnership for several years. The 1910 census lists several other men as photographers: Elias B. Hargen, a Norwegian, had his own studio; Charles Rush apparently worked for one of the others active in the city at the time; two photographers named William Brown were neighbors, but their relationship is not known. The first was a native of Ohio, aged thirty-eight, the other an Iowan, aged thirty-three. The other photographer listed in 1910 was Charles Faulkner.[10] By 1912, of those mentioned above, only Halvor Olson was still listed. F.E. Caryl's name then appeared for the first time.[11]

Coeur d'Alene had a great many photographers for a city its size in the early years of the century. This may be attributed in part to the area's growing importance as a recreational

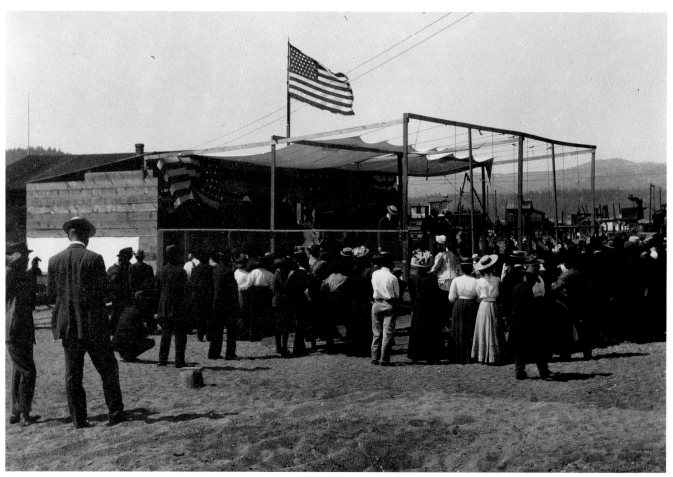

ISHS P 1985–42.15

This hastily erected building on the beach at Coeur d'Alene was for the purpose of a land drawing.

mecca for Spokane, its large neighbor only thirty-three miles to the west. Northern Pacific excursion trains ran regularly every summer in the 1890s bringing city dwellers to Coeur d'Alene where they could board steamboats for cruises on the lake and up "the shadowy St. Joe" river.[12] In 1892 the Union Pacific entered Coeur d'Alene and arranged with a local group to build a fleet of steamers for "joint passenger, freight and express business."[13]

The Panic of 1893 delayed construction of an even more ambitious project to bring pleasure seekers to the lake. An electric interurban street car system planned since 1892, was finally built during the summer of 1903. The passenger steamer *Idaho* was built at Coeur d'Alene that same season. The last spike on the railroad was driven at 2:30 p.m. on October 24, 1903 "without ceremony."[14] In the years that followed, thousands would come to Coeur d'Alene on the interurban each summer, board the *Idaho*, and take a cruise on one of America's most beautiful lakes. Photographers recorded this colorful part of our history.

EASTERN IDAHO VIII

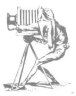

More than a dozen eastern Idaho towns had resident professional photographers before 1913. Although little is known about most of them, all are listed in the tables appended to this narrative.

Earliest to record the scenery of eastern Idaho was undoubtedly William Henry Jackson, photographer with Ferdinand V. Hayden's Geological Survey party of 1871–72. (In a lifetime of ninety-nine years, 1843–1942, Jackson would return to Idaho often, making stereopticon photographs of such scenic wonders as Shoshone Falls for commercial sales. In 1892 he brought the noted landscape painter Thomas Moran to the falls and photographed him there.) Although most of Jackson's pictures for the Hayden Survey recorded topography and geology, those of the Fort Hall Agency, Sawtell's ranch and Taylor's Bridge, on the site of modern Idaho Falls, have great historical interest. His photographs of Yellowstone are often credited with persuading Congress to make it our first national park.[1]

Census takers in 1870 and 1880 failed to find any photographers in eastern Idaho, nor were any listed in McKenney's 1880–81 business directory of the Territory. John H. Duray, recorded as a photographer at Challis in the 1880 census, was listed in Polk's directories of 1886 and 1889 as "photographer and barber" at Salmon City. William B. Fowler, located earlier at Payette, was in Salmon from sometime before 1900 until after 1913.[2]

Paris, Idaho, had pioneer photographer W.N.B. Shepard, listed in the years 1889–92, and nearby Montpelier had Leo O. Voight and J.J. McEvoy.[3]

William Henry Jackson photographed Sawtell's ranch at Henry's Lake, Idaho, in 1872. This is part of a stereo view.

USGS

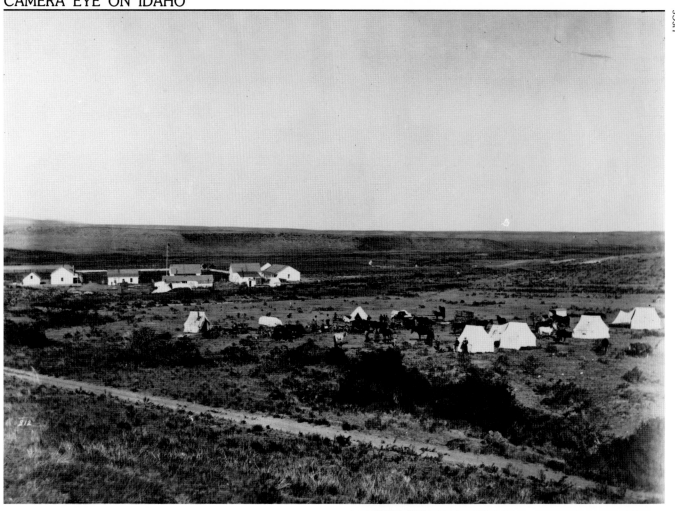

When Willard V. Hayden's geological survey crew visited Fort Hall in 1871, and pitched camp, foreground, great frontier photographer William Henry Jackson recorded the scene.

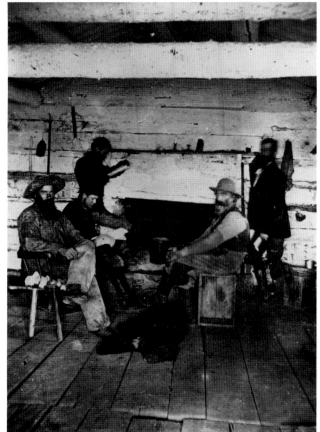

Jackson took this interior of Sawtell's ranch house. Partners Sawtell and Wurtz caught fish for sale to miners at Virginia City, Montana. They also rented lodgings to big game hunters.

USGS

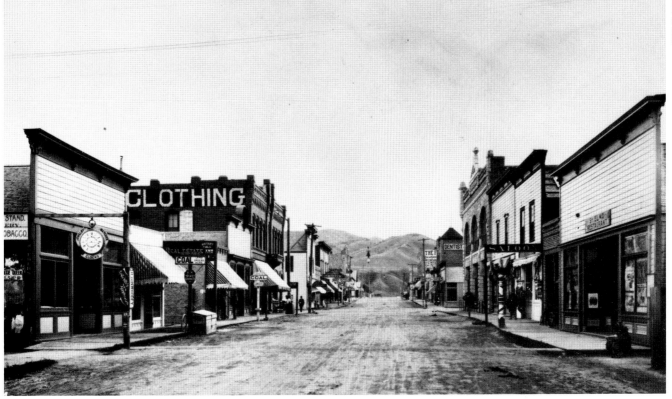

By 1896, Pocatello's Center Street had a few substantial stone and brick buildings in addition to the many typical false-gable wooden ones of new Western towns.

POCATELLO

Railroads created Pocatello, for this "Gate City" of Idaho was located at the point where Utah & Northern and Oregon Short Line rails crossed in 1882. At first the town was confined to a narrow strip of railroad land in the middle of Fort Hall Indian Reservation, but relocation of Utah & Northern shops from Eagle Rock to Pocatello in 1886 caused a boom that required more land. Squatter's shacks had spilled over onto reservation land, and although some were pulled down, others were soon built. Two thousand acres of reservation land were purchased from the Indians and in 1889 a townsite was surveyed and platted.[4]

In that year the name of C.H. Bryant, photographer, appeared in a business directory,[5] and in a few years several others began advertising in the *Pocatello Tribune*. J.V. McEvoy, who had been in Montpelier earlier,[6] came to Pocatello in 1893, despite what appears to have been a fiercely competitive market. In January, 1893, an ad in the *Tribune* announced "Remember, Hower will meet all reductions in prices on photographic productions."[7] The following month McEvoy & Hower had formed a partnership and were offering cabinet photographs at from $2.50 to $4.00 per dozen.[8] Hower and McEvoy portraits with their individual labels can be found in a number of collections, suggesting that their 1893 collaboration was short-lived. Apparently McEvoy had the most successful career in the area, since he later had branch studios in Blackfoot and Idaho Falls as well as Pocatello.[9]

Other competition in 1893 came from R.S. Sours, whose cabinet portraits sold for $2.00 per dozen,[10] and from the Pocatello Art Studio which cut the rate still further to $1.75 per dozen. In a price war like that it must have been hard for any of these men to stay in business. The Pocatello Art Studio also offered landscape photographs "on short notice and second to none."[11]

In late 1895, Pocatello acquired an outstanding woman photographer in Danish-born Benedicte Wrensted, who took over "Hower's

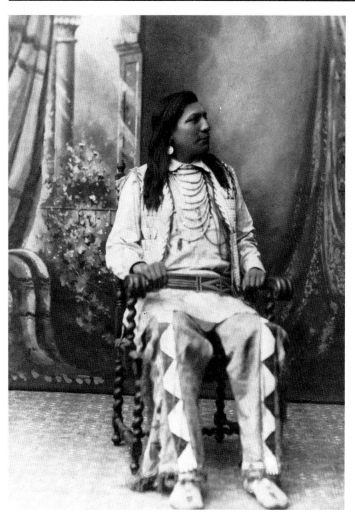

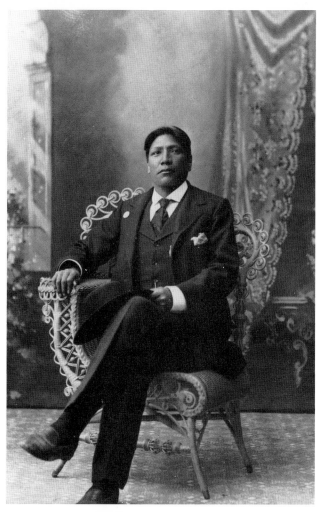

These two portraits of Pat Tyhee were taken by Benedicte Wrensted on the same day. They commemorate his becoming a Christian and giving up his Indian braids and costume.

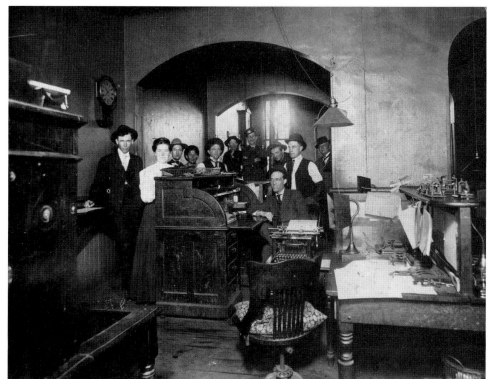

The boss's wife poses with the boys in this Pocatello railway office.

ISHS 78–97.15a,b

ISHS 72–144.1

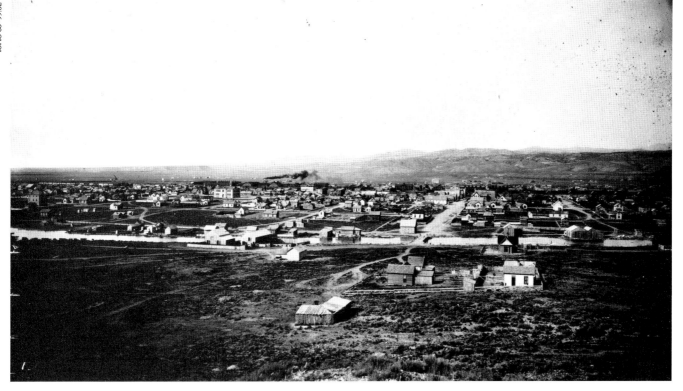

old stand." Local competition was still fierce, for in an ad published March 20, 1897, "Miss B. Wrensted" announced that she was "prepared to compete with all comers in workmanship, artistic finish and at reasonable prices. All work guaranteed. I am here to please and my customers' satisfaction is my aim. Am here to stay, not for a few days, but to remain with you. Patronize those who patronize you."[12]

Certainly there is an implication in this appeal that Pocatello had seen photographers come and go and that not all had given satisfaction.

The 1910 census tells us that Miss Wrensted was head of a household that included her seventy-nine year old mother and a seventeen year old niece, Ella Wrensted, working as a "photographer apprentice." Peter and Anna Wrensted, Ella's parents, also lived in Pocatello at this time. Peter was a forty-eight year old forest ranger.

James and William Prater were in business longest during the rest of our era. They came to Pocatello in about 1908 and were in partnership with Herbert J. Williams in 1913. Axel Hansen and Mrs. E.W. Garvey were other photographers who had studios in Pocatello in the period.[13]

This early view of Pocatello shows that the crossing of Utah & Northern and Oregon Short Line rails had created a place of some importance by 1895.

Another Pocatello street scene from the 1890s shows impressive stone architecture in the style of the day.

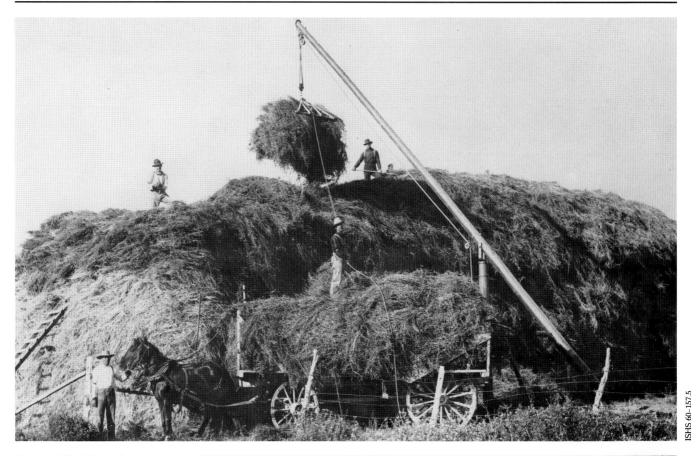

George W. Glanville, pioneer Blackfoot photographer, took this picture of haying on the state insane asylum farm.

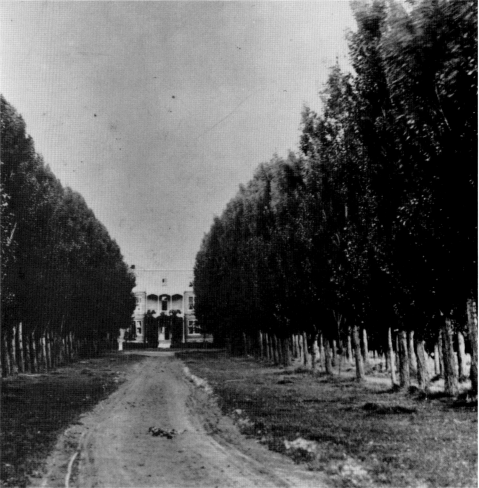

This view of the tree-lined drive that led to what was then called "the lunatic asylum" may have been taken by Glanville as well.

ISHS 60-157.5

ISHS 60-157.6

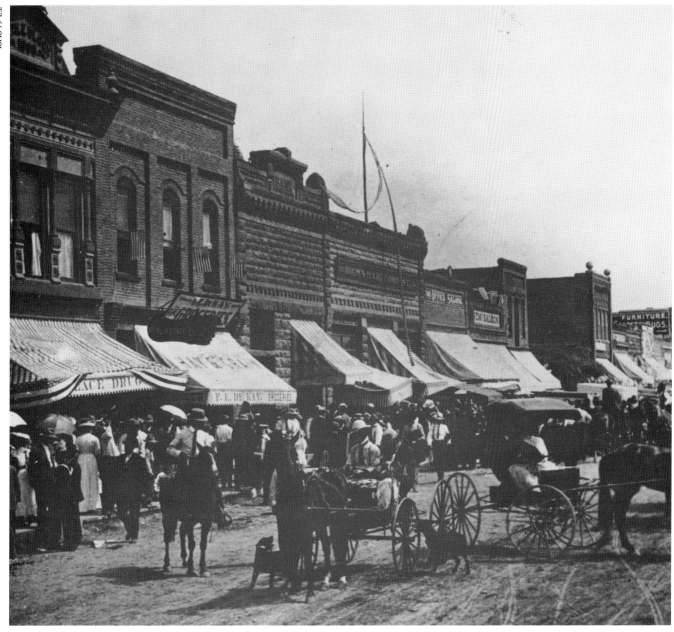

Downtown Blackfoot was a lively place when this holiday picture was taken. The dogs were excited, too.

BLACKFOOT

From 1900 on, Blackfoot, a town established as a shipping point on the Utah & Northern railroad in 1880, had a number of photographers. C.J. Anderson was the only operator in 1900, but was joined by M.A. Marshall in 1901. George W. Glanville arrived in 1903 and was active through 1913. This Iowan was in business longest of any Blackfoot photographer in the pioneer period. Joseph H. Cutler was his leading competitor from 1906 until 1912. Charles T. Ericsson, a portrait photographer from Sweden, was in town from 1910 onward.[14]

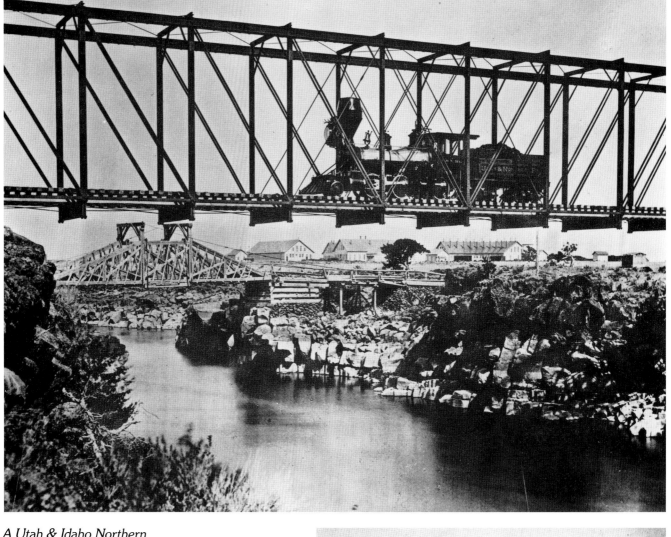

A Utah & Idaho Northern narrow gauge locomotive was photographed as it crossed the spidery iron bridge at Eagle Rock in the late eighties. Taylor's bridge and the railway shops are beyond.

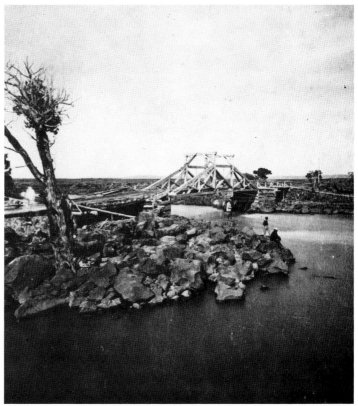

Matt Taylor's 1865 wooden toll bridge across Snake River at Eagle Rock (later Idaho Falls) was recorded by William Henry Jackson in 1871.

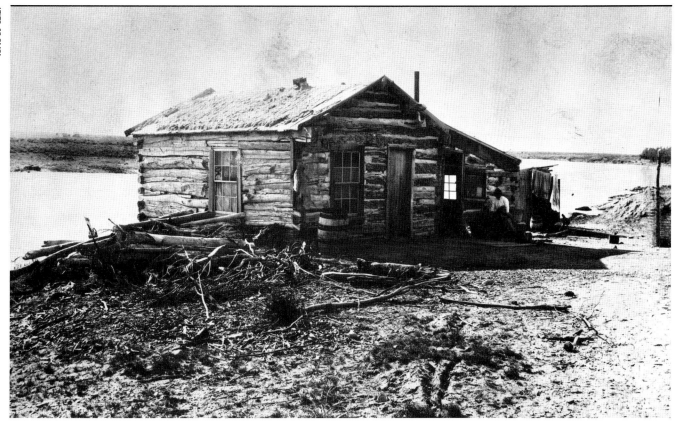

"Oldest house in town" is the label on this early Idaho Falls picture. It shows the classic log architecture early settlers brought to Idaho from the Midwest and East.

IDAHO FALLS

William Henry Jackson passed through the future site of Idaho Falls in 1871. He took a picture of Matt Taylor's bridge across the Snake River, built in 1865 when establishment of a road north to the Montana mines from Salt Lake City made this a good place to collect tolls. When the Utah & Northern railroad was completed in 1881, Eagle Rock, as the place was then called, was made a division point and machine and car shops were built that spawned a town as well. By 1885 Eagle Rock had grown to 1500 people, but dwindled to about 300 when the shops were moved to Pocatello.[15]

Idaho Falls' future was tied not to the railroad but to irrigation agriculture. After 1890, when the Eagle Rock name had been dropped, farm settlement in the area created a prosperous new community. By the turn of the century two photographers were in business there. Edgar and Imogene Carey, a husband and wife team, so typical of pioneer photography, were in business from 1900 until 1902. Ray S. Smith

operated there until 1904. Helen O'Haver, another pioneer woman in the field, had a studio in 1906. Only John M. Whitney had a really successful practice in Idaho Falls during our pioneer period, however. He was in business from 1906 until 1913 (and certainly later).[16] It was during this period that a real old-timer in Idaho photography had his last studio in Idaho Falls. Albert C. Bomar, who had pioneered the art in Boise City, Idaho City, and elsewhere since 1871, was at it again in 1910, teaching his trade to a twenty-five year old brother-in-law, Horace Dodge.[17]

Perhaps our most significant early views of Eastern Idaho towns come, not from the photographers mentioned above, but from a visitor from Des Moines, Iowa. F.J. Bandholtz took panoramic views of downtown Idaho Falls, Blackfoot, and Pocatello in the summer of 1909 that are marvels of documentation and detail.

They are reproduced in a special section on panoramic photography starting on page 147.

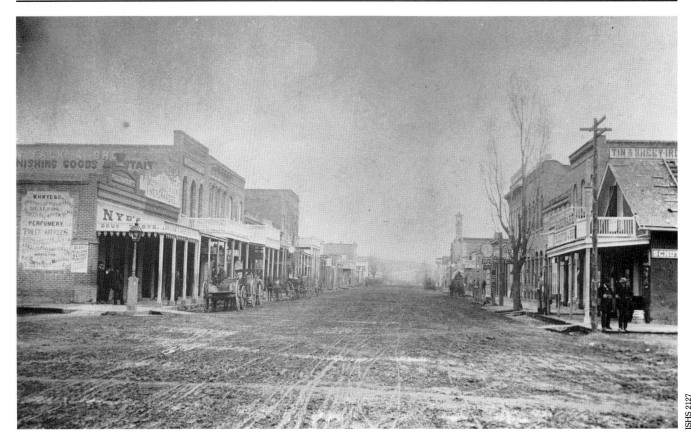

Main Street, Boise City, looked like this in 1889 when Charles S. Kingsley set up his camera at the corner of Eighth and Main and took the view to the east.

Timothy L. Graves' labeling on this photo tells the whole story. He obviously hoped to sell copies to parishioners.

CAPITAL CITY

When Idaho became a state on July 3, 1890, Charles S. Kingsley, Boise's leading photographer since 1881, had sold his business to George W. Foor of Oregon, then reclaimed it and re-opened with a hired operator. Kingsley by then had passed his bar examination and was Register of the U.S. Land Office.[1]

George Foor "purchased the plant and good will" of Kingsley in August, 1889. He was described at that time as "a landscape, flower and portrait painter," who came highly recommended.[2] In his first newspaper ad Foor asked the reader to "Lend Me Your Face!" and for a continuance of the patronage bestowed upon Kingsley.[3] For whatever reason, Foor stayed in town less than a year.

John and Horace Myers also began a Boise gallery in 1889. John was called an "artist" by the newspaper in July, when it described his shop as "a veritable art gallery" with a "fine collection of etchings, engravings and water colors."[4] A November ad called the shop "Myers Photograph foundry," and offered "frames to order." Horace Myers, whose name appears in this one, advised readers that "a good picture illy framed loses half its value."[5] All later mention of the firm refers only to H.C. Myers, often noting his trips out of town on photographic assignments for land promotion companies.[6] In 1912 C. Perry Rice joined Horace in the firm Myers & Rice. A 1913 ad offered "Landscapes of all Industrial and Scenic Features of Southern Idaho."[7] Commercial photography was now as well-established a specialty as portraits.

Timothy L. Graves had a Boise business from 1889 until 1893. He advertised copying and enlarging as his specialties but chiefly made his living as a portrait photographer. William W.

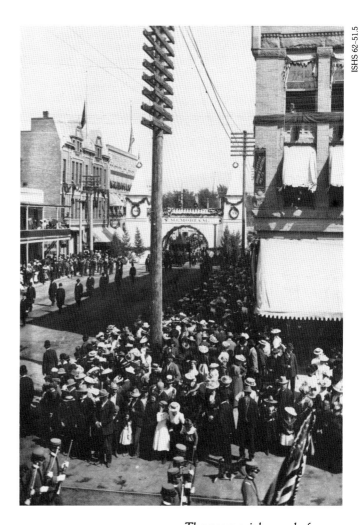

The memorial parade for President William McKinley on September 19, 1901, brought out a solemn crowd of Boiseans. The city was draped in black in honor of the slain President.

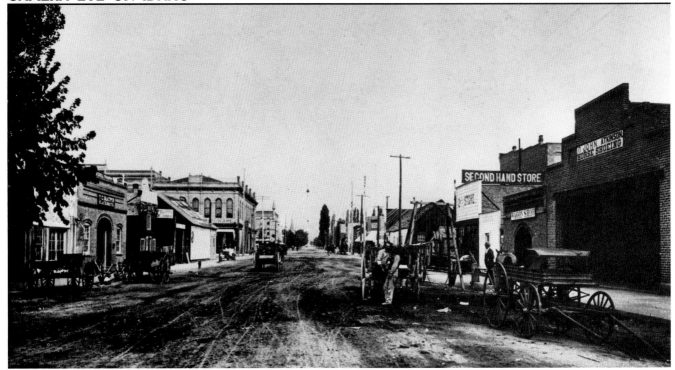

It was still a horse-drawn world in the mid-nineties when this view of Boise's Ninth Street was made. Blacksmiths, wheelwrights and wagon makers were plentiful. Peter Sonna's opera house and hardware store, left center, was at Ninth and Main.

Anton Unternahrer took this clever double self-portrait sometime around the turn of the century. Despite his obvious talent for photography, Unternahrer had a tough time making a living at it.

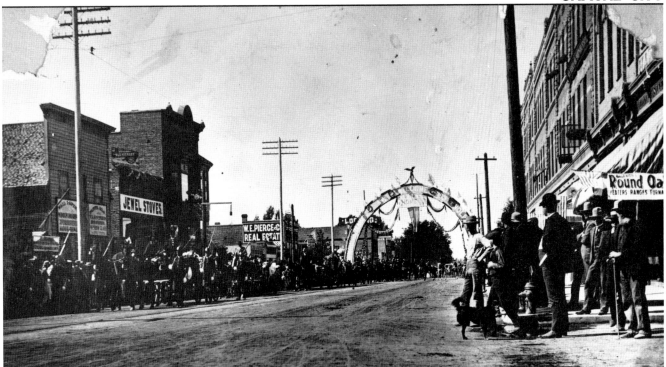

McClain, B.F. Sooy, W.T. Allen, and William Whyte were all active in the capital in the mid-nineties, primarily as portraitists. Whyte continued until 1908, during which time he had a brief partnership with C. Edwin Harvey at the turn of the century.[8] An undated portrait in the Dale Walden collection is imprinted "Whyte & Sons," but no such listing appears in city directories. Since no directories were printed between 1893 and 1899, the sons may have been involved during that time.

Calvin F. Stamper began a successful Boise practice in 1898, that continued into the teens of the new century. His ads proclaim him the winner of the "Highest Award, Idaho Intermountain Fair, 1898."[9] This must have impressed local people, at least, for Stamper was well patronized for nearly twenty years.

Not as fortunate was Anton Unternahrer. He was a photographer in 1899; a bartender, 1902–04; a saloon keeper 1906–07; tried photography again in 1908; moved to New York City in 1909–10, and was back in Boise in 1911, again working as a bartender.[10] Surviving work by Unternahrer shows him to have been a competent craftsman, but apparently unable to meet the vigorous competition of long established men like Myers, Whyte, and Stamper. George E. Tonkin was another able photographer in Boise during this period who has left

behind memorable images of the period 1899–1904.

The 1900 census listed several photographers in Boise who were apparently working for others. The larger studios obviously needed darkroom technicians, retouchers, and general help to keep up with business. As noted earlier, retouching of negatives and hand-coloring of prints was often done by women. Some accomplished artists like John Myers may have done their own.

A mention of all Boise photographers active between 1900 and 1913 is not possible in this brief narrative, but some of the more important should be noted. David C. McCandless' Rex Gallery was a Boise fixture from 1901 on. Responding to the enormous increase in amateur photography, McCandless and other local studios began processing films for the public at this time. His 1904 ad featured "Kodaks loaned."[11] C. Edwin Harvey, mentioned earlier as a partner of William Whyte in 1901, ran his own successful business thereafter for many years.

Three of the city's most prominent photographers started long-lasting businesses at the end of our pioneer period. R. Harold Sigler opened his Boise studio in 1911. More than a thousand of his negatives are preserved in the Idaho Historical Society collection. Like most

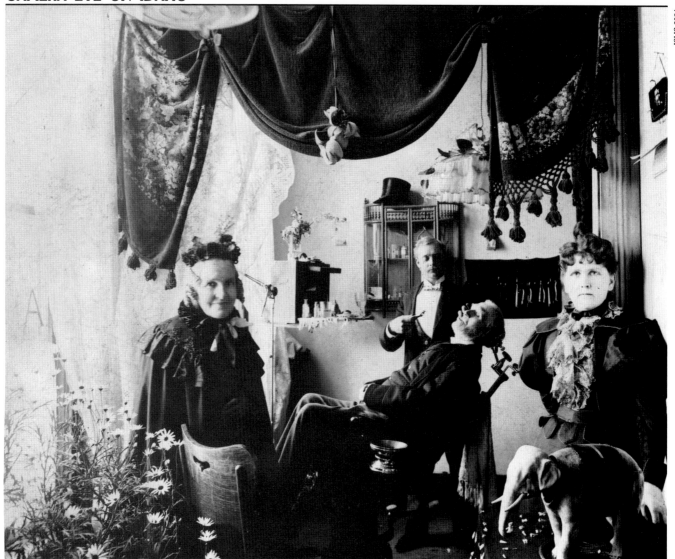

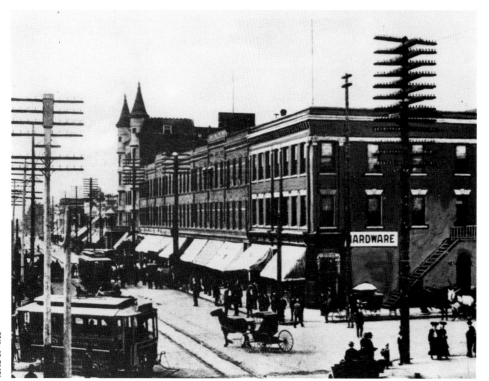

Calvin F. Stamper took this promotional picture for the American Dental Parlor in about 1898. The emphasis is on elegance. Can you imagine a dentist pulling teeth in a formal suit, or coming to work in a silk top hat?

Boise had "big city" character when this post card picture was taken in 1905 of the corner of Ninth and Main. Street cars, buggies, bicycles, and an early auto can be seen.

ISHS 73-163.4

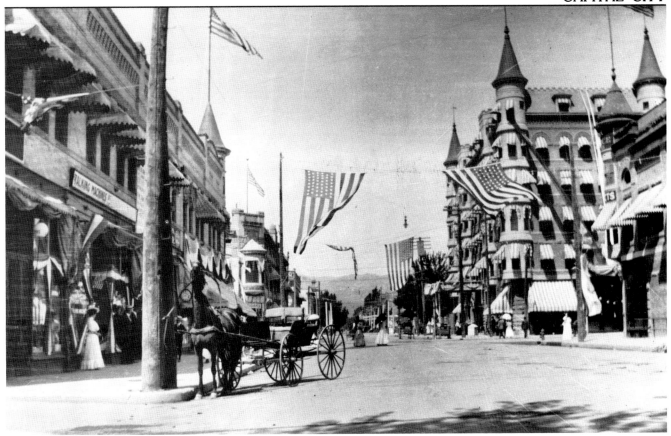

The Idanha Hotel corner at 10th and Main was gaily decorated for July 4 when this view was made.

of his contemporaries, Sigler did general commercial work but relied on portraits for the bulk of his business. A specialist in portraits, mentioned earlier, was James G. Burns who settled in Boise in 1913. This family business is now in its third generation.

Jons P. Johnson and his son Ansgar E. came to Boise in 1911 and achieved local prominence as suppliers of news and feature photographs to the *Idaho Statesman* newspaper. For many years the *Statesman* ran a full page of Johnson & Son photographs every Sunday, and because their assignments led them to cover news events of the week, their pictures have unusual historic interest. It was a tragic loss to Idaho when the entire collection of Johnson negatives was destroyed by fire on September 9, 1951.[12] Although some excellent prints have survived we can only appreciate the extent of the loss by looking at what appears in the *Statesman* over more than a quarter century. The Johnsons photographed just about all of the celebrities that came to Idaho's capital during that time and many other local activities and events. Ansgar E. Johnson, Jr. carries on the business more than seventy-five years after its Boise beginnings.

Johnson & Son's picture of a popcorn and peanut wagon records a once-familiar sight on Boise streets. It was taken in about 1913.

ISHS 73-183.0

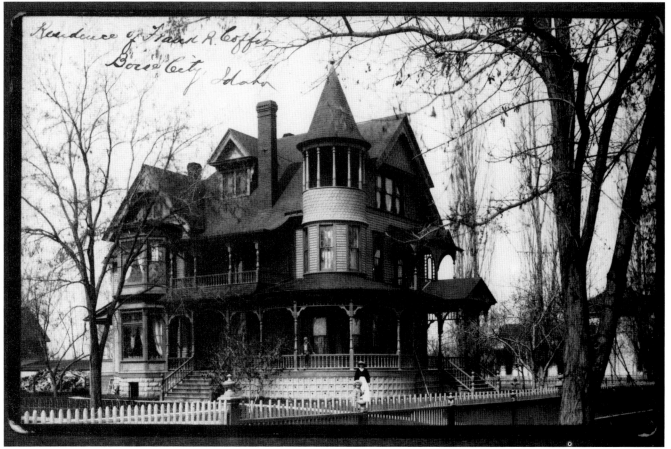

When this photograph of the elegant Queen Anne style mansion of Frank R. Coffin was taken in about 1895, it was the largest house on Boise's Grove Street.

Professor John W. Daniels built the first towered house in the city. He was a cultured Englishman who served many years as Superintendent of Schools.

SOUTHWEST IDAHO: CALDWELL X

Caldwell got its start when construction crews on the Oregon Short Line railroad reached Boise river in 1883. The Oregon-Idaho Land Improvement Co. laid out the town in September and actively began to develop it as a future rival to Boise City, which the railroad had bypassed. The capital had to wait until 1887 for a branch line, the Idaho Central, to be built from Nampa. Caldwell became an important supply and shipping center for cattle and sheep ranches in the area, and, after irrigation projects were developed, an agricultural center as well. The College of Idaho began in 1891 as Idaho's first institution of higher learning, and in 1892 Canyon County was created, with Caldwell as its county seat. Nampa, a few miles to the east, developed as a rail center after 1886, and it, too, became an important supply center for agriculture.[1]

The earliest photographs of Caldwell were reportedly taken by Friedman & Co. of Salt Lake City on a visit in April, 1884. Existing photos from that period are not labeled, but may be the ones referred to. In May of that year the *Caldwell Tribune* said that Charles Kingsley of Boise was going to build a gallery there "right away," but in the absence of any further mention it is doubtful that he did.[2]

Francis Moore, whose career we have described earlier, moved to Caldwell from Boise in 1888 and was the town's first resident photographer. J.H. Montgomery, C. Billington, and B.F. Sooy practiced there briefly in the mid-nineties, as did George Chinn and Spencer Orvis at the turn of the century. E.C. Lavering and Carl F. Hildreth had longer Caldwell careers, but John J. Prescott and his wife Clarabelle had a studio well into the teens. Mrs. Prescott was a full-fledged professional herself,

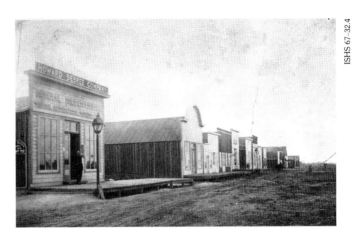

ISHS 67-32.4

This earliest surviving view of Caldwell dates from 1884, but the photographer is unknown.

M.M. Hazeltine took this early view of Frank R. Coffin's store. Hardware was the firm's specialty, but in a new town like Caldwell they sold general merchandise as well.

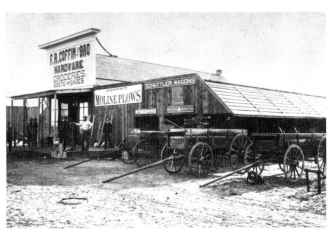

ISHS 1900-30

The outside of Caldwell's *Racket Store* was prosperous and tidy-looking when this photo was taken. The crisp detail shows iron columns identifiable as having been manufactured by Mesker Brothers of St. Louis.

The camera is an incredible tool for documenting detail. This Caldwell general store carried brooms, kerosene lanterns and washboards in addition to groceries.

ISHS 78-92.4

PHOTO BY SNODGRASS

Lucien B. Snodgrass took this delightful picture of a group of early motorists about to set out on a long trip together. Note the pilot car, right front—a necessity in a day when there were no paved roads in Idaho.

and not just a wife who helped out in the darkroom.[3]

Perhaps the most remarkable photographic family in Caldwell history was that of Lucien B. Snodgrass and his daughters Mary and Margaret. Lou Snodgrass and Mary were running the Snodgrass Picture Shop in 1911. After Mr. Snodgrass' death his daughters operated the business together until 1938 when they retired. Mary lived until she was ninety-three, and she and her sister are remembered by many still living.[4]

Alfred Ley, whose style was to be a roving photographer, had a Caldwell studio in 1912,[5] and it was in Caldwell that James G. Burns got his Idaho start that year.[6]

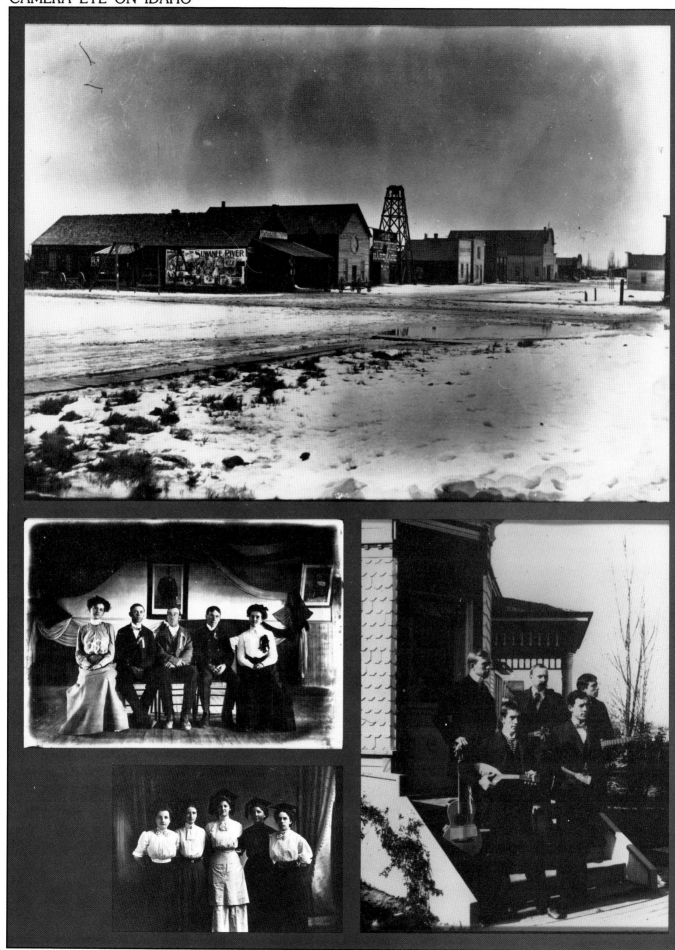

WILLIAM JUDSON BOONE

William Judson Boone, newly ordained Presbyterian minister, arrived in Caldwell with his bride of barely a week on November 9, 1887. He was the first pastor of the Caldwell Presbyterian Church and first president of The College of Idaho when it was founded in 1891. He continued in that position (which he referred to as "foreman") until his death in 1936. Photography was one of the many interests of this talented and remarkable man. The selection shown here is from the collection in The College of Idaho's Terteling Library.

Boone's winter view of early Caldwell businesses, top left, was taken in about 1895.

C of I B132

College of Idaho students are shown in two group photos, far left. Herbert H. Hayman, pioneer professor and biographer of Boone, is seated in the center of the assembly hall photo, top.

C of I B14, B74

The identity of the male ensemble photographed on a Caldwell porch is unknown. Guitars, a mandolin, and possibly a banjo, can be seen.

C of I B55

Sara Boone was about six when her father took this picture of her with a sled on Belmont Street in 1903.

C of I B154

Professor Lawrence Gipson, surrounded by women undergraduates, was photographed in the college chemistry laboratory.

C of I B16

Caldwell had electric street railway service to Boise and other valley towns from 1907 until 1928. This interurban car was photographed in front of the Saratoga Hotel in about 1910.

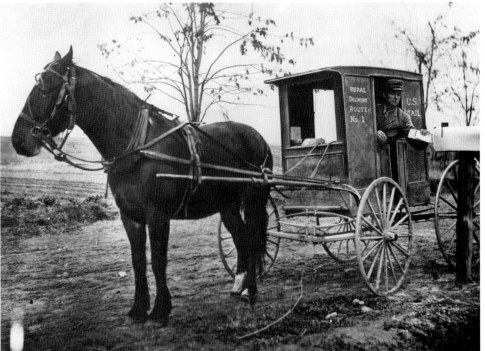

Fred L. Evans, Caldwell rural mail carrier, was captured by the camera near Greenleaf in 1912.

ISHS 63-53.2

Courtesy Mrs. Paul B. Evans

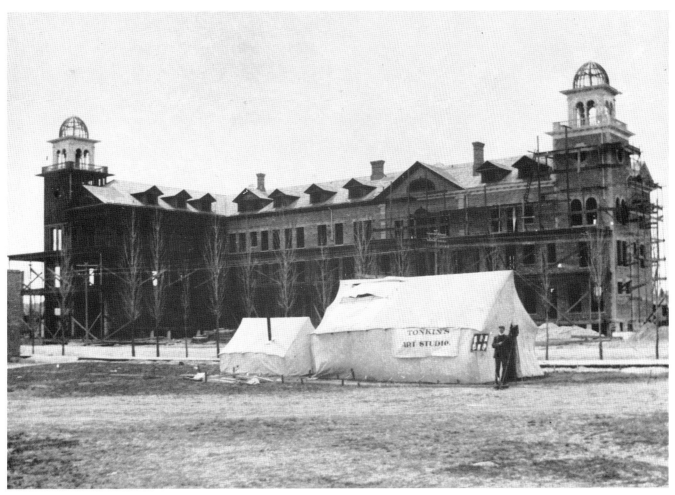

ISHS 76-2.29

NAMPA

The earliest Nampa photograph to which we can attach a name is by A.A. Simmons, taken on the depot platform, dated September 30, 1895. It records a display of local produce set up for travelers on the Oregon Short Line.[7] There are earlier photographs of Nampa and its pioneer period, but none that can be attributed to a photographer resident in the town. We do know that Horace Myers, a Boise practitioner, took promotional pictures in the area in the 1890s.[8] Herbert Lee Jellum, a native of Norway, may have been Nampa's earliest resident photographer. At least he was there in 1900 and took memorable action pictures of Nampa's great fire on July 3, 1909.[9] Norman Leek and E.W. Baker were in business briefly after the turn of the century, primarily doing portraits, and Paul Van Graven & Son carried on from 1903–08. Fred Keller's Elite Studio was in business from 1908 through 1913.[10]

Nampa's great Dewey Palace Hotel was under construction when George Tonkin pitched his "Art Studio" tent in front of it in 1902. The photographer probably slept in the smaller tent with the stove pipe at left.

Drop on Phyllis Canal near Nampa

The Phyllis Canal reached Nampa in the spring of 1890, opening up enormous tracts of sagebrush land to farming. Boise photographer Horace Myers took this picture of the young town of Nampa and the life-giving water from Boise River flowing through the new canal.

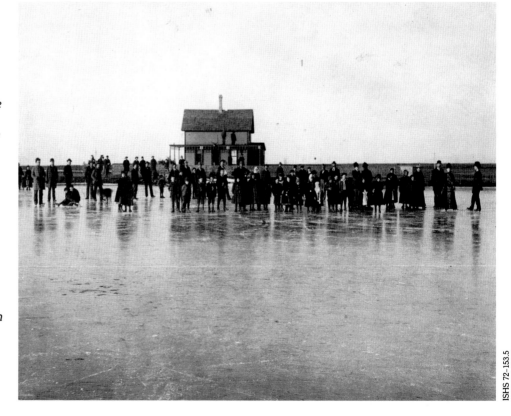

Skaters on Lake Hazel posed for the cameramen in this turn of the century picture. The lake is no longer there, but two schools in the vicinity, southeast of Nampa, are named for it.

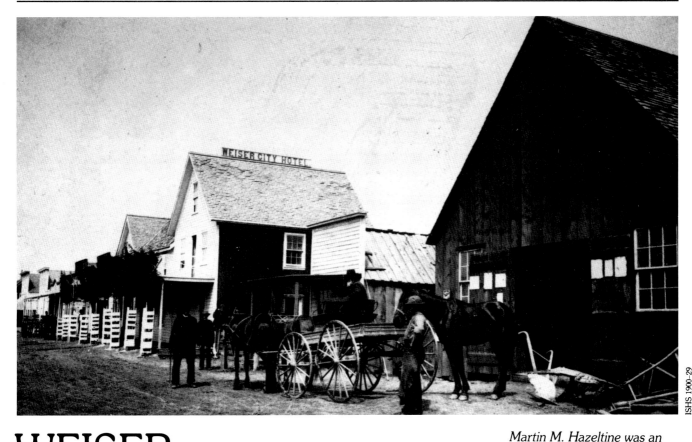

ISHS 1900-29

WEISER

Weiser, another Oregon Short Line town, had several photographers in the pioneer era. Phil Van Graven, in business with his father Paul in Nampa earlier, settled in Weiser in 1908 and continued thereafter for several years.[11] Others (listed in the tables starting on page 156) were in town for relatively short periods of time. Our most memorable early views of Weiser were taken by photographers from other places, notably M.M. Hazeltine and G.E. Tonkin.[12]

Martin M. Hazeltine was an exceptional photographer. His technically perfect prints survive in fine condition more than a century after he took them. This is Weiser in the eighties.

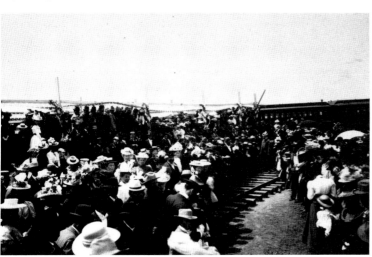

ISHS 60-193.2

George Tonkin was at Weiser on May 16, 1899 to photograph the ceremonial driving of the first spike for the Pacific & Idaho Northern Railway.

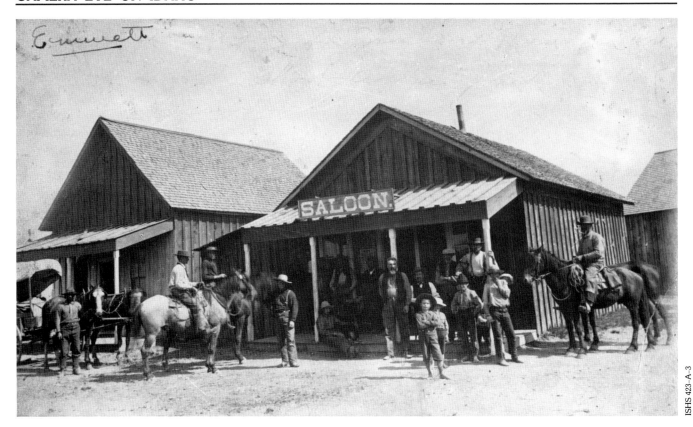

When Hazeltine set up his camera in front of this Emmett saloon sometime in the 1880s he attracted an interestingly varied crowd eager to be in the picture.

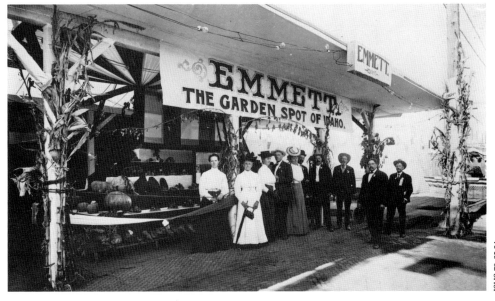

Emmett people in "Sunday best" clothes turned out to see this display of garden produce at a local fair in about 1900.

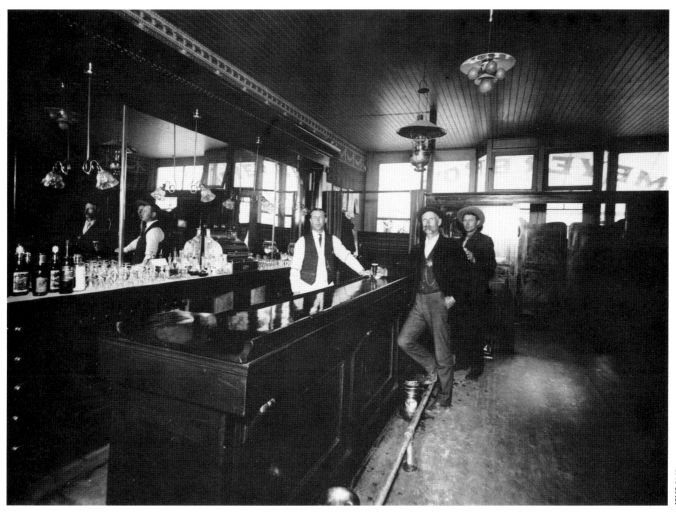

EMMETT

Emmett, originally Emmettsville, was named for the son of Irish-born lawyer T.D. Cahalan. This Payette Valley town grew up on the pioneer miners' route from the Columbia River to Boise Basin, after gold was discovered there in 1862.[13] The earliest photo we have of the place was taken by M.M. Hazeltine sometime in the 1880s. Professional photographers active after 1900 were Arthur M. Whelchel and his brother Frank, George A. Stevens, and Ralph Park. Two women briefly operated Emmett studios as well—Mrs. T.R. Johnson in 1906, and Lavinia Graham, 1910.[14]

The local sheriff posed nonchalantly, foot on rail, in the Russell Hotel bar for this early twentieth century picture. The big mirror back of the bar, and brass cuspidors in front, were standard equipment for saloons of that day.

Rube Eaton's Emmett barbershop looked like this in 1906.

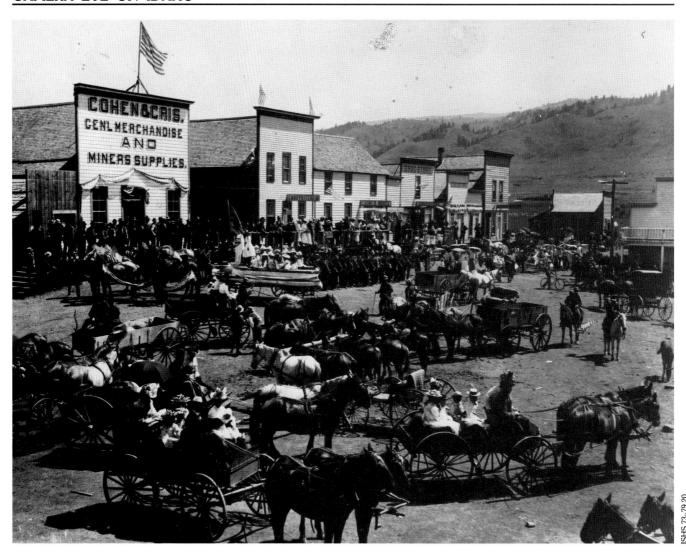

ISHS 73-79.20

Council, Idaho, was a lively place on July 4, 1901. The plaza, a feature of the town center, was crowded with wagons and carriages as people from miles around gathered for the parade and celebration.

ISHS 65-77.2

Photographer James E. Bates took this view of Payette's Shearwood Brick Works in 1909.

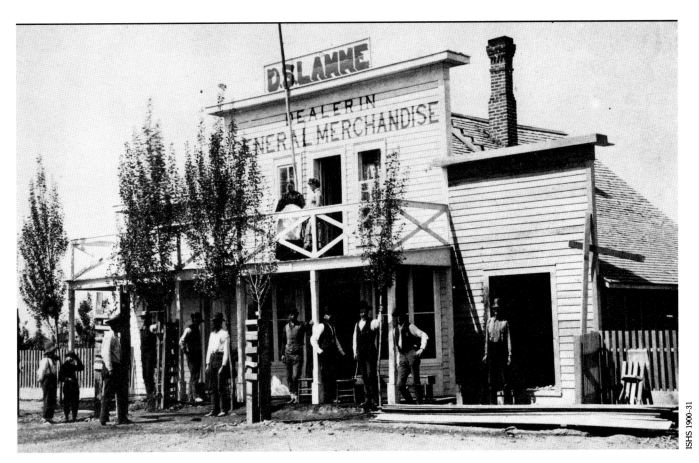

PAYETTE

Payette was called Boomerang when D.S. Lamme built his general store there. M.M. Hazeltine took this beautifully crisp photograph of it in the 1880s.

William B. Fowler, who later settled in Salmon City, was in Payette in the 1890s. Mrs. J.H. Weider ran a portrait studio there from 1906 until after 1913. James E. Bates was her chief competitor, 1908–10, and Phil Van Graven, formerly of Nampa and Weiser, began business in 1912.[15] This town, like Caldwell, Nampa, and Weiser, got its start when the Oregon Short Line was built in 1883. It was called Boomerang for awhile, and was a sawmill center for logs floated down the Payette River. Hops and orchards were planted in the valley in the late 1880s and the area became noted for award-winning fruit in the early years of the twentieth century.[16]

Nearby New Plymouth had its own resident photographer from 1906 onward. He was Theodore D. French. Other southwest Idaho towns that supported professionals in the early years include Meridian, where Mabelle Newel had a successful practice from 1909 into the teens, and Council, where States & McKenzie and William T. Calvin were active.[17] Fine early photos of these towns have been preserved, but cannot be attributed with certainty to any particular studio since they are unlabeled—a difficulty faced throughout this study. Many of our best pioneer photographs can only be credited to "anonymous."

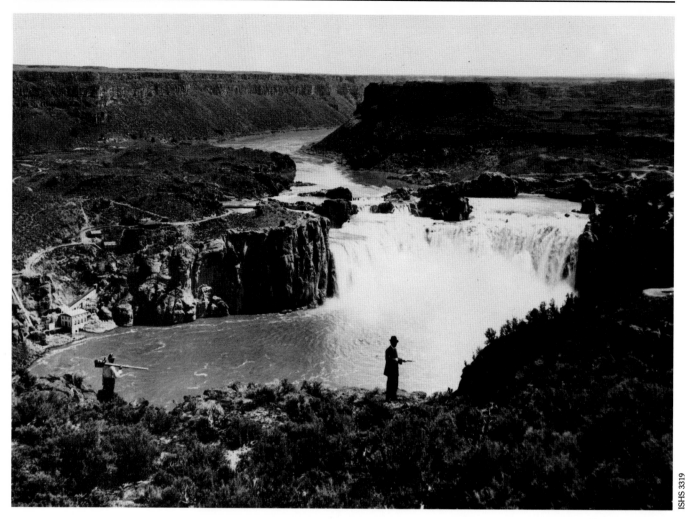

ISHS 3319

William A. Flower photographed Shoshone Falls in all its glory in 1911, as another cameraman prepares to set up at left. Flower took over the Amos Studio.

ISHS 73-221.794

Clarence E. Bisbee's sense of history led him to carefully label every glass plate negative, as in this circus parade picture.

TWIN FALLS XI

 Just as pioneer photographers had rushed to the mining camps of the 1860s on the heels of the gold-seekers, later photographers tried their luck in the new boom towns of southern Idaho created by the opening of desert lands to irrigation agriculture. Twin Falls is our most dramatic example of a permanent city laid out and built in a few short years. Its development was recorded by the camera every step of the way.

Thousands of acres of sagebrush land on the south side of Snake River canyon near Shoshone Falls were opened for entry in the summer of 1903 under provisions of the Carey Act. Settlers could file on 160 acre tracts at twenty-five dollars per acre. The money realized from these sales was used to build a canal to carry water from Snake River at Milner Dam, then under construction. By the summer of 1904, 117,000 acres had been sold and a townsite was platted. I.B. Perrine, an early settler who had developed a successful fruit farm at Blue Lakes in the canyon nearby, was the driving force behind promotion of both land and townsite development.[1]

The *Twin Falls News* reported the arrival of Ernest Tacha on March 3, 1905, saying that he was "preparing to move on his land and begin the planting of crops for this season."[2] Tacha, who had been listed as a photographer at Shoshone in 1901, had some of his pictures reproduced in the *News* on August 11, along with those of I.L. Young. The paper said "Mr. Tacha has long been accounted one of the best photographers in the state. His pictures are eloquent." Of Young, who was employed at a Twin Falls nursery, the *News* said, "Mr. Young is 'mighty handy' with his camera and a large number of farmers have had him photograph

their fields and homes. Mr. Young is permanently located in Twin Falls and is prepared to supply photographs to those who wish them."[3]

Neither Tacha nor Young stayed in the Twin Falls photography business long, although they must be accounted its pioneers. On February 2, 1906, the arrival of the city's great photo-historian for the next thirty-six years was announced with the following item:

> Clarence E. Bisbee, an experienced professional photographer and a graduate of the Illinois College of Photography at Effingham, Ill., has arrived from Newcastle, Neb. and has opened a studio in Twin Falls. Mr. Bisbee will equip his studio with modern apparatus and will be prepared to do strictly high class work. He is impressed by the fact that there is abundant scenery in the vicinity of Twin Falls to permit the most artistic landscape work. Until he secures permanent quarters Mr. Bisbee will receive orders at the Y.M.C.A. reading room.[4]

Bisbee began advertising in the *News* that week for "High Class Portrait and Landscape Photography."[5] These early references to Bisbee in Twin Falls suggest that for him photography was always to be an art, and that "high class work" was an ideal. The handsome brick studio he would later build proclaimed his philosophy with a carved slogan over its doors "Life and Art are One."

On February 23, 1906, the *News* noted the arrival of a young photographer named J. Reichardt who would be associated with Bisbee. "They will open their gallery in a large tent on Tenth avenue," said the item. This may or may not be the tent shown on page 12 since it is possible that Tacha or Young had also

Clarence E. Bisbee captured just about every local event of interest in his long Twin Falls career. Happily he often labeled his glass plate negatives precisely, as he did here; first opera given in Twin Falls, Feb. 22-23, 1912, Home talent, "Mikado."

worked in tents when they arrived in 1905.[6]

Promotional efforts fueled the growth of Twin Falls and other new towns in the area after 1904. Most of the pictures Bisbee took over the next twenty years were to show the wonders of the agricultural empire that Snake River water, volcanic soil, and hard work were creating. The captions the photographer penned on his glass plates make clear that the pictures of young orchards, potato and hay fields, new houses and city streets were intended to attract settlers and investors. For a time Bisbee even promoted Buick automobiles, with photos of shiny new machines at various scenic spots in the area. He was certainly one of Idaho's most successful early commercial photographers, producing images for business and industry.

Today these pictures have great historical value, showing as they do the development of south central Idaho over a generation. Of even greater significance, perhaps, is Bisbee's re-

cording of special events, such as visits of famous people, circuses, cornerstone-layings, amateur theatricals, and parades. Also praiseworthy is the photographer's technical skill and artistry. Bisbee's work as he had promised when he arrived in 1906, is decidedly "high class."[7]

Clarence E. Bisbee retired in 1939 and died at Twin Falls in 1954 at age seventy-eight. He was remembered at his death for "photos used extensively for publicizing early land developments in the area."[8]

Leah Amos, a native of Louisiana, was Twin Falls' leading woman photographer in the early years. In 1907 she was in partnership with Milton Helm, before he moved to Mountain Home and opened a studio there. In 1910 Mrs. Amos hired "Miss Lolo Read, formerly of Chicago, as the retouching expert for the business."[9] In 1912 William A. Flower is listed as business manager of the Amos Studio, and it was he who would take over the business.[10] There is a delightful example of Leah Amos' promotional approach in the 1908 Twin Falls directory. The ad reads: "Pictures? Here's Mine, Let me Take Yours." The photographer, then thirty, is shown in blouse and skirt, showing off a slim-waisted figure, but wearing a brimmed hat similar to those worn at the time by surveyors and cattlemen. "Views of the Twin Falls Country—Farm Scenes—Snake River Scenery—Irrigation Pictures" complete the ad,[11] showing that she competed actively in the same market as Bisbee.

The 1910 census lists William S. Rensimer and Margaret Crosby as photographers in Twin Falls, and although the former had a studio there for several years, nothing else is known of Crosby. We also find a single listing for a Frank Craig in Polk's 1906 *Gazetteer of Idaho*, but he is not listed thereafter.

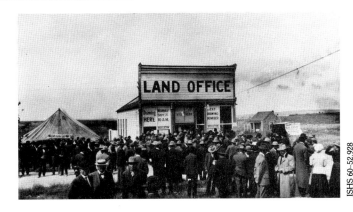

ISHS 60-52.928

Land sales were booming in the area around the new town of Twin Falls when this 1909 photo was taken. Crowds gathered for the drawing for lots and acreage.

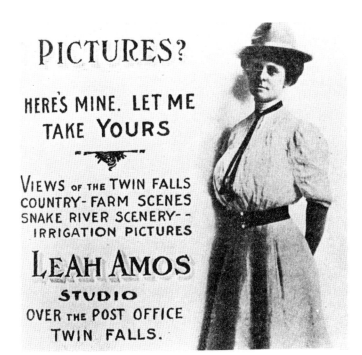

ISHS 73-221.68

Clarence E. Bisbee's handsome Twin Falls studio bore the inscription "LIFE AND ART ARE ONE."

This corner of the Bisbee studio at Twin Falls is decorated with autumn flowers, foliage, and gourds. The fireplace inscription reflects Bisbee's artistic nature and idealism.

ISHS 73-221.532

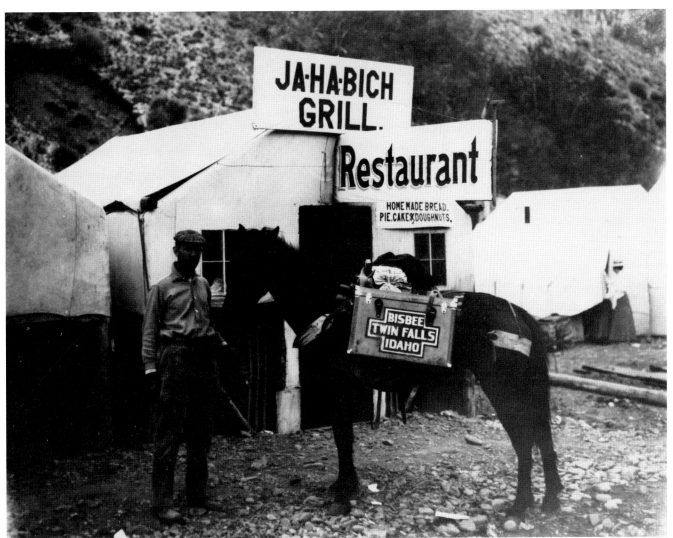

C.E. Bisbee, like photographers of an earlier generation, sometimes used pack animals to get his equipment to remote areas like Jarbidge, Nevada, scene of a 1909 gold rush.

Mr. and Mrs. Clarence Bisbee made this self portrait in their Twin Falls studio, behind what appears to be a year's supply of photographic paper.

ISHS G-74

"Home"
(outside)
July '09

The progress made on a homestead claim was recorded by the owner in these two snapshots of 1909.

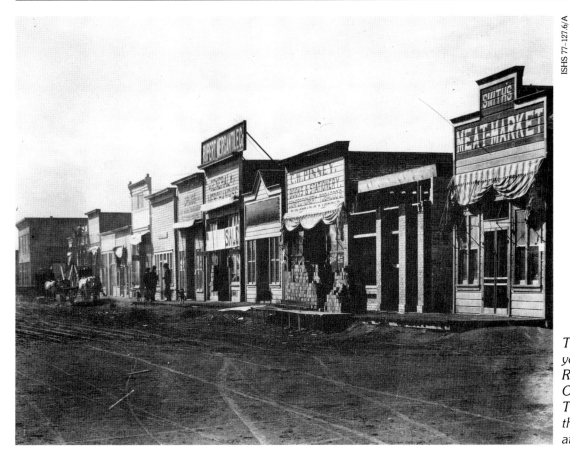

This fine view of the young town of Rupert was taken on October 29, 1909. The place was less than four years old at the time.

SOUTH SIDE—NORTH SIDE

The completion of Milner Dam in 1903–04, and of the big canals that brought water to what had been arid sagebrush country, created a number of new towns in south central Idaho. Twin Falls, Buhl, and Kimberly on the south side and Jerome and Wendell on the north side all came into being within a few years.

Although able photographers like Clarence Bisbee traveled to all of these places to take pictures for the capitalists promoting them, there was also room for resident photographers in some of them. Oscar Bode and Frank Marty had Buhl practices after 1909, and I.B. Smith settled in Jerome. Completion of Minidoka and Oakley Dams spurred the growth of Burley and Rupert. Mattie G. Smith opened a photo studio in Rupert in 1912, and Edith Robinson started one in Burley the same year. Richard Mills, pioneer photographer at Oakley since the 1890s, moved to Burley in 1908. W.A. Dahlquist and Hannibal Smith competed for the Oakley business thereafter. In all of these towns

itinerant photographers appeared from time to time, took a few pictures and moved on. We can only speculate on their movements and lengths of stay from photos with their imprints, although these are rarely dated. An exception is an Oakley "Old Folks Reunion" picture of August 9, 1901, bearing the name of "N.S. Nelson, view artist." This could be Nels Nelson who was at Troy, 1905–08, but we cannot be sure.

Other towns in south central Idaho that boasted photographers of their own in the pioneer era were Albion, where J. Whitney was in business in 1903–04; Gooding, with Clara Thoma and R.F. Hill, 1912–13; Irish born artist-photographer Joseph McMeekin in Hagerman, 1900–1910; Heyburn, with William Pittenger, 1910, and Thompson J. Smith, 1912–13, and Shoshone with Ernest Tacha, W.C. Thompson, and Edward G. Merrifield. Tacha would move to Twin Falls. Thompson had earlier been at Hailey.[12]

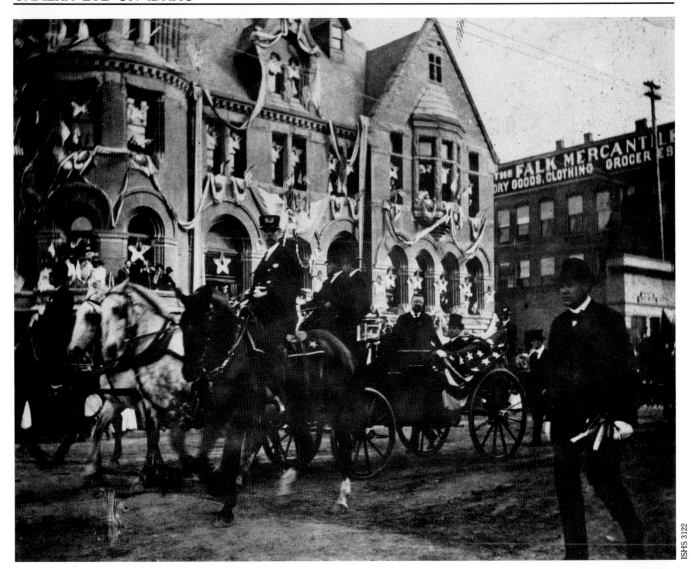

President Theodore Roosevelt visited Boise on May 28, 1903. He was passing a bunting-covered City Hall at Eighth and Idaho streets when this snapshot was taken.

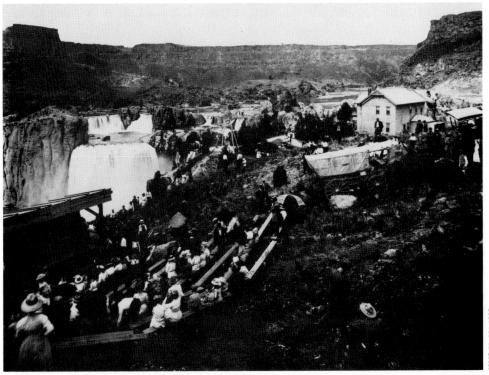

Oregon Trail pioneer Ezra Meeker was at Shoshone Falls for this Flag Day celebration in 1910. Naturally, C.E. Bisbee was there too. Meeker did more than any one individual to awaken an awareness of the trail's importance in our history.

ISHS 3122

ISHS 73-221.1002

RECORDING HISTORY XIII

Photographers have been able to capture with the camera memorable moments in our history in a way that is uniquely accurate and detailed. The desire to preserve such moments has led Idahoans to record holiday celebrations, parades, cornerstone layings, disasters, and visits by the famous. The motivation of the professional photographer in most cases was to produce a souvenir of such events that people would want to buy, especially if they themselves were included in the picture. Nothing proves as clearly as a photograph that "I was there when it happened." Why else would early Idahoans have wanted to be photographed sitting on an overturned locomotive? It was certainly a unique experience worth preserving.

Weddings, christenings, birthdays, and family reunions were also occasions to be recorded by the camera, as were lodge and club meetings, conventions, theatrical and athletic events. It is no exaggeration to say that our sense of family, community, and national history is largely dependent upon the photographs we have seen. (Could we understand the character and personality of Abraham Lincoln nearly as well without the powerful images of that memorable face, captured by the camera nearly a century and a half ago?)

Class pictures, taken yearly since the 1890s in most Idaho schools, record the growth of children in stature, if not in wisdom. They were treasured in later years for the memories they evoked of favorite teachers and classmates. They had special commercial value to the photographer in that he could sell many copies from the same negative.

Amateurs came to be some of our best recorders of local history. Armed with small portable cameras that could be taken any-

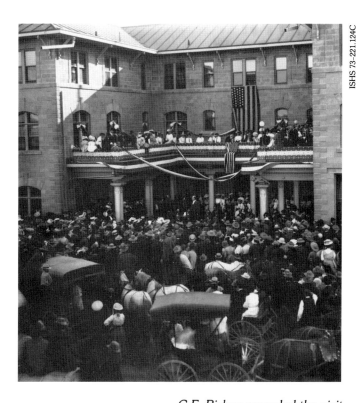

C.E. Bisbee recorded the visit to Twin Falls in 1907 of William Jennings Bryan, Democratic candidate for the Presidency. He spoke to a large crowd at the new Perrine Hotel.

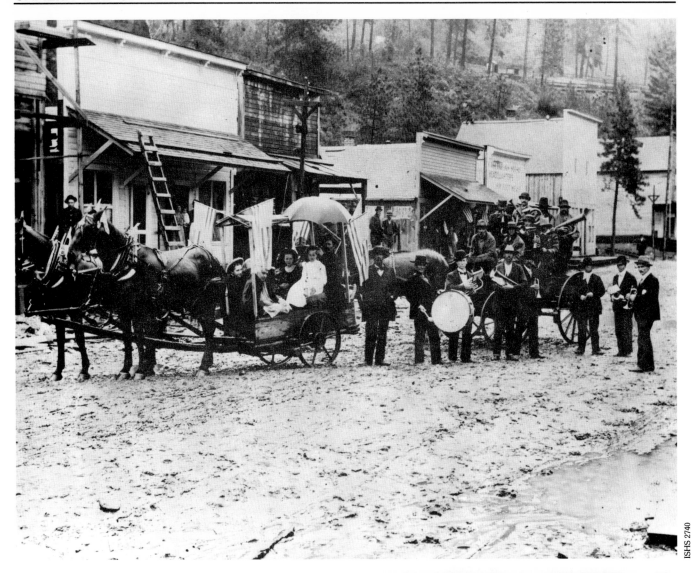

It rained on Orofino's 1890 Fourth of July parade, but these North Idahoans carried on bravely anyway. Statehood had been proclaimed only the day before.

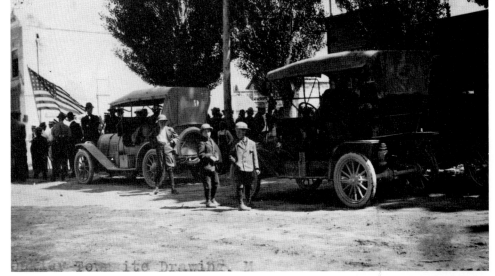

The drawing for Oakley townsite lots on May 28, 1910 attracted large crowds. Many came by automobile.

ISHS 73–126.29

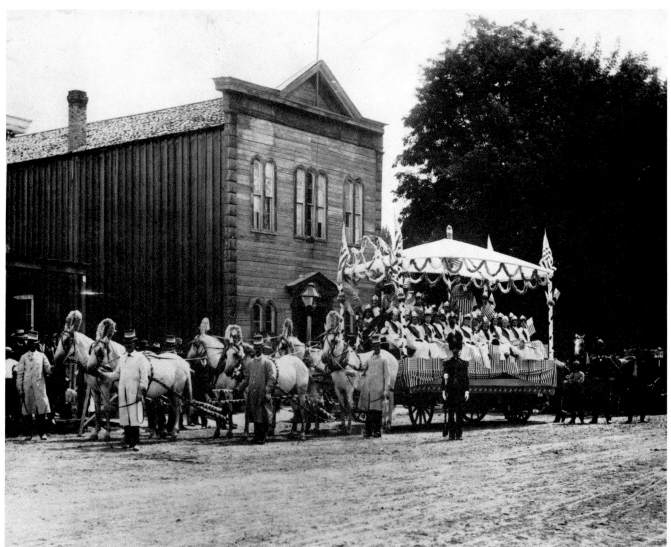

ISHS 964

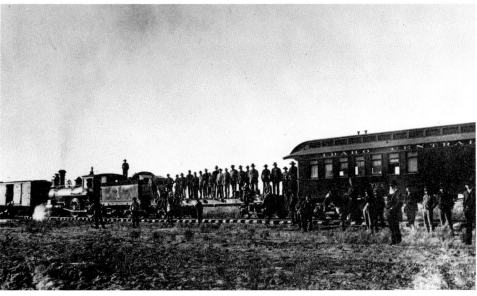

ISHS 73-139.20

Boise's 1890 Fourth of July parade was the grandest in the city's history. On July 3rd Idaho had become a state. The photo of the Liberty Car was taken near Sixth and Main Streets.

When the first Idaho Central train rolled into Boise on September 5, 1887, Charles S. Kingsley was there to record the historic moment. He sold prints of this picture as souvenirs.

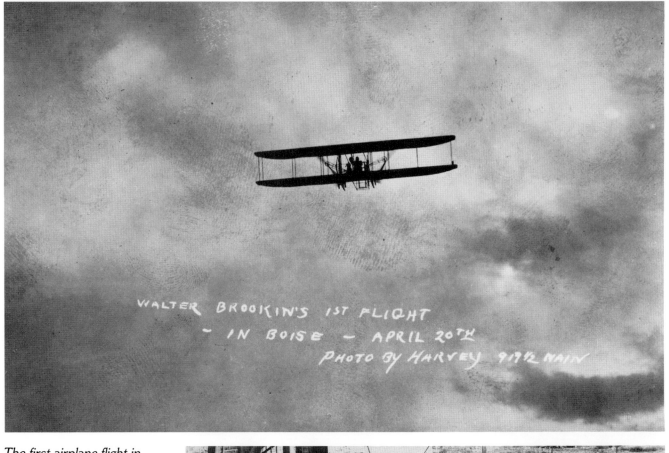

WALTER BROOKIN'S 1ST FLIGHT
~ IN BOISE ~ APRIL 20TH
PHOTO BY HARVEY 919½ MAIN

The first airplane flight in Idaho took place at the Intermountain Fairgrounds, Boise, on April 20, 1911. C. Edwin Harvey took this picture of Walter Brookins in his Wright Brothers biplane.

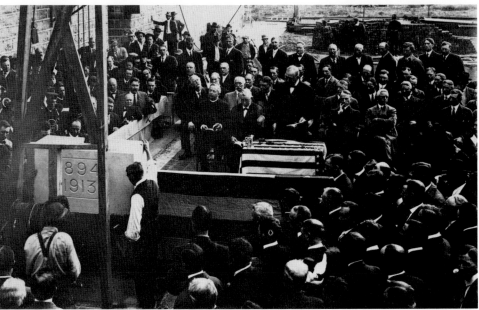

Cornerstone layings were important ceremonial occasions. This photo was taken on September 29, 1913, at the dedication of Boise's new Elks lodge building.

where, and without concerns about the sales value of what they snapped, hundreds of early Idahoans recorded anything that interested them, at times when no professional photographer was around. Amateurs were, because of their numbers, more likely to be on the scene of unexpected happenings than professionals, and often took candid photographs of great historical value.

ISHS 78-130.59

ISHS 1187-A/2

When a portion of the Fort Hall Indian Reservation was opened to settlement on June 18, 1902, this dramatic photo recorded a land rush through the sagebrush.

The construction of Arrowrock Dam on Boise River was recorded in hundreds of photographs. Walter J. Lubken took many of them for the U.S. Bureau of Reclamation.

H. Lee Jellum was on the spot during Nampa's great fire of July 3, 1909. The prominent labeling suggests that Jellum sold prints of this dramatic moment in the town's history.

Kendrick's flood of 1900 was recorded by an unknown photographer. Only four years later the town would suffer a major fire.

DISASTERS

When disaster struck, whether by fire, flood, or avalanche, pioneer photographers were soon on the scene to record the results. In rare cases, as with Nampa's great fire of 1909, action photos were taken during the event—a forerunner of what we have come to expect of news photography in our own day.

The mishaps recorded on these pages range from the tragic, when human lives were lost, to the merely amusing, if the damage was to machinery or human dignity. We even have examples of comic accidents staged for the camera's benefit. In a strictly utilitarian way, photographs of accidents or damage were also used as evidence in court cases.

When the steamer Seattle, *loaded with a cargo of flour, capsized at Coeur d'Alene, every other boat in the area rushed to the rescue, including one with a photographer aboard.*

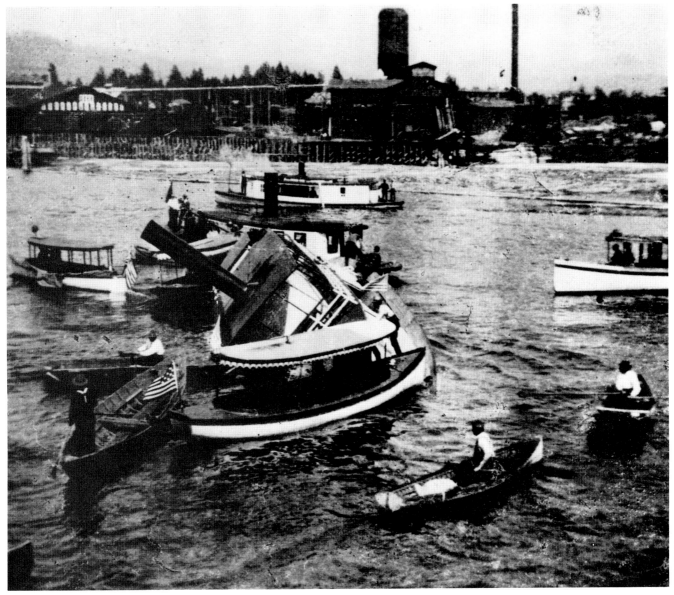

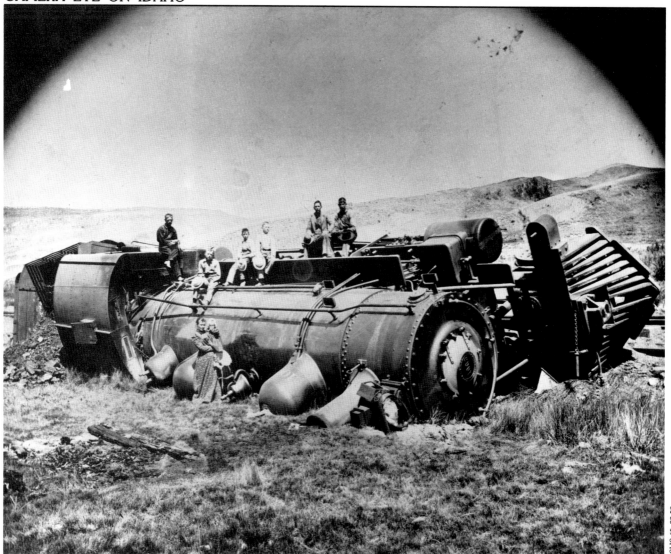

ISHS 65-99.58

When this Oregon Short Line
locomotive overturned near
Montpelier, local people
gathered to pose on the fallen
giant's flanks. The picture
says, in effect, "Look what
happened, and we were
there!"

Forest fires have raged
somewhere in Idaho every
summer since man has been
here, sometimes causing loss
of life and serious destruction
of property.

ISHS 60-83.1

Mace, Idaho, suffered an avalanche on February 27, 1910, that killed 16 people and injured 25. The search for victims was going on when these pictures were taken.

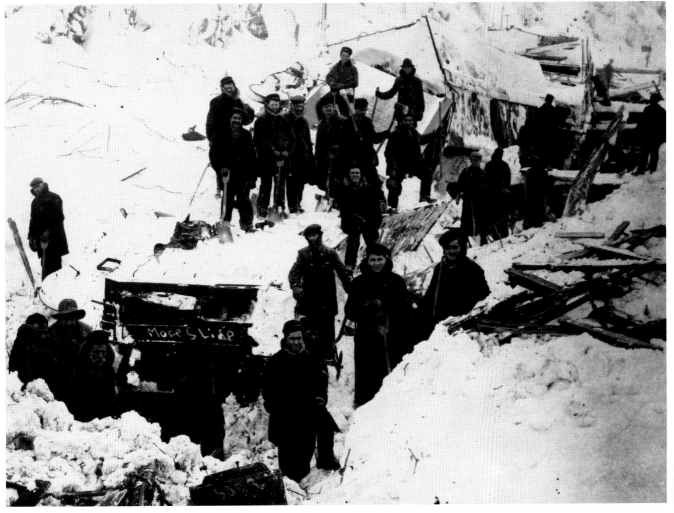

ISHS 80-37

Latah County HS 10-2-2

Kendrick was a sorry sight after the 1904 fire that leveled the business section. The depot still stands, right center.

ISHS 76-64.1/b

The aftermath of a fire between Eighth and Ninth on Main, Sunday morning August 7, 1887, was recorded by Charles Kingsley. John Lemp's saloon was totally destroyed.

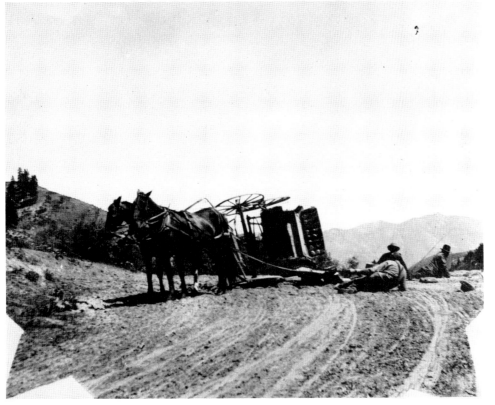

ISHS G-68.108

Charles Beck and friends were responsible for this staged accident scene. It is labeled in his 1897 snapshot album "Turnover Point."

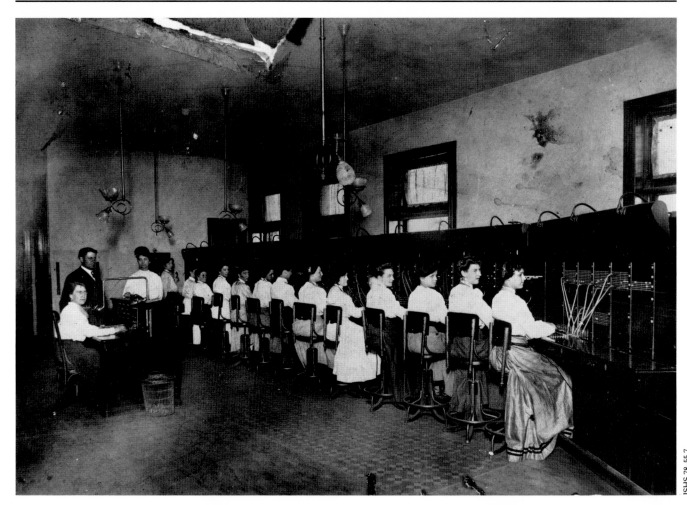

ISHS 78-55.7

Papers of the day called them "hello girls." These telephone operators at Payette at the turn of the century were part of a revolution that took women out of the home and into the commercial world. They received three dollars for a ten hour day at the switchboard.

Only a skilled amateur could have left us this intimate portrait of Mrs. E.A. Bowen before the mirror in her bedroom at Silver City.

ISHS 74-81.1/a

A WOMAN'S WORLD

 Nineteenth century photographs of Idaho women at work and play provide insights into their lives by suggesting some of the spheres of activity considered appropriate for them at the time. However, between 1863 and 1913, the period covered by our study of photography in Idaho, conventional boundaries of women's work were expanding dramatically. New machines in offices, such as the typewriter, the adding machine, and the dictaphone, provided opportunities for regular jobs that women eagerly sought. Telephone switchboards were soon operated almost entirely by women.

Women were paid less than men for most of these jobs, but regular paydays gave them an independence most had never known before. Until office machines revolutionized American commercial life, even well-educated women had few choices for employment. They could teach school, be seamstresses, clerk in stores that handled "ladies' goods," or get married. For most women, a hopefully happy marriage, keeping house, bearing and raising children was the natural and expected way to spend one's life. Sewing machines, washing machines, and carpet sweepers did reduce household drudgery for women, but did not free them of it entirely.

A specialized field in which women did well was photography. Many worked in their own homes, helping photographer husbands along with their housekeeping, but others ran their own businesses and were competent professionals. Of the 438 Idaho photographers identified in this study, 46 are women. It is certain that many others who were married to photographers worked in darkrooms or retouched negatives without ever being mentioned in business directories or the census. A married

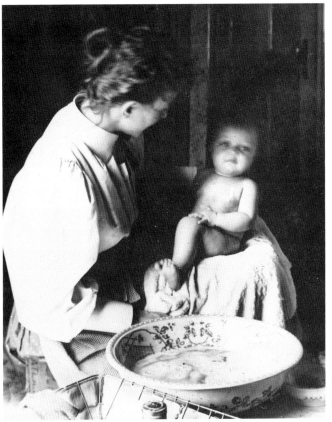

Baby Lucille Lippincott moved when daddy took this picture of mother bathing her at Silver City in the nineties, but it is a charming glimpse of home life worth showing. C.G. Dick d'Easum was the donor.

ISHS 60–139.13

103

woman was almost automatically listed as "keeping house," whatever other skills she might have had.

Many of the photographs in this section, devoted to a woman's world in an earlier Idaho, were taken by women. George Eastman's inexpensive Kodak cameras put photography into the hands of average Americans, and in most homes mothers and daughters became the recorders of family history through "snapshots" that had a charm and spontaneity never equalled in professional studios.

This little girl was having a tea party with her favorite toys when mother took her picture. The other details in the 1890s room are evocative of the time.

ISHS 76-25.38

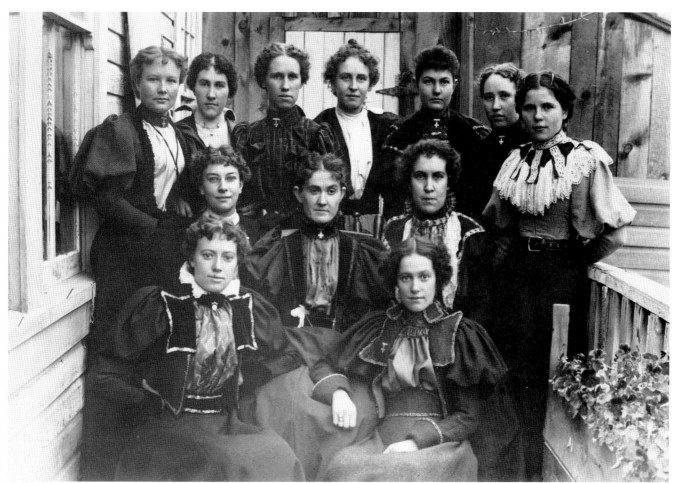

ISHS 60-139.16

ISHS 65-70.8

From the prominently displayed cross-shaped pins these Silver City women are wearing, this is probably a church organization. The photographer may have been the husband of one of the members.

Abbie Stafford, front, and two of her friends show off spectacular hats in the latest style in this Grangeville portrait of the 1890s.

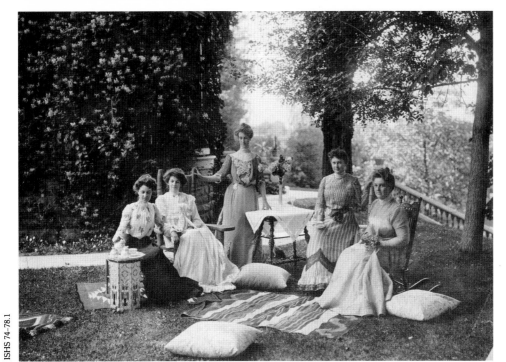

The beautiful Black sisters posed for this sedate tea party picture at the home of Mary Elizabeth Black Ridenbaugh in the late nineties. Mary, for whom Ridenbaugh Hall at the University of Idaho is named, stands at center.

Only moments later the jolly sisters posed for this happy picture, toasting each other with "a bit of the bubbly." They had grown up helping their Confederate veteran father run a stage station on the Kelton Road at Blacks Creek.

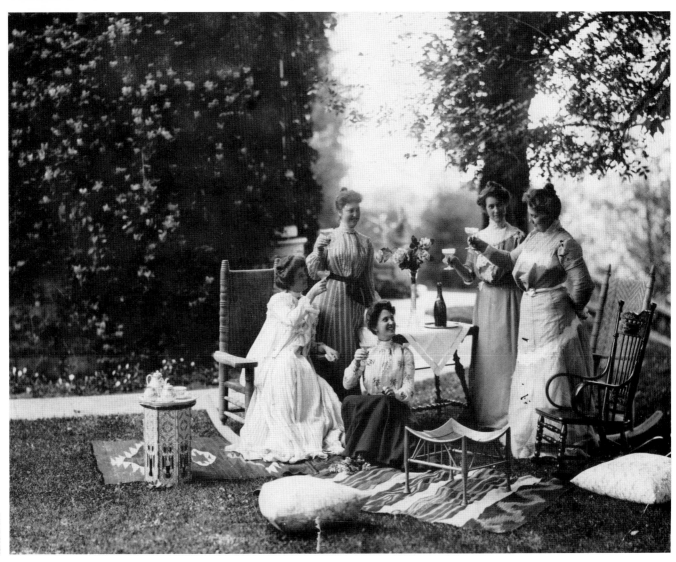

ISHS G 68.46

Amateurs like Charles Beck
recorded scenes of everyday
life as no professional did.
This Boise scene, from the
Beck album, is labeled
"Feeding Her Pets."

These Caldwell matrons put
on a benefit show for the local
library in 1904 entitled Ye
Ancient Dames. The
photographer is unknown.

ISHS 79-2.42

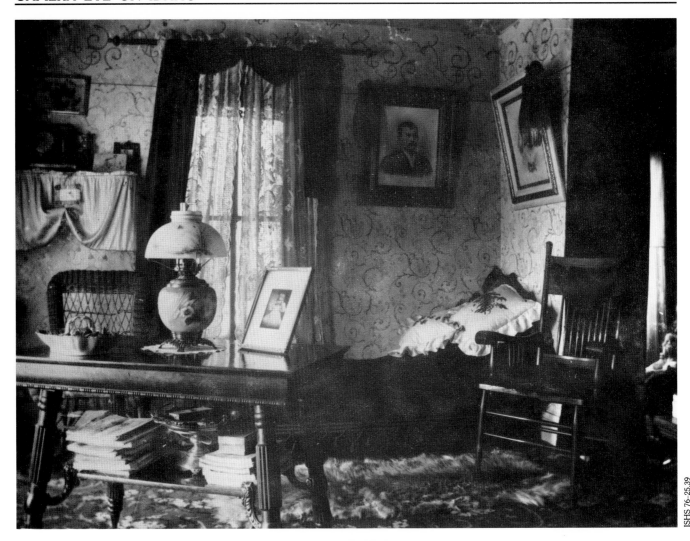

ISHS 76–25.39

Edith Strait Farrer took this
beautifully composed photo of
her parlor at Silver City. The
opulent taste of the nineties is
evident.

This quiet study of a Silver
City woman with her plants
reminds us of the long, cold
mountain winters in which the
home was an oasis of warmth.

ISHS 60–139.22

ISHS 2301

Few homestead kitchens ever looked homier than this one— appropriately enough from Homedale. Loving pride and taste show in every detail.

ISHS 60-139.15

Family pride is evident in this glimpse of a corner of a Silver City parlor in the 1890s. Plants and an ornate Victorian lamp add to a feeling of richness.

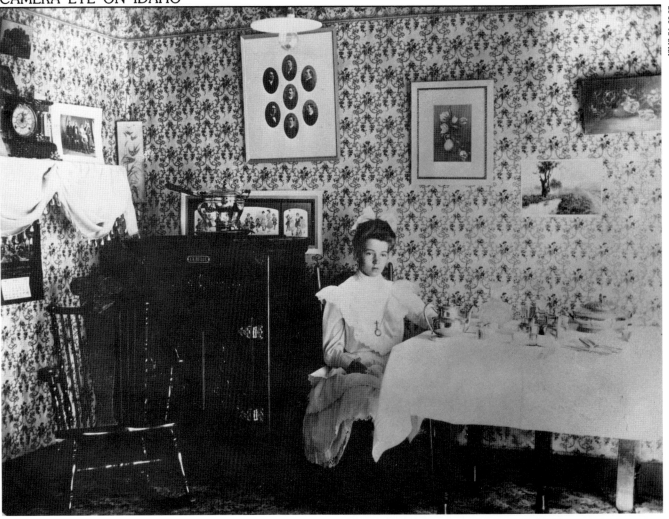

The taste of early twentieth century Idaho is shown in rich detail in this charming interior of the Delamar Home of Dr. and Mrs. Thomas Farrer. Mrs. Farrer, a fine amateur photographer, took the picture of her daughter Cordelia.

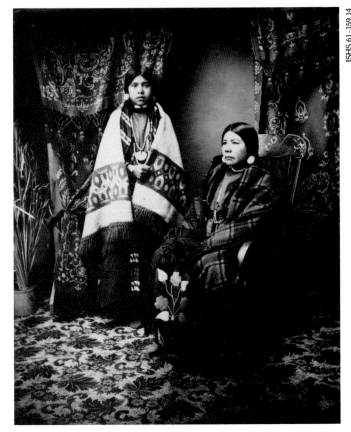

We-Yi-Ya-Tolict and her sister posed in a Lewiston Studio in about 1885 for this opulent portrait. The picture has the pattern and texture of a Matisse.

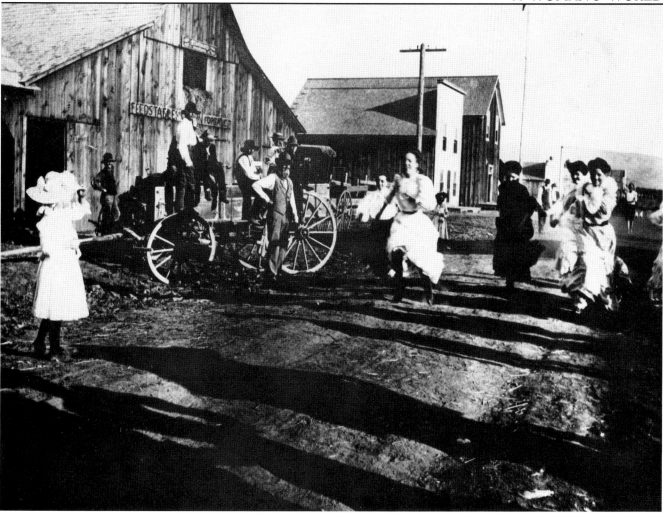

Despite long skirts, these girls enjoyed a lively foot race during Sweet, Idaho's 1902 Fourth of July celebration.

Mrs. Robert Lindsey of Silver City literally "let her hair down" for the photographer— possibly her husband.

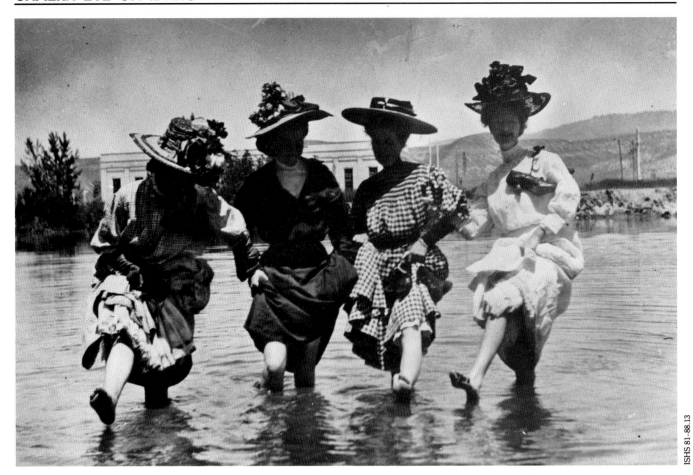

ISHS 81–88.13

These Boise belles were wading at Pierce Park in about 1910 when their amateur photographer friend snapped their picture. Professionals rarely achieved spontaneity like this—nor was that their role.

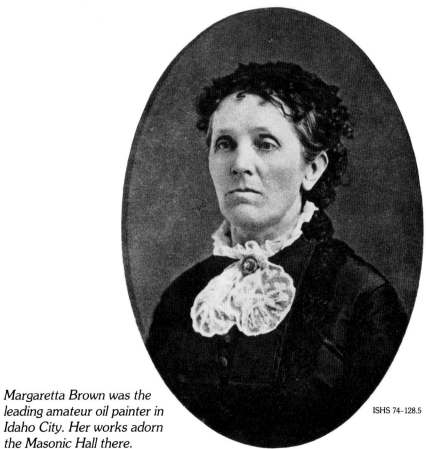

ISHS 74–128.5

Margaretta Brown was the leading amateur oil painter in Idaho City. Her works adorn the Masonic Hall there.

ISHS 75-47 2/E

ISHS 63-238.12

ISHS 61-63.1

Teaching was one of the few professions open to educated women in early Idaho, but they were typically paid only half as much as men teachers.

Mary Hallock Foote was nineteenth century Idaho's most noted writer and illustrator. She produced some of her finest work while living in Boise River canyon.

Cynthia Mann, pioneer school teacher, was a cultural leader and generous benefactor to her community. A new school was recently named for her.

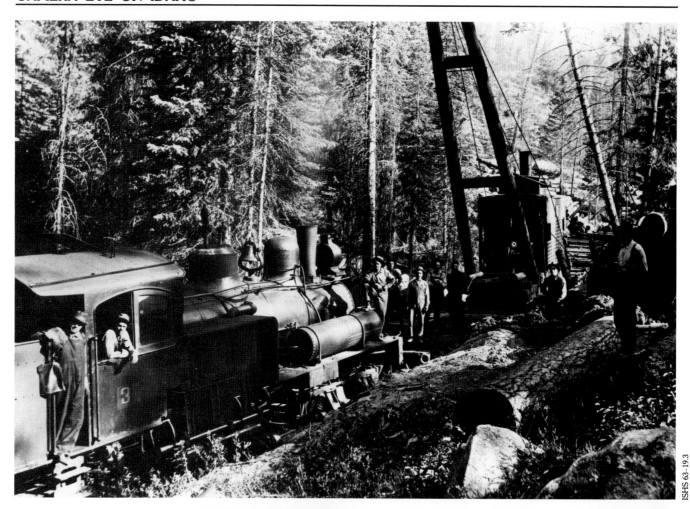

George Tonkin took this Boise-Payette Lumber Co. logging photo in about 1905. The locomotive is a Shay.

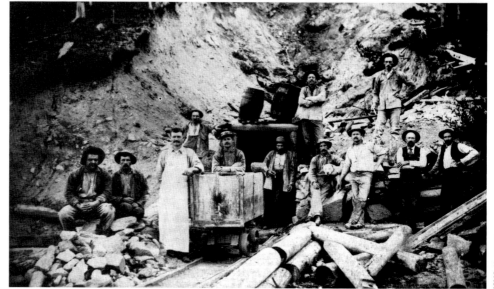

The crew of the Rescue Mine at Warrens posed for this picture in about 1900. The man in the clean white apron is obviously the cook, and not a miner.

A MAN'S WORLD

Photographs that show daily life and work tell us more about Idaho's past than all of the studio portraits put together. The tools and machines, the work clothes and the work places shown in such pictures document changing conditions over time, both social and technological. The selection shown here confirms that there really was a man's world in nineteenth century Idaho rarely shared or experienced by women.

Much of this man's world was filled with hard work, danger, and limited financial security. Miners did back-breaking manual labor, often under conditions that shortened their lives, even without accident or disaster. Farmers worked as hard for a good crop as a failed one, and accidents with horses and machinery could cripple or kill them. Loggers and men who drove logs down rivers to sawmills also lived dangerously, as did cowboys, sheepherders, freighters, and packers.

The social life of Idaho men, especially in the mining camps during their boom days, was largely limited to the saloon and the brothel. The prostitutes who were part of this man's world had no entree to the woman's world of the day. This was a dangerous world, too, for both sexes. Alcohol and drug-induced murders and suicides were all too common. Needless to say, respectable women never saw this world, although they were certainly aware of its existence and of its social cost to society—and sometimes to their own families.

Where there was crime and violence there was also punishment. This, too, was largely a man's world, and photographs recorded the faces and activities of men in prison. The camera became an indispensable tool for documenting crimes and criminals. The

ISHS 70-80.15

Placer mining was decidedly hard work, and not everyone could take it. Getting tiny particles of gold out of gravel bars like this took lots of water and perseverance.

ISHS 68–57.56

Stonecutting was the principal trade taught convicts at Idaho's penitentiary in 1911 when this fine picture was made. Sandstone quarried on the rim above the institution was carved into architectural elements for use in state buildings.

"wanted" poster and the "mug shot" were routinely used by law enforcement officials. At the Idaho Penitentiary in Boise, active from 1872 until 1973, trustees were trained to take portraits of fellow convicts that became a part of the record. Diamondfield Jack Davis and other notorious characters and petty criminals were photographed from the 1890s on. This collection of historic portraits is now housed in the Idaho Historical Society which operates the Old Idaho Penitentiary as a National Register Historic District open to the public.

When Bannock County Sheriff Martin O'Malley acquired a camera in March, 1897, the local newspaper reported that he was "practicing on prisoners in the court jail with a view of starting a rogue's gallery. The result of some of his work looks as though the originals might be guilty of any crime. Jailor Ross and Chief of Police Ellis, in O'Malley's pictures present countenances that are hardly distinguishable from the fellows whom they are guarding. They blame Mart, but he blames the Kodak."

R. I. Mills. 𝘖𝘈𝘒𝘓𝘌𝘠, IDAHO.

Jackson Lee Davis was better known as Diamondfield Jack—with a name and reputation that nearly got him hung for a crime he didn't commit. Richard I. Mills had a studio at Oakley for several years before moving to Burley.

A fellow convict at the Idaho Penitentiary probably took this "mug shot" of Diamondfield Jack Davis during his stay there. Upon his release Jack went to Nevada and struck it rich in mining.

The calendar at left tells us that it was 1907 when the gleaming dark-wood interior of Samuel Parrott's cigar store was photographed. The address was 807 Main Street, Boise.

ISHS 73-75.1

Silver City had a combination barber shop and billiard room when this early twentieth century picture was made.

ISHS 73-88.4

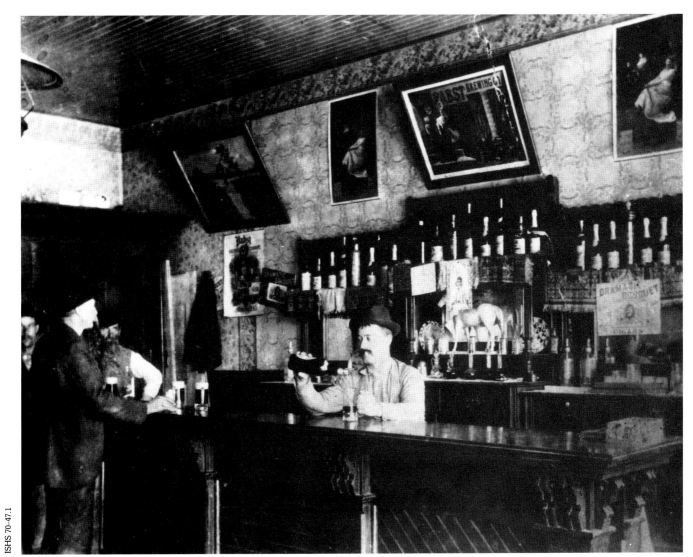

ISHS 70-47.1

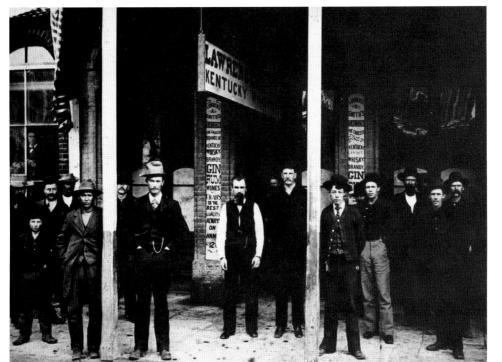

Saloon pictures document the important role this social and recreational institution played in the lives of Idaho men. Women were not allowed in most of them—at least not respectable women.

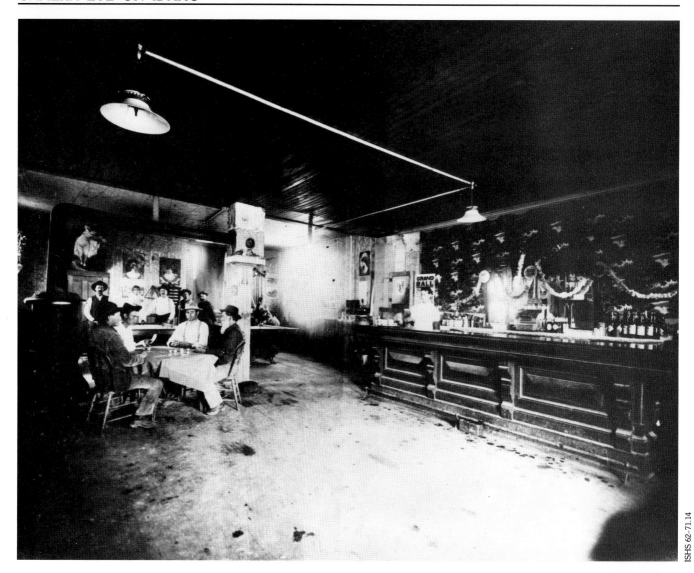

ISHS 62-71.14

This spacious saloon at Van Wyck had room for a big bar, pool tables, and a poker game. A.M. Ley who took the street scene of Van Wyck shown elsewhere may have taken this as well.

ISHS 72-229.2

The camera was used for documentation and identification of criminals soon after its invention. This is one of hundreds of such pictures made at the old Idaho Penitentiary early in this century.

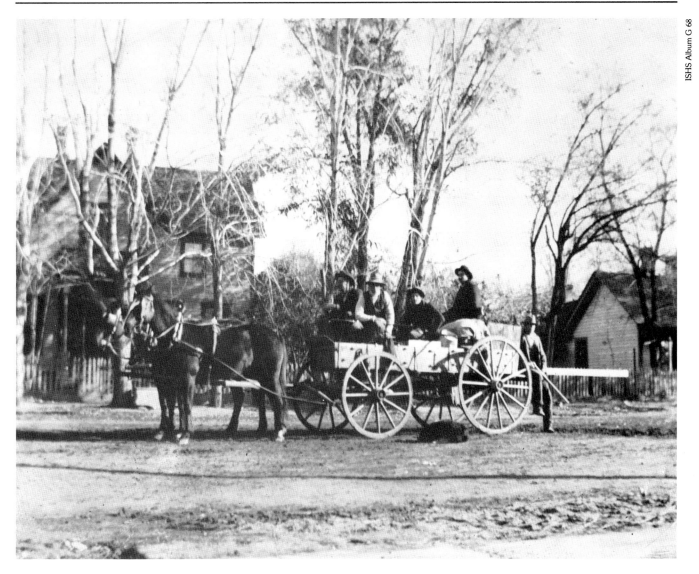

These Boise men were off on a hunting expedition in 1897. Amateur photographer Charles H. Beck left a delightful album of prints made in 1897–98, others of which are reproduced in this book.

The skill of convict stone cutters is clearly shown in this 1894 view of Warden James Campbell's son in front of one of the guard turrets.

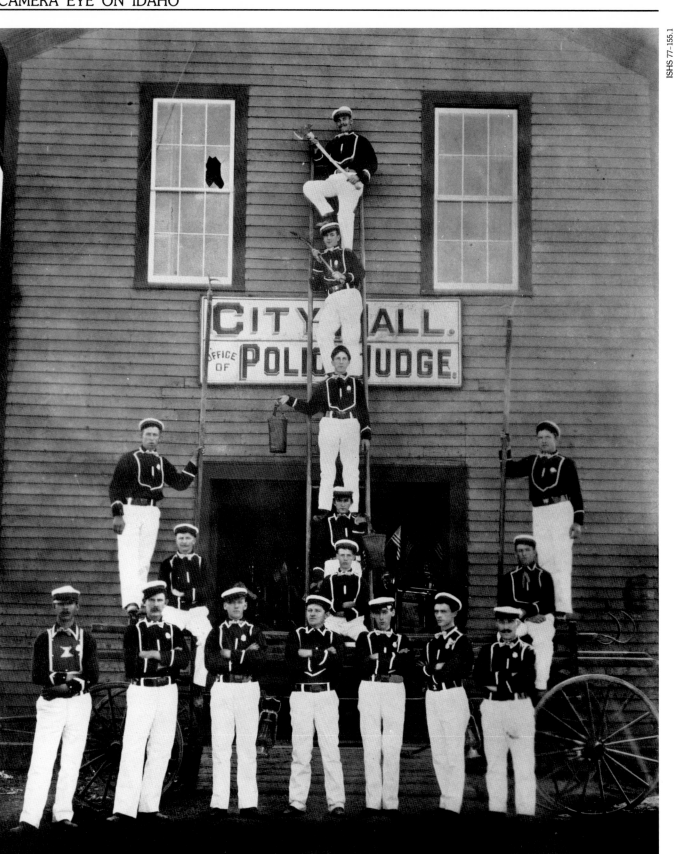

*Pocatello's fire department
struck a dramatic pose for
this 1896 portrait.*

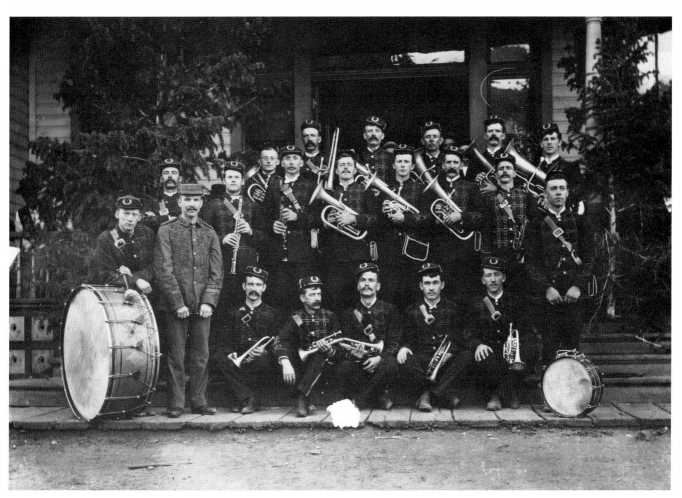

ISHS 77–147.1

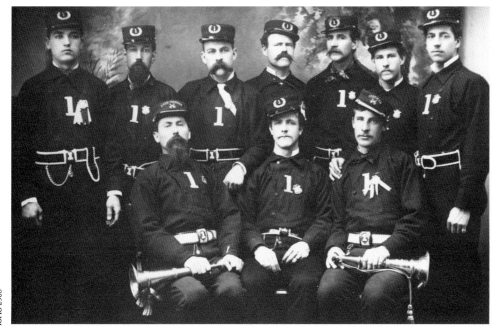

ISHS 290b

Delamar's town band posed proudly in new uniforms in about 1900. The musicians were all miners by trade, but obviously had other talents.

Bennett & Messereau had a Boise portrait studio in 1885 when they photographed members of Engine Company No. 1 of the volunteer fire department. Theo Milleman, seated at right, was foreman.

ISHS 60-65.79

Boise City's Royal Arch Masons posed in front of the Territorial Capitol shortly after its completion in 1886. This print was made from an R.H. Sigler copy of an early photo. He, like other Idaho photographers, advertised copying of old pictures as a special skill.

ISHS 79-95.11

"The Tigers of Emmett" says the inscription on this 1906–07 picture of the town's outstanding high school team. They had a bitter rivalry with Boise High that season, but won the final game of the series.

ISHS 72-92.1

Caldwell's baseball team had just won the unofficial state championship when this 1891 picture was made. Top-hatted Charles Reed, center, was the manager.

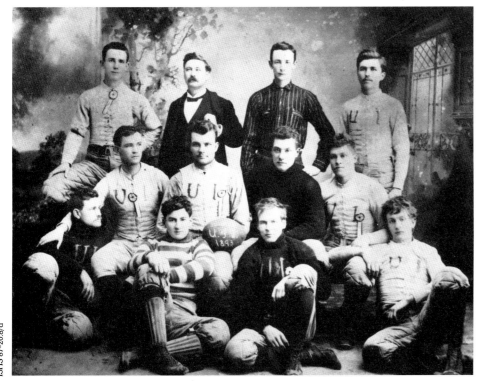

ISHS 87-20.8/d

Moscow's pioneer photographer Henry Erichson did a good business at the University of Idaho. This is his portrait of the 1893 football team.

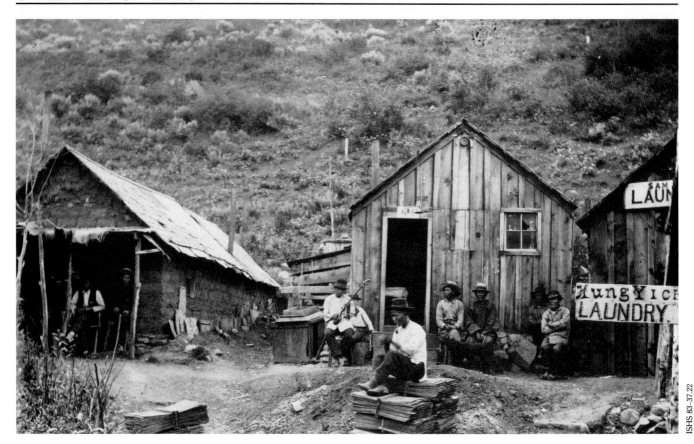

This rare photo of Delamar's Chinatown has a wealth of detail. The men seem to be listening to a countryman, center rear, who is playing a three-stringed guitar called a san hsien.

Idaho City's Chinese pioneers worked hard to survive. This old-timer was one of the last to roam Boise Basin with the familiar basket carrier.

T. J. Pilliner. Will Johnson

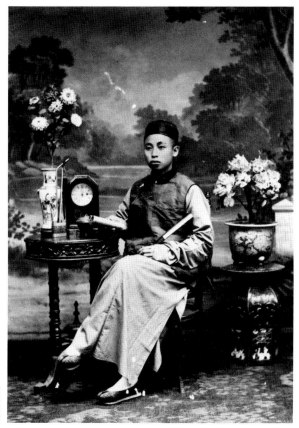

Frederick J. Pilliner learned
photography from his father
William H. He had studios in
Ketchum in 1889–90, and in
Silver City in 1891–92. This
photo of W.J. Turner's brick
yard at Mountain Home is
undated.

Gwong Louie, sometimes
called Louie Quong, was a
popular young Chinese in
early Boise. He gave this
photo to a white teacher he
admired.

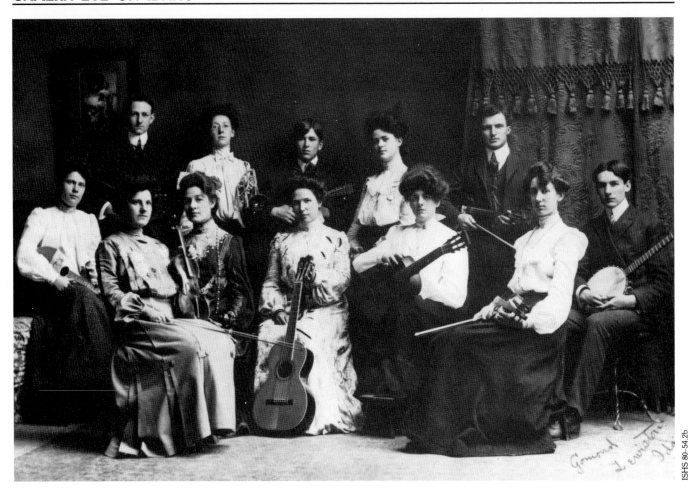

Joseph W. Gomond, a Lewiston photographer born in French Canada, took this formal portrait of Lewiston Normal School's orchestra. Gomond later moved to Wallace where he was in business for many years.

From formal to informal: These Caldwell young people are eating with gusto.

BOYS AND GIRLS TOGETHER

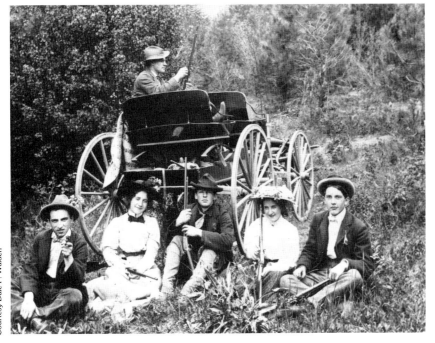

The fashionable young set of Boise's social elite posed on the front steps of Thomas Jefferson Davis' Victorian house in the late nineties. Davis made his fortune in fruit culture and real estate.

Some of the same young Boiseans took to the hills for a shooting outing. The pretty daughters of merchant Nathan Falk brought rifles too.

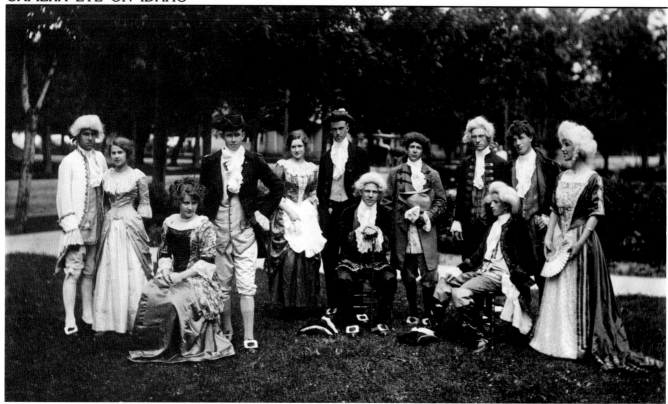

ISHS 76-126.1

Boise High School students presented Sheridan's eighteenth century play "The Rivals" the year this group picture was taken.

Courtesy Dale F. Walden

Clowning for the camera was popular with Boise's young set when this picture was snapped in the late '90s.

ISHS 76-25.26

Little Tommy Farrer was surrounded by pretty girls when his mother took this Delamar snapshot.

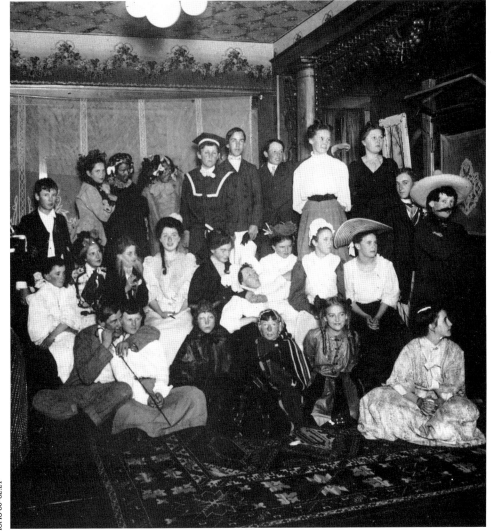

ISHS 80-82.21

This young people's party in Idaho Falls was a costume affair, and apparently great fun for all. The opulent decor of the room is impressive.

These Kendrick folks were proud enough of their own little Garden of Eden to be photographed there on October 2, 1896.

The striking contrast in size between tiny Grace Taylor, Council telephone operator, and big Bill Winkler, Sheriff, makes this picture memorable. She is wearing his six gun, another incongruous element.

This obviously posed picture in Billy Coltharp's saloon at Hagerman must have been inspired by Wild West movies of the early 1900s. The lighting effects are unusually beautiful.

ISHS 80-86.3

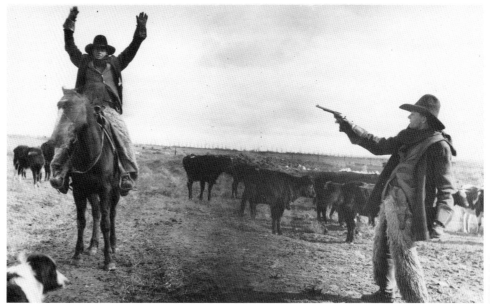

More "Wild West" fun was had by these two cowboys staging a mock holdup for the camera.

ISHS 60-52.64

Photography allowed ordinary people to have special moments in their lives recorded, and to preserve visual memories unlike anything known before. Turning the pages of the family album was a way to see people and places from the past exactly as they had looked at the second in time when the photographer clicked the shutter. Loved ones far away or long dead could be seen as they had been—a powerful stimulus to memory and emotion.

The unique quality of photographs to speak directly to us, and to persuade us of their truth, made them an unparalleled documentary tool. They were more vivid and realistic than the work of artists in other media, and in fact, led visual artists away from realistic portraiture into more expressive and creative styles. It no longer seemed worthwhile to labor for days or weeks over a portrait in oils, for example, when a photographer could produce a more realistic one in minutes. Portraits in oil were available only to the wealthy. The photograph was available to millions at a reasonable cost.

George Eastman's invention of the Kodak, and a system that permitted any amateur to take pictures without learning to use chemicals and a darkroom, revolutionized photography and went much further toward making the medium available to all. "You push the button, we do the rest," was the advertising slogan that helped sell Eastman's new portable box camera, introduced in 1888. It came loaded with a roll of flexible transparent film with a capacity of 100 exposures, complete with leather carrying case and shoulder strap, for twenty-five dollars. When the roll was finished, the unopened camera was mailed to Eastman for developing and printing. Negatives, prints, and a reloaded camera were returned, and there-

ISHS 80-54.24

This young Lewiston man was captured by another amateur photographer as he aimed his box camera.

ISHS G-68

Charles A. Beck, amateur photographer and volunteer fireman, took a number of pictures of his friends behind Boise City Hall fire station in 1897. Here are two of them.

ISHS G-68.85

Beck labeled this staged bicycle collision behind Boise City Hall "An uncordial meeting."

after the customer paid only a fee for developing and reloading. A fixed focus lens and the relatively fast shutter speed of 1/25 of a second made the system nearly foolproof, if the operator remembered to hold the camera steady and to keep the sun at his back.[1]

Photos taken with the first Kodaks are easy to recognize since they are circular. Kodak No. 1 took pictures 2½ inches in diameter; Kodak No. 2, 3½ inches in diameter. The simplicity of Eastman's system persuaded millions of people to buy the inexpensive Kodaks in the next few years, but the 100 exposure roll took too long to use up and was soon replaced with shorter ones that users could load and unload themselves. Film also became available at the local drugstore, and could be left there for processing.[2]

Chinese New Year was the occasion for this Boise scene recorded by Beck in 1897. Two Caucasian visitors to Chinatown seem to be asking about some of the Oriental delicacies being offered, including a roast pig.

ISHS 2449

The occasion for this gathering in front of Silver City's post office is unknown. As was often the case in such early street scenes, a dog figures prominently.

Amateurs with the wonderful new device could, and did, photograph everything around them. Although some timidly limited their picture-taking to lining up family and friends in stiff groups, at a distance that made them hard to recognize, others took advantage of the portable camera's small size to record candid, unposed moments in daily life, parades, and special events. When a visiting celebrity appeared in Idaho many an amateur camera was pointed at him, in the hope of preserving a memorable moment. The camera was also taken along on vacation trips, and used to record incidents along the way, including flat tires, trout that were caught, and picnics under the trees. Clowning for the camera became popular too, in striking contrast to the solemnity of earlier studio portraits, in which a smile is rarely seen.

ISHS 76-25.10c

Edith Strait Farrer captured a bit of local color at Delamar when she photographed a firewood peddler.

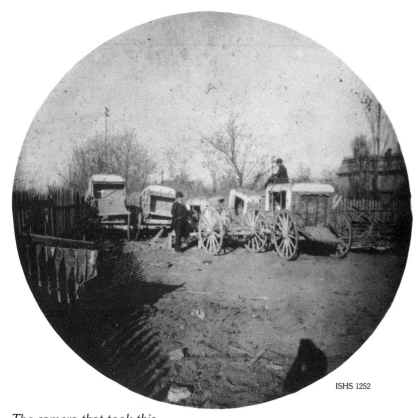

ISHS 1252

The camera that took this scene in Boise's Overland Stage Yard had to have been a Kodak No. 1, since the original print was circular with a diameter of 2½ inches.

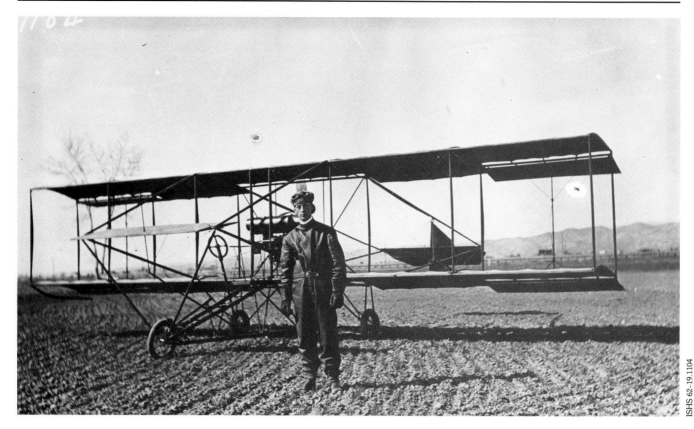

Rupert Shaw, outstanding
Boise amateur photographer,
took this picture of aviator
Eugene Ely at the fairgrounds
with his Glenn Curtiss pusher-
type plane. He flew with
Walter Brookins in Idaho's air
meet in April, 1911.

The Shaw family toured Idaho
in a 1912 Winton, visiting
remote places like Silver City,
despite rough road conditions.

Flat tires were a common
mishap on the rough Idaho
roads of 1912. "Shaw Sr. and
tire trouble" was Rupert
Shaw's inscription on this
snapshot.

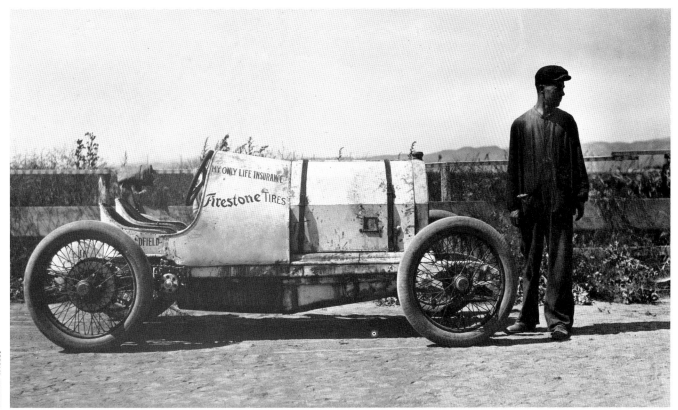

ISHS 62-19.1116

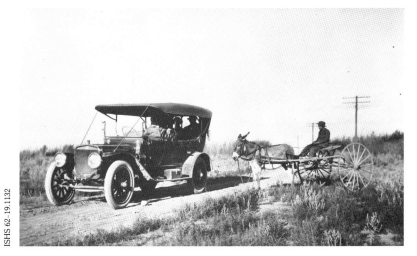

ISHS 62-19.1132

When Barney Oldfield,
famous race car driver, came
to Boise in 1911, schoolboy
Rupert Shaw snapped this
picture of his machine with a
Firestone tire ad. The
mechanic at right appears to
be drenched in oil.

The Shaw family encountered
this donkey cart while out for
a spin in the sagebrush—an
interesting meeting of new
and old.

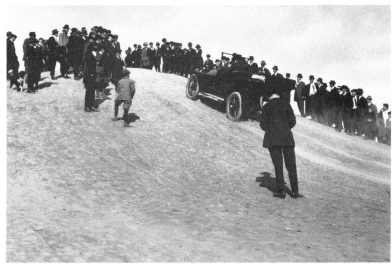

ISHS 62-19.1136

Hill climbing was a popular
test for early automobiles.
Rupert Shaw, who loved to
record the new motor age,
took this snapshot near what
is now the Highlands in Boise.

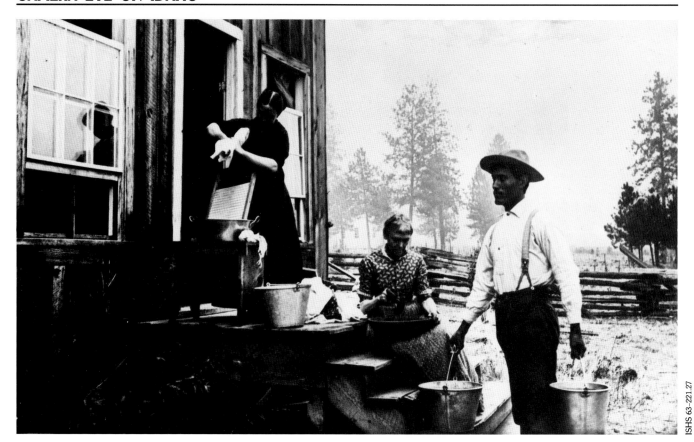

When Alice C. Fletcher, left, was sent to the Nez Perce Reservation in 1889 to arrange allotments of land to individual members of the tribe, she was accompanied by E. Jane Gay, center, a skilled amateur photographer. Jane styled herself "The Cook," but was much more than that. Her pictures are an outstanding record of that 1889–92 expedition.

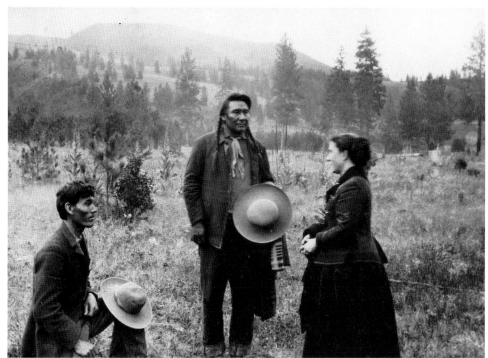

James Stewart, Chief Joseph, and Alice Fletcher. Photo by E. Jane Gay.

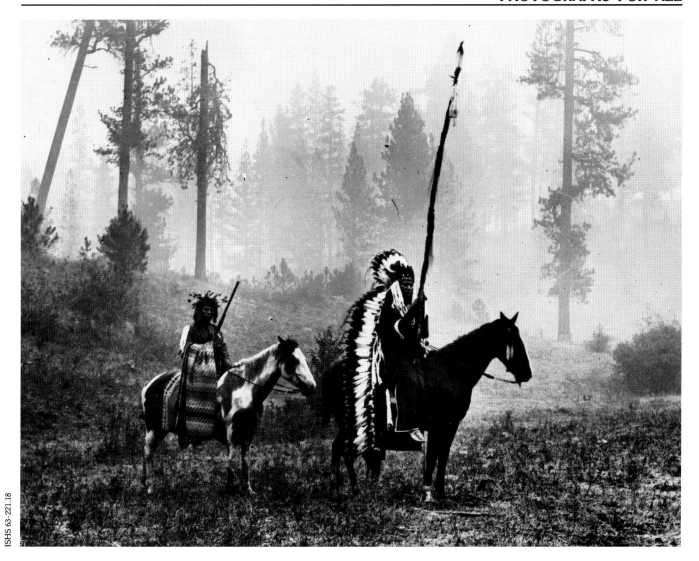

"War Poles" is one of Jane Gay's most beautiful prints, evoking a romantic view of the Nez Perce past.

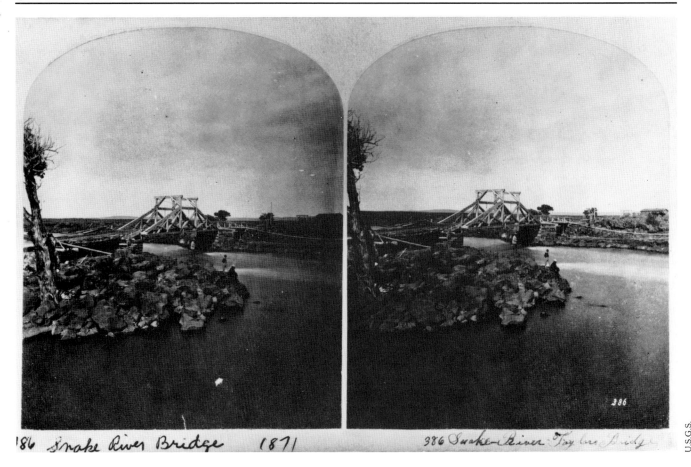

86 Snake River Bridge 1871 386 Snake River Taylor Bridge

U.S.G.S.

William Henry Jackson took this stereo view of Matt Taylor's 1865 wooden bridge across the Snake River at what would later be called Eagle Rock, and then Idaho Falls.

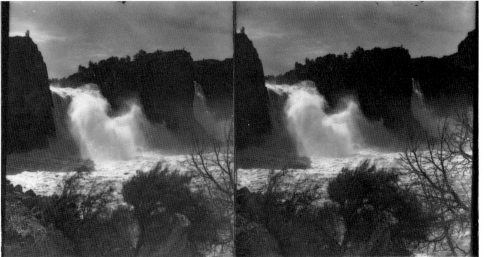

Courtesy Bruce and Velma Koch

Joseph P. McMeekin, Irish-born pioneer landscape painter, lived on Millet Island with his sister and her husband, Liberty Millet. He briefly ran a photo studio in Hagerman, Idaho, at which time (circa 1910) he took this stereograph of Twin Falls.

STEREOGRAPHS

We are able to perceive depth in nature because our eyes are spaced to give two different views of what is before us. Photographers learned to create three dimensional pictures early on by taking paired images with cameras having twin lenses spaced two and one-half inches apart. When seen through a twin-lensed viewer, called a stereopticon, the illusion of depth was dramatic. So delightful was the new discovery that millions of stereographic photos had been taken by the time people settled in Idaho, and by the 1890s many Idaho families owned collections of the card-mounted views and a stereopticon. Friends and families gathered to see the latest acquisitions, and to marvel at the wonders of the world now available in commercial sets.

As early as August, 1865, E. & H.T. Anthony & Co. of New York City were advertising in the *Owyhee Avalanche* of Silver City "Stereoscopes and Stereoscopic views. Of these we have an immense assortment, including War Scenes, American and Foreign Cities and Landscapes, Groups, Statuary, etc., etc. Also Revolving stereoscopes, for public or private exhibition. Our catalogue will be sent to any address on receipt of stamp."[1]

The earliest Idaho stereographs that can be definitely dated were those taken by William Henry Jackson while in eastern Idaho with the Hayden Survey in 1871–72, but he later returned to make many more for the series of Western views he sold nationally.[2] M.M. Hazeltine, who had lived in Boise City before moving to Baker City, Oregon, in the 1880s, also traveled widely to produce and market a series of stereographs he called "Gems of the Pacific Coast." Amateurs as well produced the pleasing three dimensional pictures, some no doubt with the hope of selling them. Joseph P. McMeekin of Hagerman, a talented oil painter, briefly tried photography and produced some stereographic views,[3] as did George Langmaid of Boise. Dale Walden has in his extensive collection Idaho stereographs by the Universal Photo Art Co. of Philadelphia, by Julia A. Condit of Malta, Idaho, and by a company that labeled its series simply "American Views." The Idaho State Historical Society has stereo mounts of Idaho subjects by the Keystone View Co., with worldwide offices, and of O.W. Watson, Spokane.

Perhaps the most active publisher of stereoscopic views in Idaho in the early twentieth century was Olaf P. Larson of Squirrel, Idaho, a small farm community southeast of Ashton that once had a post office. The Walden collection has several examples of Larson's work.

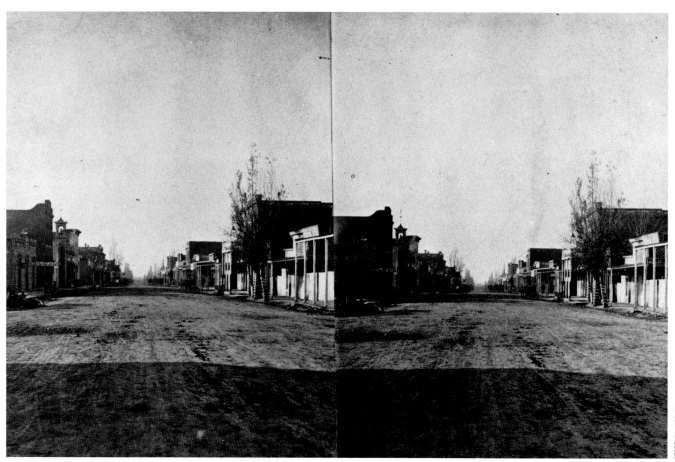

ISHS 76-138.66

Charles S. Kingsley's stereograph of Boise's Main Street was taken in November, 1881. An enlargement of one of these stereo pairs appears in Chapter V.

ISHS 76-138.62

Kingsley may have taken this stereo of Boise's First Methodist Episcopal Church in November, 1881, although its mount bears no label. The season is right, in any case.

PANORAMAS

 Lewiston was one of Washington Territory's youngest towns when a panoramic view of it was made in 1862. To get the wide-angle effect desired the photographer used a technique employed by amateurs ever since— he took three separate photographs and mounted them together to create a continuous picture.[1]

Wide-angle lenses, specially ground for the purpose, could take in up to 180°, but with a distortion of what the eye normally sees that was disturbing. The wider the angle the greater the distortion.

Cycloramas, paintings that encircled the spectator, had been popular with the public since 1840, and in the 1880s a camera was invented that could produce single-exposures of 360°, or such lesser arcs of a circle as might be desired. This panoramic camera was powered by a key-wind clock motor to turn a complete circle while roll film inside was geared to pass in the opposite direction past a slit aperture. The amount of exposure was controlled, not by a shutter, but by adjusting the speed with which the camera turned. The resulting negatives, as much as nine inches wide and several feet in length, were contact-printed to produce a continuous panoramic photograph, without distortion and with remarkable clarity of detail.[2]

A number of Idaho photographers had panorama cameras after the turn of the century, but the most dramatic examples of the genre to have survived were taken by F.J. Bandholtz of Des Moines, Iowa. He visited Idaho Falls, Blackfoot, and Pocatello in the summer of 1909, set up his camera at the principal downtown intersection in each of those cities, and took 180° views that are historic documents of great importance. It is hard to imagine any other technique that could place us on the streets of those eastern Idaho towns more vividly, or convince us more persuasively of the camera's power as a "time machine."[3] Even the added dimension of motion, achieved with Edison's invention of the kinetoscope, could not at that time equal these still photos. Early movies were flickering and unnatural in their effects, and audiences had to "suspend disbelief" to a remarkable degree to think them true to life.

The panoramic view, with its all-encompassing detail, is like nature itself. Within Bandholtz's photos of Idaho towns are countless details than can be examined with a magnifying glass or isolated into vignettes of specific interest. Whether we wish to study vehicles, people, buildings, advertising, or businesses, it is all there, just as it was at a precise moment in 1909. This may be as close as we can come to being in another place in another time.

William Judson Boone, founder of the College of Idaho in 1891, and its president until 1936, was an avid amateur photographer. He acquired a Cirkut panoramic camera early in the century with which he took photographs of the student body for many years, with the entire

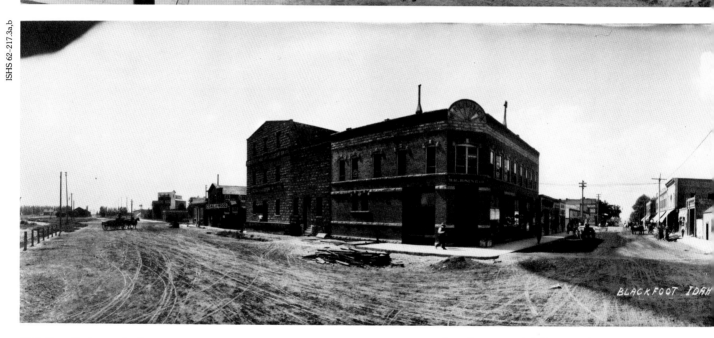

F.J. Bandholtz took these remarkably detailed panoramic street scenes of Idaho Falls, top, and Blackfoot, above, within a few days of each other.

campus as background. The students formed a circle around the spring-driven camera and waited for it to make its pass—that is, most of them did. It did not take long for a few mischievous undergraduates to discover that they could appear several times in the same picture by running ahead of the slow-moving camera and bobbing up in the back row again and again. Some were captured in motion attempting this trick and others who made it have decidedly silly looks on their faces.[4]

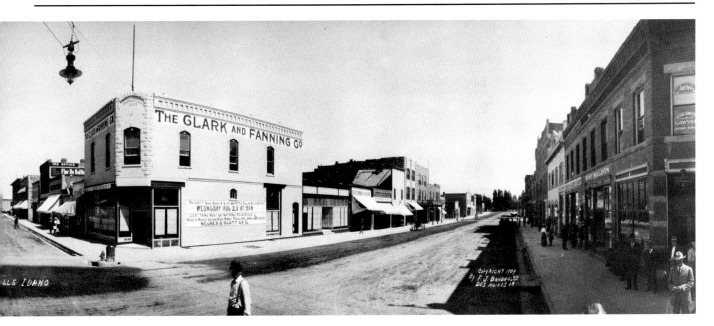

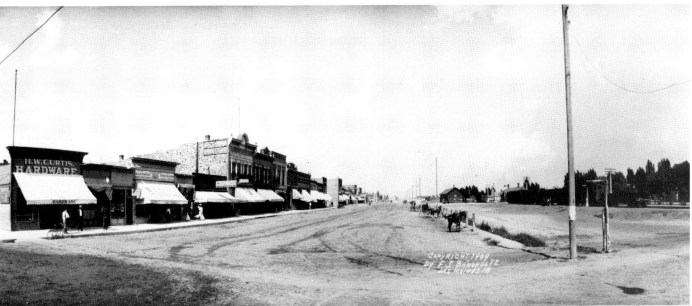

James Grover Burns of Boise owned this Eastman Cirkut camera. It turned by a spring driven motor, with variable speeds produced by geared wheels of different sizes.

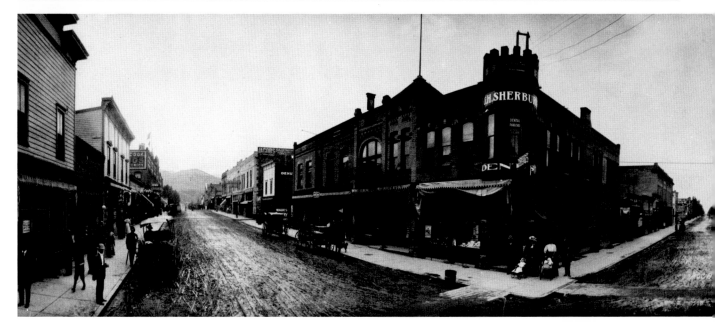

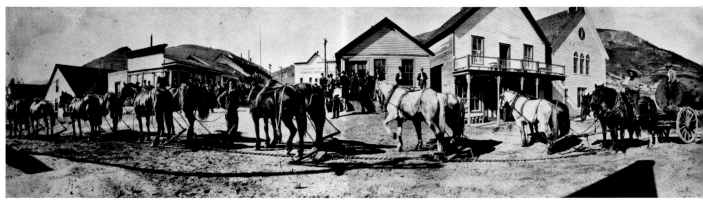

ISHS 3283

Bandholtz's view of Pocatello, top, like those pictured earlier, was made in the summer of 1909. One of the state's earliest "horseless carriages" appears on the street, center left. H.C. Myers of Boise took the street scene of Silver City, above.

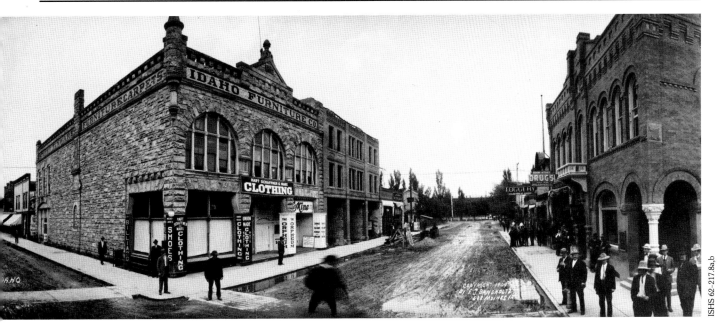

PANORAMAS FROM THE AIR

Photographs were taken from balloons as early as 1858,[5] but aerial photographs of Idaho subjects were not taken until after the turn of the century. There were hot air balloon flights at Boise's Natatorium in 1892, but their purpose was not photographic. A daring "aerialist" ascended high enough to jump out in a parachute.[6] Apparently no local photographers asked to go along for picture taking, since accounts of the occasion do not mention it, and no such photographs have survived.

1909 was a big year for aerial views, however, just as it had been for other panoramas. In April George R. Lawrence of Chicago took photographs of the Lost River irrigation project at Arco from a captive balloon.[7] An August report said that H.V. Lee had taken views of Boise with his "kite camera" and that he had been "work-ing the entire state."[8] When C.L. Huntington came to Boise in December his box kite was described as ten feet long and five and one-half feet high. A kite of that size was able to support the weight of a camera and had enough stability to permit exposures without blurring the image. The shutter was triggered by a line to the photographer's hand on the ground.[9]

Other kinds of "bird's-eye views" have long been popular with cameramen. A surprising number of such pictures were taken from the top of Idaho's capitol dome during its construction, 1905–08, and views of many other Idaho towns have been made from nearby elevated spots. Scenic photographers especially, like A.F. Thrasher, mentioned earlier, would go anywhere to get a good vista.

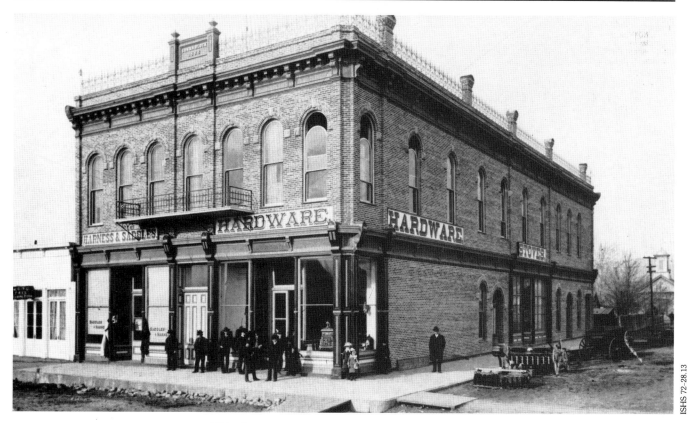

ISHS 72-28.13

Sonna's Opera House was home to early lantern slide and stereopticon shows, and in the 1890s, presented some of the first motion pictures seen in Idaho.

ISHS 3742

Audiences at early movies could read the ads of local merchants while waiting for the show to begin.

PUBLIC ENTERTAINMENT XVII

Photography, as public entertainment that could be viewed by numbers of people simultaneously, came to Idaho early. The miners of Idaho City were treated on December 3, 1864, to "views of scenery by land and sea, of the principal cities of historic interest, of many noted buildings and objects, and portraits of distinguished men." The show was considered a success "notwithstanding some defects in the machinery by which some of the beauties of the various scenes were lost."[1] The performance at the Forrest Theater, made use of "The Drummond Light, Alias the Great Panoptique" to project photographic images on a canvas screen. Thomas Drummond's invention of the 1820s produced a powerful light by the incandescence of lime in an oxyhydrogen flame, and was also known as "lime light" or "calcium light."[2]

Magnesium light was used for stereopticon showings at the Jenny Lind Theater in Idaho City on October 13 and 14, 1866. A large audience saw forty scenes of the just-concluded Civil War, and views of Yosemite, Salt Lake City, and other parts of the United States. Foreign views included Egypt, France, Germany, Great Britain, Hawaii, Italy, Spain, Switzerland, and Turkey. The stereopticon was a double slide projector invented in 1863 that allowed one image to dissolve into another.[3]

Professor Robert Mobley exhibited stereopticon slides to Boise audiences in the 1880s,[4] and by the 1890s the "magic lantern" show was a popular form of entertainment and instruction, not only in theaters, but in schools and churches. Some of the same national companies that had produced stereographic views of world landmarks and scenery, now offered the same images as lantern slides.[5]

In addition to popular travel pictures of the Holy Land, Europe, and Asia, series were now developed that illustrated a story, either read by a narrator or sung with musical accompaniment. Sentimental ballads of the day were favorites, such as one about a young beauty who married for money, only to become "a bird in a gilded cage," whose "beauty was sold for an old man's gold." Another, popular with a generation that still had poignant memories of the Civil War, featured a dying soldier's last thoughts of home and mother as he expired on the battlefield.[6]

Idaho photographers produced lantern slides in the early twentieth century, often used to promote immigration into the new irrigated lands of the southern part of the state. Scenic wonders, especially Shoshone Falls, Idaho's famous "Niagara of the West", were produced for national distribution.

By 1913, when this account of pioneer photography over Idaho's first half century ends, motion pictures were well on their way to surpassing in popularity most other forms of public entertainment. Thomas A. Edison invented his "kinetoscope" in 1889,[7] and by the late 1890s movies were being shown in Idaho. A January, 1897, kinetoscope shown in Boise of a "lynching bee" was so realistic that spectators were given "a spell of the horrors."[8] A showing of *The Empire State Express*, *Captain January*, and *My Wife* later that season "elicited hearty applause from the audience for (its) lifelike appearance."[9] In 1898 Edison placed an ad in Idaho newspapers saying that he had leased "the machine known as Edison's Projectoscope for the entire Western states, to Mozart, McNeil & LaPoint, for a term of one year" and that "all others using my name are impostors."[10]

ISHS 72-39.8

Boise's Pinney Theater, built in 1908, was one of the first in Idaho designed for motion pictures as well as stage presentations.

Motion pictures were shown, at least occasionally, in most Idaho towns by 1913. Opera houses, lodge halls, and store buildings became movie houses, often known as nickelodeons, since admission was usually five cents. Although movies shared programs with vaudeville acts and traveling theatrical companies in the early years, they would eventually put most of them out of business. Live entertainers could hardly compete with the cheap motion pictures and their variety of visual effects and locations. By 1913 weekly movie going had become a habit for many Idaho families. Few, if any, Idaho photographers made movies in the era covered by this book, although in future years the state would serve as the location for a number of Hollywood films.[11]

TABLES

The following alphabetical listing of all professional photographers known to have worked in Idaho between 1863 and 1913 was derived from state and regional gazetteers, city and county directories, newspaper items and advertisements, and from a painstaking search of all available U.S. Census records from 1870 until 1910. Since the 1890 individual census records were destroyed in a 1923 Washington, D.C. fire, this critical gap has had to be filled from other sources. Undoubtedly many who worked in Idaho in the ten year periods between censuses (or the twenty years between 1880 and 1900) were never recorded at all. And, since gazetteer listings required payment of a fee, some photographers known to have worked in Idaho at the time these were published were not included.

Newspaper references to photographers are closely related to the amount of advertising space they bought. When a new ad appeared the photographer was usually mentioned in the local news columns. Some, who never advertised, were never mentioned, at least not in connection with their professional activities.

A number of men and women who gave their occupation as "photographer" to the census takers are not to be found in business directories of the same date. This suggests that they were working in someone else's studio, were unemployed, or were working at something else when enumerated. They might still have chosen to list photography as their true profession. A complete listing of gazetteers and directories used in this compilation follows in the bibliography.

Some listings were derived from photographs in public or private collections that bear the photographer's imprint, but for whom we have been unable to find any other information. In those cases approximate dates are given, based upon the style of the photo mount and the costume of the subject.

A second table, organized by Idaho town, lists chronologically photographers known to have worked in each up to 1913. Many, of course, worked long after our arbitrary cutoff date, but tracing their subsequent careers is beyond the scope of the present study. It is a task to be undertaken by future historians of Idaho photography.

The hundreds of talented amateurs active after about 1890 are not included in the tables, but outstanding examples of their work are shown throughout the book. Probably we shall never know who took some of our finest photographs, since they were not labeled during the lifetme of those who could have furnished this information.

United States Geological Survey photographers roamed Idaho from 1868, when Timothy H. O'Sullivan visited Shoshone Falls, until the end of the period covered by this listing. They are indicated by "USGS" under "Location," since they usually worked in remote areas with teams collecting geological information or surveying boundaries.

PHOTOGRAPHER	LOCATION	ACTIVE IN IDAHO (Census dates in *italics*)
Allen, James A.	Hailey	1909–11
Allen, W.T.	Boise	1893
Allison, _____	Coeur d'Alene	1885
Allsworth, Samuel b. England, Mar. 1858 arr. U.S. 1874	Preston	*1900*
Amos, Leah b. Louisiana, 1878 (Helm & Amos, 1908) (Amos & Flower	Twin Falls	1908–13, *1910* 1910
Anderson, C.J. b. Sweden, Nov. 1863 arr. U.S. 1870	Blackfoot	*1900*
Anderson, J. Stanley b. Utah, 1866 (Anderson & Widerberg, 1906)	Rexburg	1906–13, *1910*
Anderson, Mary E. b. Utah, 1871	Rexburg	*1910*, 1911–12
Andreas, Mrs. P.M.	St. Anthony	1903–04
Armstrong, Charles B.	Idaho Falls	1911–13
Bailey, F.S.	St. Johns, Oneida Co.	1889–91
Baker, E.W.	Nampa	1901–03
Baker, J.H.	Lewiston	1889
Barker, George V.	Grangeville	1906–13
Barnard, Paul b. Iowa, Apr. 1876	Wallace	*1900*
Barnard, Thomas N. (1881–1916)	Murray Wardner Wallace	1887 1887–89 1889–1913
Barnes, James	Victor	1903–04
Bartlett, Orville O.	Coeur d'Alene	1901–02
Bates, James E. b. Iowa, 1886	Payette	1908–09, *1910*
Beard, James b. Nebraska, 1887	Arco	*1910*
Beaton, Alexander	Mountain Home	1906

PHOTOGRAPHER	LOCATION	ACTIVE IN IDAHO (Census dates in *italics*)
Bell, Lillian M.	Camas Prairie R.R.	1908
Bellus, _____ (Bellus & Stamper)	Boise	1896
Bennett & Messereau	Boise	mid 1880s
Benson, Laban b. Nebraska, July 1871	Teton	*1900*
Bevins, L.A.	Ashton	1909–11
Billington, C.	Caldwell	1893
Bisbee, Clarence E. b. Nebraska (1876–1954)	Twin Falls & Jerome (1910)	1906–13, *1910*
Bishop, Allen K. b. Illinois, Aug. 1867 (Hedum & Bishop, 1898)	Silver City	1898–1900
Bishop, Mrs. T.A.	Bonners Ferry	1908
Bixby, Nahum E. b. Iowa, 1858	Wallace	*1910*
Black Studio	Pocatello	1903
Blackwelder, E.	USGS	1911
Bode, Oscar W. b. Minnesota, 1887	Buhl	1909, *1910*
Bomar, Albert C. b. Illinois, 1849	Boise Silver City Idaho City Bonanza City Challis Idaho Falls	1871 1875 1976–80 1886–92 1894–*1900* *1910*
Bonhore, Eugene J. b. California, 1855	Lewiston	*1880*, 1890–92
Borglum, Paul M.	Pocatello	1904–06
Bowen, C.F.	USGS	1911–13
Bramwell, Claudius E. b. England, July 1863 arr. U.S. 1869	Rexburg	*1900*
Brockman, John A. b. Missouri, June 1880	Harrison Kellogg	*1900* 1912–13

PHOTOGRAPHER	LOCATION	ACTIVE IN IDAHO (Census dates in *italics*)
Brown, Carl B. b. Switzerland, Aug. 1845 arr. U.S. 1879	Payette	1896, *1900*
Brown, William b. Iowa, 1877	Coeur d'Alene	*1910*
Brown, William b. Ohio, 1872	Coeur d'Alene	*1910*
Bruce, Horace	King Hill	1910
Bryant, H.C.	Pocatello	1889–90
Bundy, Oliver C. b. Saratoga Co., N.Y. Aug. 1827	Idaho City	1863
Bunnell, Rosa M. b. Missouri, Dec. 1877	Grangeville	*1900, 1910* 1909–13
Bunnell, Walter E. b. California, May 1875	Grangeville	*1900, 1910* 1901–02
Burns, M. Bruce b. Idaho, June 1880 (Burns Bros. 1905	Moscow Lewiston	*1900*, 1903 1901–02 1903–13
Burns, Ida A. (Burns Bros. 1905	Lewiston	1905–13
Burns, James Grover (1886–1943)	Caldwell Boise	1912 1913
Burns, Robert	Kendrick, Lewiston	1903
Burns & Raymond	Coeur d'Alene	1908
Burns, W.J.	Coeur d'Alene	1910–11
Burroughs, E.R.	Pocatello	1898
Burton, George	Murray	1910
Butler, Gilbert b. England, 1847	Idaho City	1880, *1880*
Calkins, F.C.	USGS	1903, 1910–12
Calvin, William T. b. Iowa, 1859	Council	*1910*
Canova, _____	Boise	1906
Carey, Mrs. Delia	Idaho Falls	1896
Carey, Edgar E. b. Maine, Sept. 1873	Idaho Falls	*1900*, 1901–02

PHOTOGRAPHER	LOCATION	ACTIVE IN IDAHO (Census dates in *italics*)
Carey, Imogene b. Utah, Nov. 1876	Idaho Falls	*1900*
Carter, W. James	Boise	1908
Caryl, Floyd E.	Coeur d'Alene	1911–13
Castleman, Philip F.	Silver City	1866
Chandler, Gerald A.	Post Falls	1912–13
Cheney, B.F.	OSL Railroad	1880s
Cheney, Willie Tuttle (brother) (1869–1949)	Spencer	1890s
Chinn, George W. b. Missouri, Oct. 1863	Caldwell	*1900*
Cochran & Warnock	Idaho Falls	1906
Cochran, M.C. b. Indiana, 1875	Pocatello	*1910*
Colborn, Mrs. Jennie	Aberdeen	1914–15
Comstock, Edith b. Idaho, 1888	Lewiston	*1910*
Cook, Francis A.	Boise Silver City	1887 1885, 1889–90
Craig, Frank	Twin Falls	1906
Cramer, W.A.	St. Maries	1911–12
Crane, S.W.	Harrison	1903–06
Cromwell, W.J.	Idaho City Pioneer City	1864 1866
Crosby, Margaret b. Michigan, 1875	Twin Falls	*1910*
Cummings Brothers	Lewiston	1891–92
Cummings, Everett G. b. Iowa, Aug. 1861	Lewiston	*1900*, 1901–02
Cummins, George D.	Boise Nampa	1912–13 1916
Currie, Thomas (Bomar & Currie, 1879)	Centerville	1879–81
Curry, Isaac B. b. Pennsylvania, 1840	Idaho City Boise	1864–69 1869–81 *1870, 1880*

PHOTOGRAPHER	LOCATION	ACTIVE IN IDAHO (Census dates in *italics*)
Curtis, Asahel (1874–1941)	Seattle	1911
Cutler, Joseph H.	Pocatello Blackfoot	1895– 1906–12
Cutter, C.P.	Idaho Falls	1911–12
Dahlquist, W.A. (Dahlquist Bros.)	Oakley	1908–11
Davis, John b. Kansas, 1882	Pocatello	*1910*
Day, Ernest	St. Maries	1911–12
Dearinger, _____ (Sethen & Dearinger)	Mountain Home	1908
Dennis, Augustus b. Maine, 1857	Hagerman	*1910*
Denniston, Dewitt C.	St. Maries	1912–13
Diamond Brothers	Pocatello	1893
Dodge, Horace D. b. Idaho, 1885 (Lundburg & Dodge, 1908)	Idaho Falls	1907–08, *1910*
Doomes, C.H.	Troy	1910
Drewery, Harry b. England, 1871 arr. U.S. 1892	Soda Springs	1908–13, *1910*
Dunlap, J.F.	Sagle, Bonner Co.	1906–13
Duray, John H.	Challis Salmon City	*1880* 1887–90
Durrant, Walter H.	Driggs	1911–13
Eastman, Gilman L. b. Maine, Oct. 1848	Boise	*1900*
Edgerton, R.L. b. Iowa, 1874	Emmett	*1910*
Eggan, Halvor P. b. Norway, 1856 arr. U.S. 1876	Moscow	1905–13, *1910*
Eggan, James P. b. Norway, 1873 arr. U.S. 1880	Moscow	*1910*

PHOTOGRAPHER	LOCATION	ACTIVE IN IDAHO (Census dates in *italics*)
Ekeberg, Minnie (Ekeberg & Thorild)	Wallace	1901–04
Elite Studio (W.S. Rensimer)	Twin Falls	1910, *1910*
Elite Studio (Fred C. Keller)	Nampa	1908
Emery, W.G.	Moscow	1890s
English, Harry P. b. Canada, Feb. 1879 arr. U.S. 1900	Mullan	*1900*, 1912–13
Erichson, Henry (Erichson & Hanson) b. Germany, 1856 arr. U.S. 1871	Moscow	1884–1908 1891–92
Ericsson, Charles T. b. Sweden, 1874 arr. U.S. 1891	Blackfoot	*1910*, 1913
Faike, Harry M. b. Minnesota, 1883	St. Anthony	*1910*
Fair, Henry b. New Jersey, Aug. 1856 (Fair & Thompson, 1904)	Lewiston	*1900*, 1904–08
Faulkner, Charles b. Ohio, 1870	Coeur d'Alene	*1910*
Fehse, _____ (Finn & Fehse)	Wallace	1908
Fenton & Mason	Boise	1910–11
Fink, Henry (Fink Bros.) b. Iowa, 1867	Nez Perce	1906–13, *1910*
Fink, John	Nez Perce	*1910*
Finn & Fehse	Wallace	1908
Fleming, William A.	Lewiston	1889–91
Flower, William A. (Amos & Flower)	Twin Falls	1910–13
Flowerday, _____	Baker, Oregon	ca. 1905
Foor, George W.	Boise Weiser	1889–90 1891?

PHOTOGRAPHER	LOCATION	ACTIVE IN IDAHO (Census dates in *italics*)
Fortin, Joseph	Lewiston	1902–05
Fowler, William B. b. Tennessee, May, 1863	Payette Salmon	1890s *1900, 1910*, 1901–13
French, Theodore D. b. Michigan, 1874	New Plymouth	1906–13, *1910*
Frost, George A.	Lewiston	1874
Furcht, Delia E. b. Michigan, 1855	Gooding	*1910*
Gaetz, Ella	Atlanta	1890s, *1900*
Gale, H.S.	USGS	1909, 1913
Galliger, Martin b. New York, 1858	Wallace	*1910*
Gardner, Jesse J.	Nampa	1908–10, *1910*
Garvey, Mrs. W.E.	Pocatello	1913–14
Gay, E. Jane	Nez Perce Reservation	1889–92
Gibbons, Mrs. Gertrude b. Kansas, 1877	Grangeville	1909–11, *1910*
Gilbert, F.G.	Rathdrum	1910
Gilbert, Frank M. (Gilbert & Vincent)	Idaho Falls	1911–12
Gilbert, G.K.	USGS	1899
Gimble, Mary Renick (1866–1942)	Coeur d'Alene	ca. 1890–1912
Glanville, George W. b. Iowa, 1867	Blackfoot	1903–13, *1910*
Gomond, Joseph W. b. Canada, Dec. 1866 arr. U.S. 1870	Lewiston Wallace	*1900*, 1901–05 1908–13
Goodhue, Ira D.	Cottonwood	1912–13
Gordon Portrait Co.	Soda Springs	1910
Graham, Lavinia J. b. Iowa, 1870	Emmett	*1910*
Graves, Timothy L.	Boise	1889–93
Gregory, C.A.	Stanley	ca. 1900
Griffin, Mrs. H.J. (Tonkin & Griffin)	Boise	1896

PHOTOGRAPHER	LOCATION	ACTIVE IN IDAHO (Census dates in *italics*)
Hagen, E.B.	Coeur d'Alene	1910–11
Hales, Stephen	Rexburg	1903–04
Hall, John W.	Boise	1906–07
Hall, Peter J. b. Idaho, 1885	Genessee	*1910*, 1912–13
Hall, William N.	Coeur d'Alene	1887–90
Hamley, Emily	Kendrick	1903–04
Hancock, Edward S. b. Canada, 1852	Cottonwood (Grangeville, 1908)	1903–13, *1910*
Hansen, Axel	Pocatello	1906–08
Hanson, Charles W. b. Minnesota, Apr. 1867	Genessee	*1900*, 1901–08
Hanson, Frederick b. Utah, 1875	Preston	*1910*
Hanson, John A. (Erichson & Hanson) b. Denmark, Sept. 1854 arr. U.S. 1872 (Hanson & Parker, 1910)	Moscow Grangeville	1890–92 1892–1910, *1900*
Hargen, Elias B. b. Norway, 1870 arr. U.S. 1900 (Hargen & Skatrud)	Coeur d'Alene	*1910*, 1911 1911–12
Hart, Elmer W. b. Colorado, 1887 (W.H. Hart & Son)	Ilo ⎤ Later Vollmer ⎦ Craigmont	1908–13, *1910* 1913
Hart, Harry L. (Lenox & Hart)	Cottonwood	1912–13
Hart, William H. b. Iowa, 1861 (W.H. Hart & Son)	Ilo ⎤ Later Vollmer ⎦ Craigmont	1908–13, *1910* 1913
Harvey, C. Edwin (Whyte & Harvey)	Boise	1901–13 1901
Hastie, George d. Silver City, 1866	Silver City	1865–66
Hasfurther, Joseph M.	Genessee	1891–92
Hassing, F.H.	Blackfoot	1914–
Hayes, C.W.	USGS	1903

PHOTOGRAPHER	LOCATION	ACTIVE IN IDAHO (Census dates in *italics*)
Hayes & Stenmark	Wardner	1910–11
Haynes, F. Jay	Murray N.P. Railway	1884 1884–1913
Hazeltine, Martin M.	Boise Baker, Oregon	1882–90 1890–1913
Hedum, Charles C. b. Norway, Aug. 1875 arr. U.S. 1888 (Hedum & Bishop, 1898)	Silver City	1898–1913, *1900*
Helm, Daniel b. Kansas, June, 1870	Troy	*1900*
Helm, Milton H. b. Indiana, 1883 (Helm & Amos)	Twin Falls Mountain Home	1908 *1910*, 1910–13 1908
Helsom, Edwin b. England, Mar. 1868 arr. U.S. 1879	Lewiston	*1900*
Henley, G.A.	Pocatello	1906
Heroy, W.B.	USGS	1912
Heuther, J.J.	USBR	1911
Hewett, D.F.	USGS	1913
Hildreth, Carl F.	Caldwell	1906–10
Hill, Roy F. b. Missouri, 1884	Gooding	*1910*, 1911–13
Himes, Richard B. b. Ohio, 1871	Kendrick Sandpoint	1906 1909–13, *1910*
Hinthorne, B.H.	Blackfoot	1912–13
Hofmann, Henry	Tahoe, Idaho County	1913–14
Hogan, _____	Grangeville	ca. 1905
Holland, James S. b. Utah, 1882	Rigby	*1910*
Homer, John A. b. Utah, Feb. 1878	St. Anthony	*1900*
Howell, L.R.	Preston	1906
Hower, _____	Pocatello	1893–96
Hudson, Arthur	Genessee	1905–08

PHOTOGRAPHER	LOCATION	ACTIVE IN IDAHO (Census dates in *italics*)
Huntington, C.L.	in Boise	1909
Hursh, F.D.	Franklin	1910–11
Hurt, F.E.	Boise	1912–13
Hutchins, Charles	Sandpoint	1903–13
Huttstand, Fred b. North Dakota, 1889	Wallace	*1910*
Jackson, William Henry (1843–1942)	USGS	1871–1913
Jacobson, Philip (Nadeau & Jacobson) b. Michigan, 1884	Sandpoint	1909–13, *1910*
Jellum, Herbert Lee b. Norway, 1869 arr. U.S. 1885	Nampa	*1900*, 1909–13
Jenks, Joel Alonzo b. Utah, 1873	Montpelier Paris	1903–06 *1910*, 1912–13
Johnson, Ansgar E. (Johnson & Son) b. Minnesota, Sept. 1893 d. 1981	Boise	1911–13
Johnson, E.G.	Monitor, Kootenai County (later Black Rock)	1908
Johnson, Jons P. (Johnson & Son) b. Sweden, Mar. 1863 d. 1941	Boise	1911–13
Johnson, Mrs. T.R.	Emmett	1906
Jones Brothers	Union, Oregon at Placerville Silver City	1880 1881
Jones, L.I.	Wallace	1906
Jones, Robert A.	Preston	1908–13
Jones, William H.	Rathdrum	1908
Joslin, J.B.	Potlatch	1911
Joy, Emil W. b. Oregon, 1890	Montpelier Grace	*1910* 1913

PHOTOGRAPHER	LOCATION	ACTIVE IN IDAHO (Census dates in *italics*)
Junk, John	Idaho City	1864
(Sutterley Bros. & Junk)	Idaho City	1865
(Junk & Co.)	Idaho City	1865–66
	Silver City	1866
(Junk & Curry)	Idaho City	1867–68
(Junk & Leslie)	Silver City	1867–68
	(Moved to Helena, Montana, 1869)	
Keller, Fred C. (Elite Studio)	Nampa	1908–13
Kemble, Charles M.	Spink, Boise Co.	1912–13
Kingsley, Charles S. b. Oregon (1859–1940)	Idaho City	1876–81
	Boise	1881–90
Kirby, O.A.	Post Falls	1908
Knappen, C.G.	Boise	1889
Koch, George W. (George W. Koch & Co.)	Rathdrum	1901–06
Koch, John L.	Rathdrum	1901–04
Ladley, George b. Minnesota, 1878	Bonners Ferry	1908–13, *1910*
Lambrecht's Studio	Blackfoot	1914
Lane, Thomas b. New York, Sept. 1872	Pocatello	*1900*
Laney, Francis Baker	Nez Perce Reservation	1890s?
Langmaid, George W. b. Idaho, Sept. 1878	Boise	*1900*, 1905
Lavering, E.C.	Caldwell	1903–06
	Twin Falls	1907
Law, John	Idaho City	1864
	Boise	1865
Lawrence, George R. Co.	Chicago, in Arco	1909
Lee, Alice I.	American Falls	1912–13
Lee, Anton	Deary	1910–13
Lee, H.V.	in Boise	1909
Leek, Norman	Nampa	1901
Leighton, M.O.	USGS	before 1913

PHOTOGRAPHER	LOCATION	ACTIVE IN IDAHO (Census dates in *italics*)
Lenox, Harry H. (Lenox & Hart)	Cottonwood	1912–13
Leonard, _____	Boise	1898
Leonard, Joe b. Idaho 1881	Boise	*1910*, 1911
Leslie, Hiram E. b. Ohio, July 30, 1835 d. May 31, 1882		
(Junk & Leslie)	Silver City	1867
(H.E. Leslie)	Silver City	1868–70
	Boise	1870
	Silver City	1871–74
(Leslie & Potter)	Silver City	1875
(H.E. Leslie)	Silver City	1876–82
Lester, D. Curtis b. Pennsylvania, 1852	Lewiston	*1880*
Leweis, Fred	Rexburg	1914
Ley, Alfred M.	Boise	1908
	Parma	1910
	Caldwell	1912–13
Lieuallen, _____ (Smith & Lieuallen)	Coeur d'Alene	1903–04
Lindgren, Waldemar	USGS	1896–98
Logan, W.H.	Boise	1875
Lorton, Joseph S. b. Missouri, Mar. 1873	Salubria	*1900*
Lubken, Walter J. b. Idaho, 1883	Boise	*1910*, 1912–13
Ludlow, Charles b. New Jersey, 1877	St. Anthony	*1910*, 1911–13
Lundburg & Dodge	Idaho Falls	1907–08
Lupton, C.T.	USGS	1913
Lyon, T.E.	Victor	1901–02
McCandless, David C. (Rex Gallery)	Boise	1901–13
McCartney, Herman G. b. Missouri, June 1877	Harrison	*1900*
McClain, William W.	Boise	1891–92

PHOTOGRAPHER	LOCATION	ACTIVE IN IDAHO (Census dates in *italics*)
McEvoy, J.J.	Montpelier	1891–92
	Pocatello, Blackfoot, Idaho Falls	1893–
McIntyre, H.A. b. Ohio, 1843	Rocky Bar	*1870*
McMeekin, Joseph P. b. Ireland, Apr. 1859 arr. U.S. 1872	Hagerman	*1900*, 1908, *1910*
McMillan & Co.	Pocatello	1903
Maaland, Knut b. Norway, 1886 arr. U.S. 1906	Wallace	*1910*
Magden, Etta M. b. Michigan, 1896	Mountain Home	*1910*
Mallory, Martyn E. (1880–1936)	Hailey	ca. 1900–13
Mansfield, G.R.	USGS	1909–16
Markell, W.E.	Pocatello	1894
Marsh, Daniel	Weiser	1903–06
Marshal, Milton A.	Blackfoot	1901–02
	Weippe	1903–06
Martin, M.B.	Albion	ca. 1900
	Gooding	ca. 1909
Marty, Fred	Buhl	1912–13
Mason, Morton G. (Mason & Thomas)	Boise	1909–13
Mason, Peter b. Denmark, Feb. 1863 arr. U.S. 1877	Coeur d'Alene	*1900*
Maxwell, Charles N.	Moscow	*1900*
Melcher, John R. b. Ohio, 1863	Peck	*1910*
Merrifield, Edward G.	Shoshone	1908–13
Messereau, _____ (Bennett & Messereau)	Boise	ca. 1885
Middleton, Delia b. Maine, Sept. 1854	St. Anthony	*1900*

PHOTOGRAPHER	LOCATION	ACTIVE IN IDAHO (Census dates in *italics*)
Mill–aps (sic), W.F. (Millsap?)	Hailey	1889–90
Miller, C.A. (Miller & Pyfer)	Pocatello	1901–02
Miller, G.W. (Law & Miller)	Boise	1865
Mills, Richard I. b. Utah, Mar. 1871	Oakley Burley	*1900*, 1903–06 1908
Montgomery, J.H.	Caldwell	1893
Moore, Francis b. England, 1827 d. Apr. 1898 arr. U.S. 1848	Boise Caldwell	1879–88, *1880* 1888–98
Moriarity, J.T.	Wardner	1906
Morris, Charles A. b. California, 1867	Lewiston	*1910*
Moss & Ricketts	Silver City	ca. 1900
Murray, J.W.	Placerville	ca. 1905
Myers, Charles E.	Malad	1912–13
Myers, Horace C. (Myers & Rice)	Boise Boise	1889–1911 1912–13
Myers, John C.	Boise	1889–90
Nadeau & Jacobsen	Sandpoint	1909–13, *1910*
Nelson, J.H.	Mackay	1906
Nelson, Nels	Troy	1905–08
Newcomb, _____	Silver City	ca. 1890
Newell, Mabelle	Meridian	1909–13, *1910*
Nock, G.R.	Hailey	1906
Norton, S.	Silver City	1871
Nutt Brothers	Bonners Ferry	1906
Odden, Crist	Troy	1905–08
O'Haver, Helen	Idaho Falls	1906
Olson, Halvar L. b. Norway, 1850 arr. U.S. 1873	Coeur d'Alene	1908–13, *1910*

PHOTOGRAPHER	LOCATION	ACTIVE IN IDAHO (Census dates in *italics*)
Olson, John E. (son) b. Iowa, 1875	Coeur d'Alene	*1910*, 1912–13
Orvis, Spencer b. Canada, Aug. 1875	Caldwell	*1900*
O'Sullivan, Timothy H. (1840–1882)	USGS	1868
Oylear, M.M.	Leland	1906–08
Palmer, Frank b. Missouri, Dec. 1864	Rathdrum	*1900*
Park, Ralph F.	Emmett	1912–13
Parker, _____ (Hanson & Parker)	Grangeville	1910
Parsons, Charles J.	Homedale	1910
Partain, Joseph	Lewiston	1908
Pickett, Edward b. Minnesota, May 1870	Stuart Name changed to Kooskia later that year)	*1900*
Pilliner, Frederick J.	Ketchum Silver City	1889–90 1891–92
Pilliner, William H. b. England, Apr. 1826 arr. U.S. 1835	Malad Salmon Silver City Mountain Home	*1880* 1887 1891 *1910*
Pittenger, William W. b. Kansas, 1872	Heyburn	*1910*
Potter, J.C. (Leslie & Potter)	Silver City	1875
Prater, William J. b. Wales, 1882 arr. U.S. 1899 (Prater & Williams, 1910)	Pocatello	1907–13, *1910*
Prescott, John J. b. Massachusetts, 1857	Weiser Caldwell	1903–04 1906–13, *1910*
Price, D.	Reubens	1912–13
Ralston, John E. b. Indiana, Sept. 1866	Boise	*1900*
Ransom, J.G.	Pine	1909–10

PHOTOGRAPHER	LOCATION	ACTIVE IN IDAHO (Census dates in *italics*)
Ransome, F.L.	USGS	1901, 1904
Raymond, _____	Coeur d'Alene	1908
Read, B.	Pocatello	1905
Redpath, Charles	Sandpoint	1906
Reels, G.W.	Payette	1906
Reichardt, J.	Twin Falls	1906
Reimann, Nathan b. South Dakota, 1888	American Falls	*1910*, 1910–11
Rembrandt Studio	Nampa	1908
Rensimer, William S. b. Missouri, 1874	Twin Falls	*1910*, 1910–13
Rex Gallery (McCandless, David C.)	Boise	1908
Rhodes, J.W.	Weiser	1891–92
Rice, C. Perry (Myers & Rice)	Boise	1912–13
Richards, R.W.	USGS	1908, 1911
Riggs, J.W.	Lewiston	1883–87, 1891
Rinehart, Ellis W. b. Oregon, 1871	Montpelier	1901–13, *1910*
Robinson, Edith	Burley	1912–13
Roeder, V.C.	Pocatello	1898–99
Rose, Mrs. Josephine	Orofino	1906
Rosengrant, Dan L. b. Kansas, June 1876	Stuart (Name changed to Kooskia later that year)	*1900*
Ross, Daniel W. b. Ohio, 1868	Coeur d'Alene	1908–11, *1910*
Rough, Charles b. Pennsylvania, 1885	Pocatello (O.S.L. Railroad)	*1910*
Royce, L.M.	Sandpoint	1908
Rundle, William	Lewiston	1912
Rush, Charles b. Virginia, 1879	Coeur d'Alene	*1910*

PHOTOGRAPHER	LOCATION	ACTIVE IN IDAHO (Census dates in *italics*)
Russell, I.C.	USGS	1901
Sammis, Edward M.	Lewiston	1862
Sargent, Francis H. b. Nebraska, 1874	Sandpoint	1908, *1910*
Savage, C.R. (Co.)	Salt Lake City Various Idaho sites	1869–1913
Savidge, Charles b. Minnesota, 1889	Emmett	*1910*
Sawley, Mildred	Monitor Kootenai Co.	1906–08
Schultz, A.R.	USGS	1910–11
Sethen, I.J. (Sethen & Dearinger)	Mountain Home	1908
Shepard, W.N.B.	Paris	1889–92
Sherman, Clifton G.	Weiser	1912–13
Sigler, R. Harold	Boise	1911–13
Simmons, A.A. b. Illinois, June 1869	Nampa	1895
Smith, Ed.	Lewiston Boise	1891 *1900*
Smith, Hannibal H. b. North Carolina, 1879	Oakley	*1910*, 1909–13
Smith, Ida B.	Jerome	1909–11
Smith, Mattie G.	Rupert	1912–13
Smith, Ray S. b. Iowa, Feb. 1871	Idaho Falls	*1900*, 1901–04
Smith, Thompson J.	Heyburn	1910–13
Smith, W.E.	Kooskia	1906
Smith, William B.	Bellevue	1889–90
Smith & Lieuallen	Coeur d'Alene	1903–04
Snodgrass, Lucien B. (Snodgrass Picture Shop)	Caldwell	1910–13
Snodgrass, Margaret (daughter)		1910–38
Snodgrass, Mary (daughter)		1910–38

PHOTOGRAPHER	LOCATION	ACTIVE IN IDAHO (Census dates in *italics*)
Sooy, B.F.	Caldwell	1893
	Boise	1893
Soule, W.A.	Stanley	ca. 1910
Sours, R.S.	Pocatello	1893
Southerland Sisters	Coeur d'Alene	1906
Stamper, Calvin F. b. Iowa, Jan. 1866	Boise	1898–1913, *1900, 1910*
Stamper, J.L.	Boise	1901–06
Standow, Richard b. Germany, 1883 arr. U.S. 1897	Mullan	*1910*, 1912–13
Stanton, T.W.	USGS	1903, 1906–16
States & McKenzie	Council	1908
States, H.L.	Cambridge	1910–11
Steen, John H.	Boise	1909–10
Stenmark, _____ (Hayes & Stenmark)	Wardner	1910
	Wallace	1911
Sterner, John J. b. Pennsylvania, 1870	Moscow	1905–13, *1910*
Sterrett, D.B.	USGS	1910
Stevens, George A. b. Iowa, 1871	Emmett and Notus	1909–10
Stevens, Myrta May Wright	Missoula, Montana	1890s
Stevenson, John A. b. Canada, Sept. 1870	Pocatello	*1900*
Stewart, Mabel A.	Boise	1908
Stockbridge, Nellie b. Illinois, Mar. 1868 d. May, 1965	Wallace	1898–1913
Straffin, Fred D. b. Massachusetts, 1873	St. Maries	*1910*
Strang, Amelia	Lewiston	1864
Struckman, Francis b. Minnesota, July 1857	Boise	1880s
	Glenns Ferry	*1900, 1910*

PHOTOGRAPHER	LOCATION	ACTIVE IN IDAHO (Census dates in *italics*)
Sutterley Brothers (Sutterley Bros. & Junk)	Virginia City, Nevada Boise and Idaho City Salt Lake City	1865 1865–66 1866–
Tacha, Ernest	Shoshone Twin Falls	1901–02 1906–
Tandy, H.C. (Tandy & Leslie) (Tandy & Cook)	Silver City Idaho City Winnemucca, Nevada Tuscarora, Nevada	1875–78 Mid 1870s 1878 1880–81
Thayer, Oliver P. b. Massachusetts, 1875	Idaho Falls	*1910*, 1910–13
Thoma, Clara M.	Gooding	1910–13
Thomas, Charles O. (Mason & Thomas)	Boise	1910–13
Thompson, Charles	Post Falls	1891–92
Thompson, W.C.	Hailey Gooding Shoshone	1905 1909 1909
Thorild, Annie	Wallace	1901–04
Thrasher, A.F.	Virginia City, Montana	1870s, 1880s
Tollman, J.W.	Boise	1908
Tonkin, George E. (Tonkin & Griffin)	Boise Meridian Boise	1899–1904 1906–07 1909–10
Topping, H.H. b. Michigan, 1875 (Wife Ada listed as "retoucher")	Boise	*1910*
Train, Edgar H. (Train & Cromwell)	Idaho City	1865
Traphagen, V.C.	Hope	1910
Tucker, Herman A.	Wardner	1908–13
Unternahrer, Anton	Boise	1899–1908
Vader, L.M.	Kendrick	1908
Van Graven, Paul (Van Graven & Son)	Nampa	1903–08
Van Graven, Phil	Weiser	1908–13
Van Slyke, Mrs. Lizzie	Boise	1905–07

PHOTOGRAPHER	LOCATION	ACTIVE IN IDAHO (Census dates in *italics*)
Van Winkel, Isaac L.	Culdesac	1905–06
Vaughn, John W. 　　b. Iowa, Apr. 1867	Kendrick	*1900*, 1901–02
Veatch, A.C.	USGS	1910
Vernon, William N. 　　b. Ohio, Aug. 1868	Boise	*1900*, 1901–02
Voight, Leo O.	Montpelier	1891–92
Walcott, C.D.	USGS	1898–pre 1913
Walter, Eyer Fisher 　　b. Pennsylvania, 1878	St. Anthony Idaho Falls	1908, *1910* 1911–13
Ward, Mrs. Mary T.	Hailey	1902–13
Warner, Isaac V. 　　b. Pennsylvania, 1868	Malad	1906–08, *1910*
Webster, John W. 　　b. Ohio, 1858	Lewiston	1908–13, *1910*
Weider, Mrs. J.H. 　　b. Oregon, 1867	Payette Nampa	1906–13 *1910*
Weigel, _____	Idaho City	ca. 1900
Welch, F.W.	Spirit Lake	1912–13
Wendel, James F.	Ashton	1914–15
Whelchel, Arthur M. 　　b. Kansas, Aug. 1879 　　(Whelchel Bros.)	Emmett Boise Emmett	1902–13, *1910* 1909–10 1912–13
Whelchel, Frank W. 　　b. Kansas, 1886	Emmett	1912–13
Whelchel, Walter C.	Boise	1909–10
Whitney, Edward B. 　　b. Oregon, Feb. 1862	Boise	*1900*, 1901–13, *1910*
Whitney, J.	Albion	1903–04
Whitney, John M. 　　b. Oregon, 1875	Idaho Falls	1906–13, *1910*
Whyte, William 　　(Whyte & Harvey) 　　(Whyte & Sons)	Boise	1893–1908 1901 ?
Widerberg, Lafayette 　　b. Utah, 1881 　　(Anderson & Widerberg, 1906)	Rexburg	1906, *1910*

PHOTOGRAPHER	LOCATION	ACTIVE IN IDAHO (Census dates in *italics*)
Wilkinson, H.W.	Potlatch	1905–06
Williams, Herbert J. b. Idaho, 1888 (Prater & Williams)	Pocatello	*1910*
Willis, B.	USGS	1898? 1901?
Wilson, Charles E. b. Maine, 1876	Gooding	*1910*
Wilson, Henry	Meadows Valley	ca. 1900–
Wilvert, S.A.	Pocatello	1905
Womach, Walter b. Idaho, 1883	Emmett	*1910*
Wood, Thomas M.	The Dalles, Oregon Lewiston Silver City	1863 1863 1868–69
Wrensted, Benedicte b. Denmark, 1860 arr. U.S. 1887	Pocatello	1896–1913, *1910*
Wrensted, Ella b. 1893 (Niece, apprentice)	Pocatello	*1910*
Young, I.L.	Twin Falls	1905
Young, William J.	Boise	1865–66

Floods were all too common in early Lewiston, and some were recorded by the camera.

PROFESSIONAL PHOTOGRAPHERS ACTIVE in IDAHO, 1863–1913

TOWN	NAME	DATES (Census dates in *italics*)
ABERDEEN	Colborn, Mrs. Jennie	1914–15
ALBION	Whitney, J.	1903–04
	Martin, M.B.	ca. 1900
AMERICAN FALLS	Reimann, Nathan	*1910*
	Lee, Alice I.	1912–13
ARCO	Beard, James	*1910*
ASHTON	Bevins, L.A.	1909–11
	Wendel, James F.	1914–15
ATLANTA	Goetz, Ella	1890s, *1900*
BELLEVUE	Smith, William B.	1889–90
BLACKFOOT	Anderson, C.J.	*1900*
	Marshall, Milton A.	1901–02
	Glanville, George W.	1903–13, *1910*
	Cutler, Joseph H.	1906–12
	Ericsson, Charles T.	*1910*, 1913
	Hinthorne, B.H.	1912–13
	Hassing, F.H.	1914
	Lambrecht's Studio	1914
BOISE	Law & Miller	1865
	(Law, John)	
	(Miller, G.W.)	
	Young, William J.	1865–66
	Sutterley Bros.	1865
	Brewster, J.C., (operator)	
	Curry, Isaac B.	1869–81, *1870, 1880*
	Leslie, Hiram E.	1870
	Bomar, Albert C.	1871
	(Bomar & Bayhouse)	
	Logan, W.H.	1875
	Moore, Francis	1879–88, *1880*
	Kingsley, Charles S.	1881–90
	Bennett & Messereau	Mid 1880s
	Hazeltine, Martin M.	1882–90
	Struckman, Francis	1880s
	Cook, Francis A.	1887
	Myers, Horace C.	1889–1911
	(Myers & Rice, 1912–13)	
	Myers, John C.	1889–90
	Knappen, C.G.	1889
	Foor, George W.	1889–90

TOWN	NAME	DATES
		(Census dates in *italics*)
	Graves, Timothy L.	1889–93
	McClain, William W.	1891–92
	Sooy, B.F.	1893
	Allen, W.T.	1893
	Whyte, William	1893–1908
	Griffin, Mrs. H.J.	1896
	Leonard, _____	1898
	Stamper, Calvin F.	1898–1913, *1900, 1910*
	Unternahrer, Anton	1899, 1908
	Tonkin, George E. (Tonkin & Griffin, 1909–10)	1899–1904
	Smith, Edward	*1900*
	Vernon, William N.	*1900*, 1901–02
	Ralston, John E.	*1900*
	Eastman, Gilman L.	*1900*
	Harvey, C. Edwin (Whyte & Harvey, 1901)	1901–13
	Stamper, J.L.	1901–06
	McCandless, David C. (Rex Gallery, 1908)	1901–13
	Whitney, Edward B.	*1900*, 1901–13, *1910*
	Langmaid, George W.	*1900*, 1905
	Van Slyke, Mrs. Lizzie	1905–07
	Hall, John W.	1906–07
	Canova, _____	1906
	Carter, W. James	1908
	Ley, Alfred M.	1908
	Stewart, Mabel A.	1908
	Tollman, J.W.	1908
	Steen, John H.	1909–10
	Whelchel, Arthur M.	1909–10
	Whelchel, Walter C.	1909–10
	Leonard, Joe (with H.C. Myers)	*1910*, 1911
	Lubken, Walter J.	*1910*, 1912–13
	Topping, H.H.	*1910*
	Fenton & Mason	1910–11
	Mason & Thomas (Mason, Morton G., Thomas, Charles O.)	1910–13
	Sigler, R. Harold	1911–13
	Johnson & Son (Jons P. and Ansgar E.)	1911–13
	Cummins, George D.	1912–13
	Hurt, F.E.	1912–13

TOWN	NAME	DATES (Census dates in *italics*)
	Rice, C. Perry (Myers & Rice)	1912–13
	Burns, James Grover	1913
BONANZA CITY	Bomar, Albert C.	1886–92
BONNERS FERRY	Nutt Bros.	1906
	Bishop, Mrs. T.A.	1908
	Ladley, George	1908–13, *1910*
BUHL	Bode, Oscar W.	1909–, *1910*
	Marty, Fred	1912–13
BURLEY	Mills, Richard I.	1908
	Robinson, Edith	1912–13
CALDWELL	Moore, Francis	1888–98
	Montgomery, J.H.	1893
	Billington, C.	1893
	Sooy, B.F.	1893
	Chinn, George W.	*1900*
	Orvis, Spencer	*1900*
	Lavering, E.C.	1903–06
	Hildreth, Carl F.	1906–10
	Prescott, John J.	1906–13, *1910*
	Prescott, Clarabelle (wife)	1906–13, *1910*
	Snodgrass, Lucien B.	1910–13
	Snodgrass, Mary	1910–13
	Snodgrass, Margaret	1910–13
	Ley, Alfred M.	1912–13
	Burns, James Grover	1912
CAMBRIDGE	States, H.L.	1910–11
	Lorton, Joseph S. (Salubria)	Before 1913
CENTERVILLE	Currie, Thomas	1879–81
CHALLIS	Duray, John H.	*1880*
	Bomar, Albert C.	1894, *1900*
COEUR d'ALENE	Allison, _____	1885
	Hall, William N.	1889–90
	Gimble, Mary Renick	ca. 1890–1912
	Mason, Peter	*1900*
	Bartlett, Orville	1901–02
	Smith & Lieuallen	1903–04
	Southerland Sisters	1906
	Burns & Raymond	1908
	Burns, W.J.	1910–11
	Ross, Daniel W.	1908–11, *1910*
	Olson, Halvor L.	1908–13, *1910*

TOWN	NAME	DATES (Census dates in *italics*)
	Olson, John E. (son)	*1910*, 1912–13
	Hargen, Elias B.	*1910*, 1911
	Brown, Wiliam	*1910*
	Brown, William	*1910*
	Rush, Charles	*1910*
	Faulkner, Charles	*1910*
	Caryl, Floyd E.	1911–13
COTTONWOOD	Hancock, Edward S.	1903–13, *1910*
	Lenox & Hart (Hart, Harry L., Lenox, Harry H.)	1912–13
	Goodhue, Ira D.	1912–13
COUNCIL	States & McKenzie (H.L. States)	1908
	Calvin, William T.	*1910*
CULDESAC	Van Winkel, Isaac L.	1905–06
DEARY	Lee, Anton	1910–13
DRIGGS	Durrant, Walter H.	1911–13
EMMETT	Whelchel, Arthur M.	1902–13, *1910*
	Johnson, Mrs. T.R.	1906
	Stevens, George A.	1909–10, *1910*
	Graham, Lavinia	*1910*
	Savidge, Charles	*1910*
	Edgerton, R.L.	*1910*
	Womach, Walter	*1910*
	Whelchel, Frank W.	1912–13
FOREST	Hart, William H.	1902–07
GENESSEE	Hasfurther, Joseph M.	1891–92
	Hanson, Charles W.	*1900*, 1901–08
	Hudson, Arthur	1905–08
	Hall, Peter J.	*1910*, 1912–13
GLENNS FERRY	Struckman, Francis	*1900, 1910*
GOODING	Martin, M.B.	ca. 1909
	Thompson, W.C.	1909
	Furcht, Delia E.	*1910*
	Wilson, Charles E.	*1910*
	Hill, Roy F.	*1910*, 1911–13
	Thoma, Clara M.	1910–13
GRACE	Joy, Emil W.	1913
GRANGEVILLE	Hanson, John A.	1892–1910, *1900*
	Bunnell, Rosa M.	*1900*, 1909–13, *1910*
	Bunnell, Walter E.	*1900*, 1901–02, *1910*

TOWN	NAME	DATES (Census dates in *italics*)
	Hogan, _____	ca. 1905
	Barker, George V.	1906–13
	Hancock, Edward S.	1908
	Gibbons, Mrs. Gertrude	1909–11, *1910*
	Parker, _____	1910
HAGERMAN	McMeekin, Joseph P.	*1900*, 1908, *1910*
	Dennis, Augustus	*1910*
HAILEY	Mill–aps, W.F. (Millsap?)	1889–90
	Mallory, Martyn	ca. 1900–13
	Ward, Mrs. Mary T.	1902–13
	Thompson, W.C.	1905
	Nock, G.R.	1906
	Allen, James A.	1909–11
HARRISON	Brockman, John A.	*1900*
	McCartney, Herman G.	*1900*
	Crane, S.W.	1903–06
HEYBURN	Pittenger, William W.	*1910*
	Smith, Thompson J.	1910–13
HOMEDALE	Parsons, Charles Jr.	1910
HOPE	Traphagen, V.C.	1910
IDAHO CITY	Bundy, Oliver C.	1863
	Cromwell, W.J.	1864
	Train, Edgar H.	1865
	Curry, Isaac B. (Junk & Curry, 1866)	1864–69
	Junk, John	1864–69
	Tandy, H.C.	mid–1870s
	Kingsley, Charles S.	1876–81
	Bomar, Albert C. (Bomar & Kingsley, 1876) (Bomar & Currie, 1879) (Bomar & Butler, 1880)	1876–80
	Butler, Gilbert	*1880*, 1880
	Weigel, _____	ca. 1900
IDAHO FALLS	McEvoy, J.J.	1893–
	Carey, Mrs. Delia	1896
	Carey, Edgar E.	*1900*, 1901–02
	Carey, Imogene (wife)	*1900*
	Smith, Ray S.	*1900*, 1901–04
	O'Haver, Helen	1906
	Cochran & Warnoch	1906
	Whitney, John M.	1906–13, *1910*

TOWN	NAME	DATES (Census dates in *italics*)
	Dodge, Horace D.	1907–08, *1910*
	Lundburg & Dodge (Acme Studio)	1907–08
	Bomar, Albert C.	*1910*
	Thayer, Oliver P.	*1910*, 1910–13
	Walter, Eyer F.	1911–13
	Cutter, C.P.	1911–12
	Gilbert & Vincent (Gilbert, Frank M.)	1911–12
	Armstrong, Charles B.	1911–13
ILO (with VOLLMER became CRAIGMONT)	Hart, W.H. & Son	1908–13, *1910*
JEROME	Smith, Ida B.	1909–11
	Bisbee, Clarence E. (see Twin Falls)	1910
KELLOGG	Brockman, John A.	1912–13
KENDRICK	Vaughn, John W.	*1900*, 1901–02
	Burns, Robert	1903
	Hamley, Emily	1903–04
	Himes, Richard B.	1906
	Vader, L.M.	1908
KETCHUM	Pilliner, Frederick J.	1889–90
KING HILL	Bruce, Horace	1910
KOOSKIA	Smith, W.E.	1906
LELAND	Oylear, M.M.	1906–08
LEWISTON	Sammes, Edward M.	1862
	Wood, Thomas M.	1863
	Strang, Mrs. Amelia	1864
	Frost, George A.	1874
	Lester, D. Curtis	*1880*
	Bonhore, Eugene J.	*1880*, 1890–92
	Riggs, J.W.	1883–87, 1891
	Baker, J.H.	1889
	Fleming, William A.	1889–91
	Smith, Ed.	1891
	Cummings Bros.	1891–92
	Cummings, Everett G.	*1900*, 1901–02
	Helson, Edwin	*1900*
	Gomond, Joseph W.	*1900*, 1901–05
	Fair, Henry	*1900*, 1904–08
	Fortin, Joseph	1902–05
	Burns Brothers	1903–08

TOWN	NAME	DATES (Census dates in *italics*)
	Burns, Ida A. (Burns Photo Co., 1908–13)	1905–13
	Partain, Joseph	1908
	Webster, John W.	1908–13, *1910*
	Comstock, Edith	*1910*
	Morris, Charles A.	*1910*
	Rundle, William	1912
MACKAY	Nelson, J.H.	1906
MALAD	Pilliner, William H.	*1880*
	Warner, Isaac V.	1906–08, *1910*
	Myers, Charles E.	1912–13
MERIDIAN	Tonkin, George E.	1906–07
	Newell, Mrs. Mabelle	1909–13, *1910*
MONITOR (later BLACK ROCK)	Sawley, Mildred	1906–08
	Johnson, E.G.	1908
MONTPELIER	McEvoy, J.J.	1891–92
	Voight, Leo O.	1891–92
	Rinehart, Ellis W.	1901–13, *1910*
	Jenks, Joel Alonzo	1903–06
	Joy, Emil W.	*1910*
MOSCOW	Erichson, Henry (Erichson & Hanson, 1890–92) (Hanson, John A.) (Moscow Art Studio, 1905–08)	1884–1908
	Emery, W.G.	1890s
	Burns, M. Bruce	*1900*, 1903
	Maxwell, Charles N.	*1900*
	Eggan, Halvor P. (Inga, wife; James P., son)	1905–13, *1910*
	Sterner, John J.	1905–13, *1910*
MOUNTAIN HOME	Pilliner, William H.	*1900*
	Beaton, Alexander	1906
	Sethen & Dearinger (Sethen, I.J.)	1908
	Magden, Etta M.	*1910*
	Helm, Milton H.	*1910*, 1910–13
MULLAN	English, Harry P.	*1900*, 1912–13
	Standow, Richard	*1910*, 1912–13
MURRAY	Haynes, F.J.	1884
	Allison, _____	1885
	Barnard, Thomas N.	1887
	Burton, George	1910

TOWN	NAME	DATES (Census dates in *italics*)
NAMPA	Simmons, A.A.	1895
	Jellum, Herbert Lee	*1900*, 1909–13
	Baker, E.W.	1901–03
	Leek, Norman	1901
	Van Graven & Son (Van Graven, Paul)	1903–08
	Gardner, Jesse	1908–10, *1910*
	Rembrandt Studio	1908
	Keller, Fred C. (Elite Studio, 1908)	1908–13
	Weider, Mrs. J.H.	*1910*
NEW PLYMOUTH	French, Theodore D.	1906–13, *1910*
NEZ PERCE	Fink, Henry	1906–13, *1910*
	Fink, John (Fink Bros.)	*1910*
OAKLEY	Mills, Richard I.	*1900*, 1903–06
	Dahlquist, W.A. (Dahlquist Bros.)	1908–11
	Smith, Hannibal H.	*1910*, 1912–13
OROFINO	Rose, Mrs. Josephine	1906
PARIS	Shepard, W.N.B.	1889–92
	Jenks, Joel Alonzo	*1910*, 1912–13
PARMA	Ley, Alfred M.	1910
PAYETTE	Fowler, William B.	1890s
	Brown, Carl B.	1896, *1900*
	Reels, G.W.	1906
	Weider, Mrs. J.H.	1906–13
	Bates, James E.	1908–09, *1910*
	Van Graven, Phil	1912–13
PECK	Melcher, John R.	*1910*
PINE	Ransom, J.G.	1909–10
PIONEER CITY	Cromwell, W.J.	1866
PLACERVILLE	Murray, J.W.	ca. 1905
POCATELLO	Bryant, H.C.	1889–90
	Sours, R.S.	1893
	Pocatello Art Studio	1893
	Diamond Brothers	1893
	McEvoy, J.J. (McEvoy & Hower)	1893–
	Hower, _____	1893–96
	Markell, W.E.	1894

TOWN	NAME	DATES (Census dates in *italics*)
	Cutler, Joseph H.	1895–96
	Wrensted, Benedicte	1896–1913, *1910*
	Burroughs, E.R.	1898
	Roeder, V.C.	1898–99
	Stevenson, John A.	*1900*
	Lane, Thomas	*1900*
	Miller, C.A.	1901–02
	(Miller & Pyfer)	
	McMillan & Co.	1903
	Black Studio	1903
	Borglum, P.M.	1904–06
	Read, B.	1905
	Wilvert, S.A.	1905
	Henley, G.A.	1906
	Hansen, Axel	1906–08
	Prater, William J.	1908–13, *1910*
	(Prater & Williams, 1913–14)	
	Williams, Herbert J.	*1910*
	Wrensted, Ella	*1910*
	Davis, John	*1910*
	Cochran, M.C.	*1910*
	Rough, Charles	*1910*
	Garvey, Mrs. W.E.	1913
POST FALLS	Thompson, Charles	1891–92
	Kirby, O.A.	1908
	Chandler, Gerald A.	1912–13
POTLATCH	Wilkinson, H.W.	1905–06
	Joslin, G.B.	1911
PRESTON	Allsworth, Samuel	*1900*
	Howell, L.R.	1906
	Jones, Robert A.	1908–13
	Hanson, Frederick	*1910*
RATHDRUM	Palmer, Frank	*1900*
	Koch, George W.	1901–06
	Koch, John L.	1901–04
	Jones, William H.	1908
REUBENS	Price, D.	1912–13
REXBURG	Bramwell, Claudius E.	*1900*
	Hales, Stephen	1903–04
	Anderson, J. Stanley	1906–13, *1910*
	Anderson, Mary E. (wife)	*1910*, 1911–12
	Widerberg, Lafayette	1906, *1910*
	Leweis, Fred	1914

TOWN	NAME	DATES (Census dates in *italics*)
RIGBY	Holland, James S.	*1910*
ROCKY BAR	McIntyre, H.A.	*1870*
RUPERT	Smith, Mattie G.	1912–13
SAGLE, Bonner County	Dunlap, J.F.	1906–13
ST. ANTHONY	Homer, John A.	*1900*
	Middleton, Delia	*1900*
	Andreas, Mrs. P.M.	1903–04
	Walter, Eyer F.	1908, *1910*
	Faike, Harry M.	*1910*
	Ludlow, Charles	*1910*, 1911–13
ST. JOHNS, Oneida County	Bailey, F.S.	1889–91
ST. MARIES	Straffin, Fred D.	*1910*
	Cramer, W.A.	1911–12
	Day, Ernest	1911–12
	Denniston, Dewitt C.	1912–13
SALMON CITY	Pilliner, William H.	1887
	Duray, John H.	1887–90
	Fowler, William B.	*1900*, 1901–13, *1910*
SALUBRIA	Lorton, Joseph	*1900*
SANDPOINT	Hutchins, Charles	1903–13
	Redpath, Charles	1906
	Sargent, Francis H.	1908, *1910*
	Royce, L.M.	1908
	Jacobsen, Philip (Nadeau & Jacobsen, 1910)	1909–13
	Himes, Richard B.	1909–13, *1910*
SHOSHONE	Tacha, Ernest	1901–02
	Merrifield, Edward G.	1908–13
	Thompson, W.C.	1909
SILVER CITY	Hastie, George	1865–66
	Castleman, Philip F.	1866
	Junk, John (Junk & Leslie, 1867–68)	1866–67
	Leslie, Hiram E.	1867–82
	Wood, Thomas M.	1868–69
	Norton, S.	1871
	Potter, J.C. (Leslie & Potter)	1875
	Bomar, Albert C.	1875
	Tandy, H.C. (Tandy & Leslie)	1875–78

TOWN	NAME	DATES (Census dates in *italics*)
	Jones Brothers	1881
	Cook, Frarncis A.	1885, 1889–90
	Newcomb, _____	ca. 1890
	Pilliner, Frederick J.	1891–92
	Pilliner, William H.	1891
	Bishop, Allen K.	1898, 1900, *1900*
	Hedum, Charles C. (Hedum & Bishop, 1898)	1898–1913, *1900*
	Moss & Ricketts	ca. 1900
SODA SPRINGS	Drewery, Harry	1908–13, *1910*
	Gordon Portrait Company	1910
SPINK, Boise County	Kemble, Charles M.	1912–13
SPIRIT LAKE	Welch, F.W.	1912–13
STANLEY	Gregory, C.A.	ca. 1900
	Soule, W.A.	ca. 1910
STUART (later KOOSKIA)	Rosengrant, Dan L.	*1900*
	Pickett, Edward	*1900*
TAHOE, Idaho County	Hofmann, Henry	1913–14
TETON	Benson, Laban	*1900*
TROY	Helm, Daniel	*1900*
	Nelson, Nels	1905–08
	Odden, Crist	1905–08
	Doomes, C.H.	1910
TWIN FALLS	Young, I.L.	1905
	Tacha, Ernest	1906–
	Bisbee, Clarence E. (Bisbee & Reichardt, 1906) (Reichardt, J.)	1906–13, *1910*
	Craig, Frank	1906
	Lavering, E.C.	1907
	Helm, Milton H. (Helm & Amos, 1908)	1908
	Amos, Leah (Helm & Amos, 1908)	1908–13, *1910*
	Rensimer, William S. (Elite Studio)	*1910*, 1910–13
	Crosby, Margaret	*1910*
	Flower, William A.	1910–13
VICTOR	Lyon, T.E.	1901–02
	Barnes, James	1903–04

TOWN	NAME	DATES
		(Census dates in *italics*)
VOLLMER (with ILO became CRAIGMONT)	Hart, W.H. & Son (Hart, Elmer W.)	1908–13, *1910*
WALLACE	Barnard, Thomas N.	1889–1913
	Stockbridge, Nellie	1898–1913
	Barnard, Paul	*1900*
	Ekeberg & Thorild (Ekeberg, Minnie; Thorild, Annie)	1901–04
	Jones, L.I.	1906
	Finn & Fehse	1908
	Gomond, Joseph W.	1908–13, *1910*
	Bixby, Nahum E.	*1910*
	Galliger, Martin	*1910*
	Huttstand, Fred	*1910*
	Maaland, Knut	*1910*
	Hayes & Stenmark	1910–11
WARDNER	Barnard, Thomas N.	1887–89
	Moriarity, J.T.	1906
	Tucker, Herman A.	1908–13
	Stenmark, _____	1910
WEIPPE	Marshall, Milton A.	1903–06
WEISER	Rhodes, J.W.	1891–92
	Prescott, John J.	1903–04
	Marsh, Daniel	1903–06
	Foor, George W.	1891?
	Van Graven, Phil	1908–13
	Sherman, Clifton G.	1912–13

Amateur photographer Dr. Guy Atley took this striking snapshot of a crew digging an Oregon Short Line train out of a snowdrift near Ashton.

ISHS 63-251.18

NOTES

I

1. This, and later references to photographic techniques, are largely drawn from two classic works by Beaumont Newhall, *The History of Photography; From 1839 to the Present Day*. 4th edition, revised (New York, 1964), and *The Daguerreotype in America* (New York, 1961). See also Gus McDonald, *Camera; Victorian Eyewitness* (New York, 1980).

2. W. Rossiter Raymond, *Camp and Cabin* (New York, 1880). 155–156.

3. Silver City *Owyhee Avalanche*, 27 December 1873, p. 1, c. 3; 23 July 1875, p. 1, c. 1.

4. Idaho gazetteers and city directories, 1880–1913, and various Idaho newspapers, 1862–1913.

5. United States Census, 1880, 1900, 1910. Polk's 1886 Gazetteer, 727: Polk's 1891-92 Gazetteer, 1282. Challis, Idaho *Silver Messenger*, 31 July 1894, p. 4, c. 4.

6. Reproduced on page 12. The tent studio of G.E. Tonkin, at Nampa in 1903 is shown on page 75.

7. The Burns and Johnson studios, still active in Boise in 1990, are notable examples.

8. Newhall, *History of Photography*, 49, 57.

9. Idaho City *Idaho World*, 16 July 1880, p. 3, c. 1.

10. *Idaho World*, 18 July 1879, p. 1, c. 1; 10 October 1879, p. 3, c. 1; 5 September 1879, p. 1, c. 1; 2 January 1880, p. 3, c. 1.

11. *Idaho World*, 5 November 1880, p. 3, c. 2–3.

12. *Idaho World*, 14 November 1879, p. 3, c. 1.

13. A.D. Coleman, "Curtis: His Work" in *Portraits from North American Indian Life* (Los Angeles, 1972), pp. V-VII.

14. Charles M. Russell, *Good Medicine; Memories of the Real West* (New York, 1929), p. VII, where Russell is quoted as saying "The West is dead! You may lose a sweetheart, but you won't forget her."

15. See photographs reproduced on pages 86.

16. Boise, *Idaho Statesman*, 3 January 1915, Sec. III, 3, full page.

17. Polk's 1912-13 Idaho Gazetteer, 682.

18. *Idaho Statesman*, 24 May 1887, p. 3, c. 1; 5 July 1887, p. 3, c. 2.

19. Delores J. Morrow, "Female Photographers on the Frontier" in *Montana The Magazine of Western History,* Summer, 1982, 76–84.

20. Clarence King, *Records of the Geological Exploration of the Fortieth Parallel,* Record Group 47, National Archives, Washington, D.C., quoted in *Twin Falls News,* 26 January 1906, p. 2, c. 1–4.

21. Information furnished by Lucille Burns Sawyer and Stanley M. Burns, Boise, 1988.

22. Numerous items in the Dale F. Walden collection of photographic ephemera, Boise.

23. *Idaho Statesman,* 6 October 1889, p. 1, c. 7.

24. *Idaho Tri-weekly Statesman,* 6 March 1877, p. 3, c. 2.

25. *Idaho World,* 14 April 1866, p. 3, c. 1.

26. *Idaho World,* 6 October 1866, p. 3, c. 2.

27. Silver City *Owyhee Avalanche,* 20 July 1867, p. 2, c. 3.

28. *Idaho World,* 25 July 1868, p. 3, c. 1.

II

1. Lewiston *Golden Age,* 2 August 1862, p. 2, c. 4.

2. *Golden Age,* 24 October 1863, p. 4, c. 4.

3. Newhall, *History of Photography,* 21.

4. *Golden Age,* 19 November 1864, p. 4, c. 2.

5. Newhall, 17–28.

6. Ibid. 21.

7. Ibid. 22.

8. Ibid. 47–48.

9. Interview by Author with Lucille Burns Sawyer, Boise, 1988.

10. See page 9.

11. Newhall, 48.

12. Ibid. 48–49.

13. Merle W. Wells and Arthur A. Hart, *Idaho Gem of the Mountains* (Northridge, California, 1985), 36.

14. "Census Report of Special Marshal Frank Kenyon, filed September 16th, 1864. Silas D. Cochran, Acting Secretary, I.T." in the Idaho State Historical Society Library.

III

1. Arthur A. Hart, *Basin of Gold: Life in Boise Basin, 1862-1890* (Boise, 1986).

2. *Idaho Directory including the Principle Towns in Boise, Owyhee and Alturas Counties with a Brief Account of Each Place and Statement of Quartz Ledges, Mills, etc. for the Year 1864.* George Owen.

3. Delores J. Morrow, "Female Photographers on the Frontier" in *Montana The Magazine of Western History*, Summer, 1982, 76–84.

4. *Idaho World*, 5 August 1865, p. 2, c. 5.
 Photo mount labeled "Junk & Curry" in Idaho Historical Library, Boise. Probably 1866.
 Owyhee Avalanche, 20 July 1867, p. 2, c. 3.

5. *Idaho Tri-weekly Statesman*, 6 February 1869, p. 2, c. 1.

6. *Statesman*, 10 August 1875, p. 3, c. 2.

7. *Statesman*, 18 September 1875, p. 3, c. 1.

8. *Statesman*, 30 August 1881, p. 3, c. 4.

9. Printed photo mounts in Idaho Historical Library, Boise.

10. Silver City *Idaho Avalanche*, 8 June 1878, p. 3, c. 3.
 Pacific Coast Directory for 1880–81 (San Francisco), 238.

11. *Idaho Avalanche*, 20 June 1885, p. 3, c. 5.
 Statesman, 5 February 1887, p. 2, c. 3.

12. *Statesman*, 15 August 1871, p. 2, c. 4; p. 3, c. 1.
 Avalanche, 10 April 1875, p. 3, c. 2.
 World, 8 August 1879, p. 3, c. 1.
 World, 16 July 1880, p. 2, c. 5.

13. United States Census, 1880.

14. *World*, 16 July 1880, p. 2, c. 5.

15. *World*, 30 July 1880, p. 2, c. 5.

16. *Statesman*, 3 November 1889, p. 3, c. 1.

17. *Statesman*, 4 April 1890, p. 3, c. 4.

IV

1. Merle W. Wells, *Gold Camps and Silver Cities*, 2nd ed. (Boise, 1983), 26–46.

2. Acquired for the Idaho State Historical Society in 1977 with the generous assistance of Dale F. Walden.

3. The Idaho State Historical Society has several hundred cartes-de-visite, some in the original family albums.

4. *Owyhee Avalanche*, 26 August 1865, p. 2, c. 4.

5. *Idaho Tri-weekly Statesman*, 4 August 1866, p. 2, c. 1.

6. There are several in the collections of the Idaho State Historical Society.

7. *Avalanche*, 3 June 1882, p. 3, c. 4.

8. *Avalanche*, 23 July 1875.
 Avalanche, 14 October 1876, p. 3, c. 6.

9. *Avalanche*, 10 August 1875, p. 3, c. 2.

10. *Avalanche*, 8 June 1878, p. 3, c. 3.

11. *Idaho Avalanche*, 20 June 1885, p. 3, c. 5.
 R.L. Polk & Co.'s Idaho Gazetteer and Business Directory for 1889–90, 1033.

12. *Ketchum Keystone*, reprinted in *Idaho Daily Statesman*, Boise, 1 September 1889, p. 1, c. 6.
 Avalanche, 7 December 1889.

13. *United States Census*, 1880.
 Salmon City *Idaho Recorder*, 10 September 1887, p. 1, c. 2., U.S. Census, 1900.

14. *Idaho Recorder*, 22 October 1887, p. 4, c. 4.

15. *Avalanche*, 5 September 1891, p. 3, c. 1.

16. *Avalanche*, 25 August 1895.

17. Polk, *Idaho State Gazetteer and Business Directory*, 1901–02, 1912–13.

V

1. *Idaho Tri-weekly Statesman*, 29 July 1865, p. 3, c. 3.

2. *Statesman*, 3 October 1865, p. 2, c. 3.

3. *Pacific Coast Directory for 1880–81* (San Francisco), 1428.

4. *Statesman*, 26 June 1875, p. 3, c. 2.

5. *Statesman*, 20 July 1875, p. 3, c. 3.

6. *Statesman*, 31 July 1875, p. 3, c. 2.

7. *Statesman*, 7 August 1875, p. 3, c. 1.

8. Information on Moore and other Caldwell photographers mentioned later was supplied by Lorene Thurston of Caldwell.

9. *Statesman*, 15 January 1884, p. 3, c. 5.

10. Letter in the Oregon Historical Society archives, Portland, written by Andrews, 24 March 1948.

11. *Statesman*, 19 November 1881, p. 3, c. 1.

12. McKenney and Polk *Directories*, 1880-81, 1886, 1889-90.

VI

1. Lewiston *Idaho Signal*, 17 January 1874, p. 2, c. 5; p. 3, c. 1.

2. The 1880 census listed Frost as "Mechanical Engineer," living on the Nez Perce Indian Reservation and Mt. Idaho Road.

3. 1880 Census.

4. *Lewiston Teller*, 11 August 1887, p. 3, c. 2.

5. *Teller*, 25 November 1886, p. 3, c. 4.

6. *Teller*, 17 March 1887, p. 3, c. 1.

7. *Teller*, 26 May 1887, p. 3, c. 1.

8. *Teller*, 11 August 1887, p. 3, c. 2.

9. *Teller*, 22 September 1887, p. 3, c. 2.

10. *Teller*, 12 January 1888, p. 3, c. 3.

11. The Idaho State Historical Society has at least one photo taken at Spalding attributed to Fleming by the donor: ISHS 61-159.4.

12. Cummings is listed in R.L. Polk & Co.'s 1901-02 *Idaho State Gazetteer*, but not in the 1903-04 issue.

13. *Pacific Coast Business Directory for 1896* (San Francisco).

14. *R.L. Polk & Co.'s Lewiston and Nez Perces County Directory, 1905*, 176.

15. *An Illustrated History of North Idaho, Embracing Nez Perces, Idaho, Latah, Kootenai and Shoshone Counties* (Western Historical Publishing Company, 1903), 645.

16. *Moscow Mirror*, October 1885, p. 3, c. 1.

17. *History of North Idaho*, 645.

18. Ibid, 519.

19. *Latah County Pioneer Personal Data Record*, E6.

20. *R.L. Polk & Co.'s Idaho State Gazetteer and Business Directory*, 1905, 1906, 1908, 1912-13.

21. W.G. Emery, *A History of Moscow, Idaho* (Undated, but contextually, 1890s), 21.

VII

1. Merle W. Wells and Arthur A. Hart, *Idaho Gem of the Mountains* (Northridge, California, 1985), 44-51.

2. Ruby L. Hult, *Steamboats in the Timber* (Caldwell, 1962).

3. Montana Historical Society, *F. Jay Haynes, Photographer* (Helena, 1981).
 Freeman Tilden, *Following the Frontier with F. Jay Haynes, Pioneer Photographer of the Old West* (New York, 1964).

4. Patricia Hart and Ivar Nelson, *Mining Town* (Seattle, London, and Boise, 1984).

5. *R.L. Polk & Co.'s Idaho State Gazetteer and Business Directory*, 1901–02, 1903–04.

6. R.L. Polk & Co. directories for those years.

7. Ibid.

8. *Directory of Coeur d'Alene City for the Year 1887* (Spokane Falls).

9. Notes written by her daughter Germaine Gregory, October 1987. Museum of North Idaho.

10. *United States Census*, 1970.

11. R.L. Polk & Co., directories.

12. *Coeur d'Alene Press*, 21 May 1892, p. 1, c. 6.

13. *Press*, 2 July 1892, p. 1, c. 7.

14. *Press*, 31 October 1903, p. 1, c. 5.

VIII

1. Peter B. Hales, *William Henry Jackson and the Transformation of the American Landscape* (Philadelphia, 1988).

2. R.L. Polk & Co. directories, several years.

3. Ibid.

4. Hiram T. French, *History of Idaho* (Chicago and New York, 1914), 243–245.

5. *R.L. Polk & Co.'s Idaho Gazetteer and Business Directory for 1889–90* (Portland), 1022.

6. Polk, 1891–92 directory.

7. *Pocatello Tribune*, 13 January 1893, p. 4, c. 1.

8. *Tribune*, 10 February 1893, p. 4, c. 3.

9. Mount imprints on photos in the Idaho State Historical Society, Boise.

10. *Tribune*, 6 January 1893, p. 4, c. 4.

11. *Tribune*, 31 March 1893, p. 4, c. 1–4.

12. *Tribune*, 20 March 1897, p. 4, c. 3.

13. Polk directories.

14. Ibid.

15. French, 260–261.

16. Polk directories.

17. *U.S. Census*, 1910.

IX

1. *Idaho Daily Statesman*, 4 April 1890, p. 3, c. 4.

2. *Statesman*, 11 August 1889, p. 3, c. 1.

3. *Statesman*, 20 August 1889, p. 4, c. 2.

4. *Statesman*, 3 July 1889, p. 3, c. 1.

5. *Statesman*, 9 November 1889, p. 3, c. 3.

6. *Statesman*, 5 April 1894, p. 8, c. 4.

7. *Statesman*, 19 September 1913, p. 7, c. 3–4.

8. City and state directories (see bibliography).

9. Stamper scattered spot ads throughout the 1899 *Boise City Directory*, compiled by E.G. Taylor and printed by the Statesman Printing Company.

10. Boise City directories for years cited.

11. Polk directory, 1904, 285.

12. Arthur A. Hart, *Fighting Fire on the Frontier* (Boise, 1976), 75.

X

1. Merle W. Wells and Arthur A. Hart, *Idaho Gem of the Mountains* (Northridge, California, 1985), 86–87.

2. Information on Caldwell photographers was supplied by Lorene Thurston of Caldwell, 1987.

3. R.L. Polk & Co. directories.

4. Thurston.

5. Information on A.M. Ley furnished by Jennie Cornell of Middleton, 1987.

6. Information furnished by Lucille Burns Sawyer, 1988.

7. In the collection of the Canyon County Historical Society, Nampa.

8. Ibid.

9. Idaho State Historical Society collection.

10. Polk directories.

11. Ibid.

12. Reproduced on page 77.

13. French, 284–286.

14. Polk directories.

15. Ibid.

16. French, 276–278.

17. Polk directories.

XI

1. Wells and Hart, 105–107.

2. *Twin Falls News*, 3 March 1905, p. 5, c. 3.

3. *News*, 11 August 1905, p. 8, c. 2.

4. *News*, 2 February 1906, p. 5, c. 3.

5. *News*, 9 February 1906.

6. *News*, 23 February 1906, p. 5, c. 3.

7. The superb Bisbee collection was preserved through the efforts of Gus Kelker of Twin Falls and the Twin Falls County Historical Society. The glass plate negatives at Twin Falls were copied on modern film in 1973 by the Idaho State Historical Society, which maintains a complete set.

8. *Twin Falls Times-News*, 3 June 1954, p. 1, c. 1–2.

9. *Twin Falls News*, 18 October 1910, p. 5, c. 5.

10. Polk directory, 1912–13, 682.

11. Polk directory, 1908–09, 41.

12. Polk directories, 1905–13.

XIV

1. Newhall, 89.

2. Harry I. Gross, *Antique and Classic Cameras* (Philadelphia and New York, 1965).

XV

1. *Owyhee Avalanche*, 19 August 1865, p. 3, c. 4.

2. Peter B. Hales, *William Henry Jackson and the Transformation of the American Landscape* (Philadelphia, 1988).

3. In the collection of Bruce and Velma Koch, Oakland, California.

XVI

1. Martin M. Hazeltine used this technique in Boise in 1883 when preparing a panorama for E. Green, English-born artist of lithographic views. Green drew a view of the city from Hazeltine's photos, sold subscriptions at three dollars each, and sent them to San Francisco to be lithographed. The Idaho State Historical Society has a framed copy of this print. See *Idaho Daily Statesman*, 29 December 1883, p. 3, c. 2, and 5 January 1884, p. 3, c. 1.

2. Eaton S. Lothrop, Jr., *A Century of Cameras* (Dobbs Ferry, N.Y., 1973), 56, 75, 97.
 Harry Gross, *Antique and Classic Cameras*.

3. In the collection of the Idaho State Historical Society, Boise.

4. College of Idaho collection, Caldwell.

5. Newhall, 51.

6. *Statesman*, 30 August 1892, p. 8, c. 1.

7. Photo 62–217.1, in Idaho State Historical Society collection, dated 11 November 1909. See also *Statesman*, 24 April 1909, p. 6, c. 5.

8. *Statesman*, 2 August 1909, p. 5, c. 3.

9. *Statesman*, 12 December 1909, p. 5, c. 1–4.

XVII

1. *Idaho World*, 10 December 1864, p. 3, c. 1.

2. *Encyclopaedia Britannica*, 14th Edition (London, New York, Chicago, Toronto, 1938), Volume 7, 680.

3. *World*, 13 October 1866, p. 2, c. 4.

4. *Idaho Daily Statesman*, 15 December 1883, p. 3, c. 1.

5. Idaho State Historical Society has examples.

6. Copies of lantern slides loaned by Mrs. Frank Crookham of Caldwell are in the Idaho State Historical Society.

7. Newhall, 91.

8. *Statesman*, 19 January 1897, p. 6, c. 2.

9. *Statesman*, 30 March 1897, p. 8, c. 3.

10. *Statesman*, 18 October 1893, p. 6, c. 6.

11. See Tom Trusky, *Silent and Talkie Feature Films Made in the Gem State* (Boise, 1990).

SELECTED BIBLIOGRAPHY

DIRECTORIES

R.L. Polk & Co., of Portland, Oregon, published directories of Pacific Northwest states, counties, and cities from the mid-1880s until the end of the period covered by this book. An *Oregon, Washington and Idaho Gazetteer and Business Directory*, labeled "Volume 2," appeared in 1886–87. We have not found Volume 1 in any public collection visited, nor a Volume 3, but "Volume IV," for 1889–90 survives in several locations. Subsequent editions of an *Idaho Gazetteer and Business Directory* found and consulted include those of 1901–02, 1903–04, 1906, 1908, 1910–11, 1912–13, and 1913–14. Also extant is an *Idaho and Wyoming Gazetteer and Business Directory* for 1908.

City and county directories in various combinations were also published by R.L. Polk & Co. Those used in this work, in alphabetical order, are:

Boise City Directory, 1902–03, 1904, 1905, 1906–07, 1908, 1909–10, 1911, 1912–13.

Bonneville, Bingham, Fremont, Jefferson and Madison Counties Business Directory, 1914–15.

Coeur d'Alene and Kootenai County Directory, 1911–12.

Coeur d'Alene City and Kootenai, Bonner and Shoshone Counties Directory, 1912–13.

Grangeville and Idaho County Business Directory, 1913–14.

Lewiston and Nez Perces County Directory, 1905.

Twin Falls Directory, 1905, 1908–09, 1910.

Other directories consulted include, in chronological order:

George Owens, *A general directory and business guide of the principal towns in the upper country, embracing a portion of California; together with mining and statistical information concerning Idaho Territory and a map of Idaho and Montana.* San Francisco, 1864.

George Owens, *Idaho directory: including the principal towns in Boise, Owyhee and Alturas counties, I.T., with a brief account of each place and statement of quartz ledges, mills, etc. for the year 1864.* San Francisco [1865?].

George Owens, *A general directory and business guide of the principal towns east of the Cascade Mountains for the year 1865 including valuable historical and statistical information, together with a map of Boise Basin, embracing a portion of Ada, Owyhee and Alturas counties.* San Francisco, 1865.

L.M. McKenney, *Business Directory of the Pacific States and Territories for 1878.* San Francisco, 1878.

L.M. McKenney, *Pacific coast directory containing names, business and address of merchants, manufacturers and professional men; county, city, state, territorial, and federal officers and notaries public of California, Nevada, Oregon,*

Washington, Utah, Montana, Idaho, Arizona and British Columbia. San Francisco, 1880–81.

Charles E. Reeves, *Directory of Coeur d'Alene City for the Year 1887.* Spokane Falls, Washington Territory, 1887.

Register Publishing Company, *The Mercantile Directory of the Pacific Coast.* San Francisco and Portland, 1890.

Leadbetter & Wolterbeck, *Boise City Directory for 1891, containing an alphabetical list of the business firms and private citizens of Boise City.* Boise, 1891.

Western Publishing Co., *Boise City, Nampa and Caldwell Directory Number 1, July, 1893.* Salt Lake City (printed in Boise).

Merchants' Publishing Company, *Pacific Coast Business Directory for 1896.* San Francisco, 1896.

E.G. Taylor, *Boise City Directory,* 1899.

Farr & Smith, *Boise City and Ada County Directory.* Boise, 1901–02.

Ellis A. Davis, *Davis' New Commercial Encyclopedia: Washington, Oregon and Idaho: The Pacific Northwest.* Berkeley, California, Seattle, Washington, 1909.

Mercantile Directory Company, *Business Directory and Mercantile Register of Spokane and Neighboring Cities and Towns in Washington and Idaho.* Spokane and Seattle, 1910–11.

Gazetteer Publishing Company, *Idaho State Business Directory.* Denver, 1910–11.

George P. Keiter, *Bonneville, Bingham and Fremont Counties Directory.* Idaho Falls, 1910.

THE FEDERAL CENSUS

Microfilm of individual records in the United States decennial censuses of 1870, 1880, 1900, and 1910 were scanned for photographers. (There are no such records for 1890 due to their loss by fire in Washington, D.C. in 1923).

NEWSPAPERS

These Idaho newspapers for the period 1862–1913 were searched for references to early photographers:

Boise: *Idaho Tri-weekly Statesman; Idaho Daily Statesman.*
Caldwell: *Tribune.*
Coeur d'Alene: *Press.*
Challis: *Silver Messenger.*
Emmett: *Index.*
Hailey: *Wood River Times.*
Idaho City: *Idaho World.*
Idaho Falls: *Idaho Register.*
Lewiston: *Golden Age; Idaho Signal; Teller.*
Moscow: *Mirror.*

Nampa: *Leader.*
Pocatello: *Tribune.*
Salmon City: *Idaho Recorder.*
Silver City: *Owhyee Avalanche; Idaho Avalanche.*
Twin Falls: *News; Times-News.*

BOOKS

Coleman, A.D., *Portraits from North American Indian Life*, Los Angeles, 1972

French, Hiram T., *History of Idaho*, Chicago and New York, 1914.

Gross, Harry I., *Antique and Classic Cameras*, Philadelphia and New York, 1965.

Hales, Peter B., *William Henry Jackson and the Transformation of the American Landscape*, Philadelphia, 1988.

Haller, Margaret, *Collecting Old Photographs*, New York, 1978.

Hart, Arthur A., *Fighting Fire on the Frontier*, Boise, 1976.

———— , *Basin of Gold: Life in Boise Basin, 1862–1890*, Boise, 1986.

Hart, Patricia, and Nelson, Ivar, *Mining Town*, Seattle, London and Boise, 1984.

Hult, Ruby El, *Steamboats in the Timber*, Caldwell, Idaho, 1962.

King, Clarence, *Records of the Geological Exploration of the Fortieth Parallel*, Washington, 1869.

Lathrop, Eaton S., Jr., *A Century of Cameras*, Dobbs Ferry, New York, 1973.

McDonald, Gus, *Camera; Victorian Eyewitness*, New York, 1980.

Montana Historical Society, *F. Jay Haynes, Photographer*, Helena, 1981.

Newhall, Beaumont, *The History of Photography; From 1839 to the Present Day*, 4th edition, revised, New York, 1964.

———— , *The Daguerreotype in America*, New York, 1961.

Raymond, W. Rossiter, *Camp and Cabin*, New York, 1880.

Russell, Charles M., *Good Medicine; Memories of the Real West*, New York, 1929.

Tilden, Freeman, *Following the Frontier with F. Jay Haynes, Pioneer Photographer of the Old West*, New York, 1964.

Wells, Merle W., *Gold Camps and Silver Cities*, 2nd edition, Boise, 1983.

Wells, Merle W., and Hart, Arthur A., *Idaho Gem of the Mountains*, Northridge, California, 1985.

Western Historical Publishing Company, *An Illustrated History of North Idaho, Embracing Nez Perces, Idaho, Latah, Kootenai and Shoshone Counties*, 1903.

ACKNOWLEDGMENTS

Idaho's centennial celebration provided the impetus for the publication of this work on pioneer photographers, long in preparation, but slow in coming into final form. At an early meeting of the Idaho Centennial Commission, publication and funding for the project were approved. My thanks to members of the Commission and the Idaho Centennial Foundation, and especially to the members of the publications committee who gave uncounted hours of volunteer time over a period of four years to see that the centennial produced a lasting legacy of much needed books about Idaho and its heritage: Judith Austin, David Crowder, Bill Harwood, James Heaney, Alan Minskoff, Mary Reed, Adrien Taylor, Merle Wells, and Jean Wilson. Your insights, patience, and special expertise are deeply appreciated.

The author is indebted to many people who made reference materials available for use in preparation of this study of pioneer photographers. First, I much appreciate the contributions of former colleagues at the Idaho State Historical Society who shared my interest and enthusiasm for collecting historic Idaho images for the Society's collection—surely the most comprehensive in the state. J.V. "Cap" Root devoted hundreds of hours to the collection in the 1960s. Rachel Smith, Jim Davis, and Karen Ford all made significant contributions of effort, interest, and professional skill in cataloging and managing the collection as it more than doubled in my seventeen years at the Society.

I am especially grateful to the present staff at the State Historical Library and Archives for all of the help they have given. Thank you, Elizabeth Jacox, Guila Ford, and John Yandell.

Duane Garrett, using his exceptional sensitivity and technical skills with historic images, made nearly all of the prints of early photographs selected for inclusion in this book. Ralph Tucker did most of the Society's photo work in earlier years.

Dale F. Walden, the Society's Honorary Curator of Americana, an expert in many things, but especially in early photography, made his nationally known collection available for study and gave valued suggestions throughout the progress of the work. Dale was one of the first in Idaho to study and exhibit the work of early photographers. Over the years he has donated scores of rare and valuable early Idaho photos to the Idaho Historical Society, as well as a superb collection of antique cameras.

People throughout Idaho and the Northwest have assisted with leads to pioneer photographers in their communities, and with access to reference materials. I am most grateful to: Jan R. Boles, Caldwell; Stanley M. Burns, Boise; Arlen Call, Twin Falls Public Library; Jean Clark, Museum of North Idaho, Coeur d'Alene; Jennie Cornell, Middleton; Dorothy Dahlgren, Museum of North Idaho, Coeur d'Alene; Carol A. Edwards, U.S. Geological Survey, Denver; Michelle A. Farah, Latah County Historical Society; Lora Feucht, Nez Perce County Historical Society; Mary C. Griffin, Bellevue Public Library; Henry R. Griffiths, Jr., Boise; Fran Jacobson, Boise; Ansgar Johnson, Jr., Boise; Joann Jones, Latah County Historical Society; Gus Kelker, Twin Falls; Ron and Judy Klein, Juneau, Alaska; Bruce and Velma Koch, Oakland, California; William B. Mallory, Hailey; Elaine Miller, Washington State Historical Society; Delores J. Morrow, Montana Historical Society; Linda Morton, Owyhee County Historical Society; Keith Peterson, Pullman, Washington; Ginger Piotter, Ketchum Community Library, Regional History Department; Helen Rand, Baker, Oregon; Mary Reed, Latah County Historical Society; Virginia Ricketts, Jerome County Historical Society; Lucille Burns Sawyer, Boise; Joanna C. Scherer, Smithsonian Institution; Carol Simon-Smolinski, Lewiston; Carmelita Spencer, Idaho County Historical Society; Lorene Thurston, Canyon County Historical Society; Tom Trusky, Boise State University.

Most of all, I am indebted to my best friend and partner in all projects—my wife, Novella D.

Arthur A. Hart
Boise, Idaho 1990